THE SCREEN

The Screenwriter's Path takes a comprehensive approach to learning how to write a screenplay—allowing the writer to use it as both a reference and a guide in constructing a script. The book sets out a unique approach to story structure and characterization that takes writers, step by step, to a completed screenplay—and it is full of practical advice on what to do with the finished script to get it seen by the right people. By demystifying the process of writing a screenplay, Lake empowers any writer to bring their vision to the screen.

Readers will learn:

- To write for the *reader*—not the audience, the agent, or the actor.
- The relationship between creativity and generating story ideas—and how to enhance your own creativity.
- How to get to the heart of your main character—and to get under the surface to see the inner motivations of every character.
- The 7-step story structure method and how it unlocks the puzzle to screenplay structure in a straightforward way that anyone can use.
- The importance of considering writing an adaptation rather than an original screenplay—and what that can mean for your writing career.
- What elements of screenwriting are unique to writing an adaptation—and why every writer needs to know them.
- The keys to unlocking the emotional story in a successful screenplay.
- Why the element of surprise is crucial to keeping a reader's interest.
- The value of rewriting . . . and rewriting and rewriting.
- Why it's imperative to understand the *business* of screenwriting.
- The real-world ways you can get your script seen by people who count.

Diane Lake is an Associate Professor of screenwriting at Emerson College and is a regular speaker at industry conferences. Her film *Frida* won the American Film Institute's Film of the Year and was nominated for six Academy Awards in 2003, winning two. She has been commissioned to write films for Columbia, Disney, Miramax, and Paramount, and has written a mini-series for NBC, created a half-hour series for ABC, and worked with numerous independent producers, actors, and directors. Diane has been a member of the Writers Guild of America (WGA) for over 20 years, where she has also served as an arbiter to determine film credits. Visit Diane's website at www.DianeLake.com or to schedule Diane for a speaking engagement, please email MichaelGriffin@ScreenwritersPath.com.

THE SCREENWRITER'S PATH

From Idea to Script to Sale

Diane Lake

Focal Press
Taylor & Francis Group
NEW YORK AND LONDON

First published 2017
by Focal Press
711 Third Avenue, New York, NY, 10017

and by Focal Press
2 Park Square, Milton Park, Abingdon, Oxon OX14 4RN

Focal Press is an imprint of the Taylor & Francis Group, an informa business

© 2017 Taylor & Francis

The right of Diane Lake to be identified as author of this work has been asserted by her in accordance with sections 77 and 78 of the Copyright, Designs and Patents Act 1988.

All rights reserved. No part of this book may be reprinted or reproduced or utilised in any form or by any electronic, mechanical, or other means, now known or hereafter invented, including photocopying and recording, or in any information storage or retrieval system, without permission in writing from the publishers.

Trademark notice: Product or corporate names may be trademarks or registered trademarks, and are used only for identification and explanation without intent to infringe.

Library of Congress Cataloging-in-Publication Data
Names: Lake, Diane author.
Title: The screenwriter's path / Diane Lake.
Description: New York : Focal Press, 2016.
Identifiers: LCCN 2016018184| ISBN 9781138649590 (hardback)
 | ISBN 9781138647398 (pbk.)
Subjects: LCSH: Motion picture authorship—Vocational guidance.
Classification: LCC PN1996 .L25 2016 | DDC 808.2/3—dc23
LC record available at https://lccn.loc.gov/2016018184

ISBN: 978-1-138-64959-0 (hbk)
ISBN: 978-1-138-64739-8 (pbk)
ISBN: 978-1-315-62575-1 (ebk)

Typeset in Minion
by Apex CoVantage, LLC

CONTENTS

Fade In x

PART ONE
Taking the First Steps: What You Need to Know to Write a Screenplay 1

1 Original or Adapted: Which Are You Writing? 3
 Original Screenplays: What You Probably Want to Write 4
 Adapted Screenplays: What You Should Really Think about Writing 5
 Whichever You Choose, a Story Is a Story Is a Story 6
 To Theme or Not to Theme 8
 New Media, Webisodes and TV: It's a New World for the Screenwriter 9
 Chapter 1 Exercises 10

2 Concept 12
 The Big Idea 14
 The Logline 15
 The Premise 17
 Chapter 2 Exercises 19

3 Genre — 20

What Kind of Movie Is This, Anyway? — 20
Understanding the 'Rules' of the Top 7 Genres in Film Today — 22
 Comedy — 22
 Romantic Comedy — 23
 Action — 23
 Thriller — 25
 Horror — 26
 Sci-Fi — 26
 Family — 27
Breaking the 'Rules' of the Top 7 Genres in Film Today — 28
Chapter 3 Exercises — 28

4 Character — 29

Whose Story Do You Want to Tell? — 29
Getting to the Heart of Your Main Character — 31
Five Character Questions — 33
 Who Is This Person and What Does He/She Want or Need? — 33
 What Is the Emotional Life of Your Main Character? — 34
 Why Should I Care About Your Main Character? — 35
 What Was Your Main Character's Life Like Before the Story Starts? — 35
 How Does Your Main Character Talk? — 36
Supporting Characters: Please, No Stock Types — 37
 Distinctiveness — 37
 Variety — 38
 Depth — 38
Chapter 4 Exercises — 39

5 Character/Structure — 40

Let's Talk Arcs — 40
Why Character and Structure Aren't Mutually Exclusive — 41
Using Subplots: A Major Crossroads for Character and Structure — 41
What If the Journey of Your Main Character Mirrors the Trajectory of the Film? — 44
How Understanding This Symbiotic Relationship Can Take You to a Higher Level of Storytelling — 45
Chapter 5 Exercises — 46

6 Structure — 48

Obligatory Thanks to the Greek Guy: How
 Aristotle Made It All Clear — 48
Act I: Setting Up Your Story and Main Character's
 Journey — 49
 The Tyranny of Page One — 49
 Writing a Killer First 10 Pages — 51
 Ending the Act with a Bang-up Finish — 53
Act II: Taking Your Main Character on a Wild Ride — 54
Act III: Making the Impossible Possible—Bringing
 It All Together — 55
The 7 Steps — 56
Page Numbers: Why Nearly All Scripts Are Around
 100 Pages — 61
 *Seriously? I'm Supposed to Follow Some Cookie-
 Cutter Formula?!* — 61
 *Why It Works: The Discipline of Storytelling
 Construction* — 62
 *Going Your Own Way: When to Break Ranks with
 the 7 Steps* — 62
Pacing and How to *Feel* It — 63
 What Makes a Story Move — 63
 Writing Action: More Words Means More Care — 66
Deviating from the Norm: Nonlinear Structure
 and the Anti-Narrative Film — 72
Chapter 6 Exercises — 73

7 Dialogue — 74

Writing Good Dialogue: Can It Be Taught? — 74
Working Like Crazy to Be Conversational — 80
Why Less Is Always More — 84
Subtext: Saying What's Not Being Said Says It All — 90
Chapter 7 Exercises — 93

8 Writing the Adaptation — 94

Why Adaptations Are Favored Over Originals in
 the Industry Today — 95
Public Domain: Stories Free for the Telling — 103
Published Stories: Contacting Authors and
 Acquiring Options — 105
How to Know What Makes a Good Story for
 Adaptation — 108
Breaking Down a 400-page Novel into a
 100-page Screenplay: A Daunting Task — 110

	Sample Option and Shopping Agreements	111
	Option Agreement	112
	Shopping Agreement "Tasteless"	114
	Chapter 8 Exercises	117
9	**When to Use Your Bag of Tricks**	**118**
	Montages	119
	Flashbacks	122
	Voiceovers/Narration	124
	Chapter 9 Exercises	126
10	**Why It's the Little Things That Count**	**127**
	Formatting	127
	Top 7 Things *Not* to Do in Your Screenplay	136
	Proofreading	142
	Chapter 10 Exercises	145

PART TWO

Slogging Away: How to Know If You're on the Right Track — **147**

The Pitch: Every Writer's Touchstone	147
The Emotional Story: Make Sure You're On It	154
The Element of Surprise—And Why It Makes All the Difference	156
The Writer's Life—And How to Live It	161
Decide on a Routine That Works	161
Everything Is Material	163
Form a Writers Group and Stay With It	166
Travel. Seriously. Everywhere.	171

PART THREE

You're Done!—So What's Next? — **173**

Rewriting: Hemingway Was Right	173
Proofreading—*Again*	174
Polishing It Until It Shines	175
Launching It into the World	175
Partying—Yes, This Is the First Step	176
Getting Your Script Read	177
Finding an Agent, Manager or Attorney	178
Entering Contests	183
Websites That Can Really Help	184

PART FOUR
Knowing Your Business **187**
 Understanding the Collaborative Process 187
 Keeping Up with Trends 189
 Knowing the Players 191

Fade Out *195*
General Index *196*
Film Index *199*

FADE IN

Why is it that everyone in L.A.—from the valet who parks your car to the ride handler at Disneyland to the thousands of college kids who are interning all over town—is working on a screenplay? Why do people descend on the town hoping that just being there will help them to break in as a writer?

It's because we all love movies. I mean, we *really* love them. Most of us who travel the immensely difficult road to become a screenwriter spent the Saturdays of our childhood sitting in the movie theatre—probably really close to the screen, too. Why? Because we wanted to lose ourselves in those movies. We wanted to be taken to a place we'd never been before, we wanted to be swept away.

I've always thought it a real shame that I only have one life. One body, a few years on the planet, and I'm done. Seriously—how unfair is that? I think that's part of why I write. I want to live other lives, be other people, see places I'll never get to go. I want to do it all—and as Katharine Hepburn once famously said, "You cannot have it all." And I think she was right—but on paper, in the stories I create, I can be anyone and go anywhere.

My grandmother—who as far as I know never left the state of Iowa—told me that in her dreams at night, she went everywhere . . . the boulevards of Paris, the jungles of South America, the gardens of Italy She confidently went to sleep at night knowing a great journey was in store for her. After I realized I was a writer, I wondered if she was too . . . if, given the right circumstances, she might have been able to share some of those journeys with the rest of us. Because what is a writer? Someone who not only has stories to tell but takes the time to commit them to print.

My husband once said that he thought I became a screenwriter as a kind of compensation for not having the right 'shape' to be an actress. Because as

we know, it's tough to be anything other than size 2 and gorgeous if you want to be up on that screen. And I think he might be right. Because at heart, I'm a ham. I love nothing more than sitting around and reading plays and screenplays aloud and acting out the parts. And as a writer, I can *be* all the parts—the old man on his death bed, the painter who lived two centuries ago, the private detective who falls in love with his murdering client, the murdering client who seduces him . . . I can be all of them. Gender and appearance don't matter—as a writer, I get to play all the parts because I *create* all the parts. I give birth to all of these worlds and during the time I'm writing, I get to live in them. Life may give me finite limitations, but writing gives me infinite possibilities—if I can imagine it, I can live it.

In my 20-plus years as a screenwriter, I've been hired to write films for Disney, Miramax, Paramount and Columbia. I created a kids' series for ABC and wrote a mini-series for NBC—as well as worked with independent producers on numerous projects. My produced credit, *Frida*, opened the Venice film festival in 2002 and was named a top 10 film of the year by almost everyone—and it received six Academy Award nominations. So I've been fortunate to be there, in the trenches, cranking out screenplays for the studios. But I've also had the chance to write scripts that I initiated—that came from my heart—and those have been bought or optioned in the US, France and Australia. It seems like something of mine is always in development—I've been lucky.

And luck is important. Don't let anyone tell you that if you're good, you'll succeed in this business. It would be lovely if that was true, but it's not. I know many a fine writer who has given up a 'regular' life to move to L.A. and try and make it as a screenwriter but the timing wasn't right—they were writing serious films when comedies were all that people wanted, they couldn't write stories with happy endings, they were into fantasy before fantasy was big, their work never got seen by the people who could have made a decision to produce it . . . so many reasons that good writers don't make it. I've often said selling a screenplay is about as easy as winning the lottery. And I'm not kidding.

So why try?

Great question. The answer? Because you have to. Because you're a storyteller with characters bopping around in your head clamoring to get out. Because you want to create worlds that will help you get something that's deep inside you out so that you can share it with the world. If you really want this, you have to be driven. Having the drive, though, is only the first step. You also need to have the skill.

And that's where this book comes in. I'm not sure you can be taught to have a talent for writing but if you have some talent—and some determination—this book can help you hone it so that you can give it your best shot. It can also help you uncover the talent you may not even know is inside you by

helping you go step by step along the path of discovery. After all, did Claude Monet spring to life ready to create Impressionism and change the world of art forever? Are you kidding me? He had to draw first. So he took drawing classes and then painting classes. And he got tips from all the great painters. He traveled to study art in other countries. He copied old masters at the Louvre to perfect his talent. He studied the art world of his day—and most important of all, he practiced. And practiced and practiced. He spent his formative years starving and unable to buy art supplies because his work wasn't being bought. He was once thrown out of an inn in the middle of winter—NAKED—because he hadn't paid his bill. (Can you tell I've written a screenplay on Monet?) Point is, he sacrificed so much for his art and *he kept at it* because he had to, he had something inside him that needed to be expressed.

Do you? Do you have something you have to say, stories you have to tell?

If so, come with me, and I'll take you on a path that will help you be the best screenwriter you can be.

PART ONE
Taking the First Steps
What You Need to Know to Write a Screenplay

1

ORIGINAL OR ADAPTED

Which Are You Writing?

While it may seem odd to begin talking about screenwriting by asking this question, it really is the first question you need to answer.

An original screenplay is one that you write without basing it on anything else. So you haven't taken your story from a book, a magazine article, an editorial in the newspaper, etc. The story for this screenplay is something that you came up with. It can be purely fictional or it can be based on a real event. But in both cases, the story is yours.

This is an easy distinction if you've come up with a story about a young kid who stows away on a spaceship bound for Mars. It's easy to see that's certainly fictional and unless you copied the idea from someone else's work, it would be your original story. But if you write about a murder that really happened in your town, is that an original story? Well, the answer is, "it depends."

If the murder has certain facts that define it—what happened and when it happened—and you don't rely on anyone else's analysis of this murder, you can write your story of the murder and it would be original. However, if you take your analysis of why the murderer did what he did from a newspaper reporter's analysis of the guy's motives, then it's not original—it's based on someone else's unique telling of that story.

It's a fine line, isn't it? If a murder happens, 10 screenwriters could write about it in 10 different ways, each telling their own original story of that murder.

If you read a series of articles by a newspaper reporter and you use those as the basis for your story, you're writing an adapted screenplay, not an original one. You can contact the newspaper reporter and ask her permission to use her articles as the basis for your screenplay, but believe me, you'll have to

pay her handsomely for the privilege! (More about optioning rights to stories in Chapter 8.)

So if you're basing your original story on real events, just be sure that your telling of those events is from your unique perspective and you haven't used anyone else's analysis of those events.

Many screenwriters, though, simply want to write an original story about a road trip or a romance or a death or a cyborg or whatever. You have this story that just sort of 'came' to you and you have the need to tell it. That's definitely an original story, no question.

Interesting fact: more adapted screenplays are produced each year than original ones. That means more stories based on novels, biographies, newspaper articles, etc., are produced each year than original stories. A big reason this is the case is that studios and producers like to be sure a story has public interest. If a novel has been published and has sold well, there's a bit of validation there that the story is of interest to people, so more people might go to a movie based on that novel. If a series of newspaper articles on the drug underworld in Manhattan really captured the interest of the public, the studios think there's a good chance the story might capture people's interest on film as well. Bottom line? The studios—and many producers—are risk-averse, they want sure things. As we know, there are no sure things when it comes to making a successful movie, but if the genesis of the film is a successful book or newspaper article, they're more inclined to take that risk.

So ask yourself, which will it be, original or adapted?

Original Screenplays: What You Probably Want to Write

If you want to be a screenwriter, chances are it's because you have original stories you want to tell. They can be stories loosely based on your own life or they can be stories you've totally imagined, but either way, you just have something inside you that makes you a storyteller.

My mother, a very simple woman who left school in the 7th grade, asked me once where all my stories came from. I thought about that because, well, I'd never really thought about it until she asked that question. So I tried to think of a way to explain it that she could relate to. Here's our conversation:

```
                    MOM
          Where do all them stories you
          write come from anyway?

                    ME
          Well . . . think about it like this.
          Imagine you're on a bus. You look
          across the aisle and see a man.
```

```
                    ME [CONT'D]
          Don't you wonder what he's doing on
          the bus? What he does for a living?
          What his life is like? Don't you
          wonder about that?

                    MOM
          Huh? I probably just look at him
          and wonder how come he's got such
          a big nose.
```

And believe me, she wasn't being funny. My sweet mother didn't look at the world the way I did at all. I guess most people don't. I expect most people look at others and analyze them given their own wants and desires as far as that other person is concerned, but do they really wonder about the inner life of their boss or grandparent or the check-out clerk at the supermarket? Doubtful.

But that's what writers do. Writers wonder about those things and imagine the answers—and those imagined answers become stories.

Some people dream stories, others look at one thing and that makes them think about another thing and from the connection comes a story idea. Every person I meet, every person I know, could be a story. Therapists are driven to listen to patients' stories and help them make sense of them in regard to their lives. Writers are driven to write those stories down and imagine even bigger stories, stories that resonate even more.

However you make connections, the stories that keep coming back to you—that stay in your head and just won't go away—those are fodder for an original screenplay. If a story stays with you a long time or if it just comes to you one day and sort of makes you gasp with wonder, however it happens, you'll know when you need to write a screenplay based on it—the story itself will speak to you.

So it's understandable that you'd want to write stories that mean something to you, that resonate with you, and that's the most common choice for the beginning writer. Nothing wrong with that. But there's a whole other story area that you need to think about, and if you do, maybe you'll change your mind and jump ship from writing original stories.

Adapted Screenplays: What You Should Really Think about Writing

Adapted screenplays, ones that are based on another source, have outpaced original screenplays in terms of production for quite a few years now. Interestingly, it's the same with reality television right now—more of those shows are popping up than ever before. Is it because they're better and of a higher quality than scripted shows? Stupid question, right? To those of us who write

stories, reality shows are the scourge of our time! But let's think a minute about just *why* they're so popular.

Could reality shows be as popular as they are just because they're true? They're 'real' people, 'just like us' one could say. No one can say the stories being told on *Survivor* or *The Bachelor* are unreal, can they? In fact, part of the fun for many people watching them is to see how far these people will go in their quest for money or fame. People like real—witness the ancient Romans creating spectacles by having the Christians fight the lions, and the popularity of sports is never-ending—people love watching things happen in real time where they can't predict the outcome. Which *means*, bottom line, people like to watch stories that are happening now, that they can follow in real time. The real holds more allure than the 'made up'.

So maybe you should rethink that original screenplay you think you want to write and ask yourself if there's a 'real' story out there that you could tell. Whether it's adapting a fairy tale (nearly all of which are old enough to be in public domain), or your great-grandmother's trek out of Germany to escape the Nazis in WWII, or the story of a race car driver's comeback after being injured, there are a multitude of real stories that are dying to be told.

Another reason to try an adapted story is that there are so many of them! If you love to write, let's say you've written short stories or plays or newspaper/magazine articles but aren't sure exactly *what* you'd write if you were to tackle a screenplay, going the adapted route may be for you. If you can find a true story that you can bring, through your original eyes, to the screen, it's a way for you to get going.

Getting going is important. A lot of people talk about writing a screenplay but not many of them ever actually do it—and that could be just decision anxiety, i.e., "what do I write first?" Writing an adaptation will let you get underway now, not a few months from now.

Another reason to write an adaptation is to have it in your repertoire—you want an adaptation sample script to be able to show that you can tell true stories.

If you're adapting a 500-page book or a long, involved trial—well, that's probably too big a task for a new screenwriter . . . better to understand how screenplays are done by writing your own, original screenplay first. But a fairy tale? Might be interesting to tackle.

The ins and outs of writing an adaptation are discussed in more detail in Chapter 8. For now, just be aware that if you're drawn to true stories, adaptations may be the way to go.

Whichever You Choose, a Story Is a Story Is a Story

This is hugely important to understand, whether you dream up a screenplay about a child battling leukemia or whether you write a film based on the true

story of a child who is battling leukemia, you need for that battle to be a story that's worth telling.

Wait a minute, you might say, any story of a child battling leukemia is important. Agreed—for sure. But that doesn't make it worthy of telling as a *screenplay*.

There was, for a very long time, a category of TV movie called 'the disease of the week' movie. A young woman (almost always a woman, sometimes a child) fights against all odds to overcome her terrible disease and return to her loving husband/boyfriend/parent/family. You see vestiges of this sort of story on television today, no doubt about it. It's a formula that some networks found to work for them very well:

ACT I: Life is good, then she finds she has a disease that will either kill her or severely ruin her quality of life. Oh, she's usually beautiful, too.

ACT II: Her battle with the disease is arduous—it takes a toll on her and her significant other, perhaps even strains the bonds of their relationship. She has a best friend who is always there for support, though. But the battle is tough and as the act ends, it looks like it will be a losing battle for her—she will die or be disfigured for life or end up in a wheelchair or whatever.

ACT III: After she's reached her lowest point, something happens to turn everything around . . . she begins to get better! And the support of her significant other is a big part of her improvement. As the act wears on, we can hardly believe it—maybe she's going to make it! And as the film ends, she does. All is right with the world.

Did you feel a bit of cynicism creeping into my summary? Yeah, well, you're right—this is not my favorite way to tell a story. It's formulaic to the max and it pulls on our heartstrings—I mean, if we say we didn't like the movie, that could be taken as us not having any empathy for people battling leukemia, or whatever disease the character had.

There was, by the way, another category of TV film called the 'woman in jep' movie—the woman in jeopardy. Just as with the disease of the week movie, the woman in jeopardy followed the same format—but in place of the disease, she was in some sort of situation where she was threatened by an ex, stalked by a co-worker, a witness to a mob killing, etc. This put her in jeopardy and she spent the movie trying to get out of it and also have her tormentor captured . . . you can plug in the woman-in-jep points to the disease of the week outline and see how that story went.

Your job as a screenwriter is to tell moving stories, funny stories, wild and crazy stories, fantastical stories—all of which should say something new, take us someplace we haven't been, contribute to the understanding of the human being in a different way than what we've seen before. If you're going to tell that story of the child battling leukemia, ask yourself what's special about *this particular child* that elevates the story above *any* child battling that horrible disease. What makes this child's story worthy of a film that everyone should watch, that everyone will get something out of, a film that will change the way we look at people battling such diseases and make us rethink what we already knew about such situations?

Never let anyone tell you that coming up with a viable story is easy. And that's the crux—a good story. And it takes a writer to do it. There's a scene in that fabulous movie *The Player* [1992], a movie every writer should see, where a studio exec invites other execs at their morning meeting to pick a story out of the newspaper—the exec's claim is that he can take any story and make it a movie. A colleague reads a headline about a volcano killing people in South America, the exec says great—that's a great example of triumph over tragedy, cast Jimmy Smits for the romance angle and it will practically write itself. And, as one person says to end the scene, it's an interesting choice to leave the writer out of the creative process. But when we tell stories that are all formula, that's exactly what we're doing. And there are enough people in Hollywood aiming that low—writers need to be the ones aiming for the stars.

Your job as a screenwriter is to tell us new stories—not formulaic ones that most decent writers could write the way Ikea furniture is put together! It's a skill to put together Ikea furniture—it's not an art. Screenwriting is an art and you need to remember that you're an artist. So choose your colors carefully, and paint a truly great story.

To Theme or Not to Theme

I've been in more than one meeting where the studio executive asked me something like, "What theme are you going for?" I really struggle with this question because the fact is, I don't actually think in 'themes' . . . sorry. That's not the right answer. I know many writers believe in having a theme that they're always coming back to as they write.

Maybe it's just a matter of semantics, though. So what's my problem with themes?

Here's the thing—too often, people have this overriding idea they're writing about and everything they write in the script is to support that idea. It could be "gun control is bad" or "love is all there is" or "Communism is good" or "you can't trust anyone" or whatever. For me, if this theme grows organically out of the telling of your story, then I have no problem with it—it

will seem natural and real to me because it's where the story takes me. But most of the time, I find a writer *begins* with this theme and then works to make sure everything in the script supports it—and that comes across to me as false, contrived, and I don't buy it for a second. Whether it's a political theme or an emotional one, I want it to come out of the characters in your story and what they find themselves up against or what they're struggling with—I want it to be organic.

So if you're someone who thinks about the overarching meaning of what you're going to write about before you write it, just do me a favor and don't be heavy-handed about it because I promise you, if you try to shove a theme down your audience's throat, they'll barf all over you in response—they'll see what you're doing and be way less involved with your film.

Or maybe not. Depends on your point of view. The classic example of theme in screenplay is *The Wizard of Oz*'s [1939] 'there's no place like home'. Note that it's something our main character, Dorothy, says she wants throughout the film and she gets her wish by the end. Well, don't lynch me, but if I was writing that story, Dorothy would have stayed in Oz. Return to Kansas?! Are you kidding me? I knew what kind of fate she'd have in store for her (I grew up in neighboring Iowa) so I wanted her to discover the wonders of the world and carve a unique life for herself, not just return to business as usual and go back to the dusty farm. But if you buy into the 'theme' idea, your character too often does, or discovers, exactly what they're supposed to—which is so predictable. How boring is that? Why couldn't the theme have been 'discovering yourself requires leaving home' or something similar? Or, at the very least, why couldn't the theme have been more subtle? Or, maybe, thinking about theme leads to predictability and we should just write a good story!

So I say, throw out the old-fashioned homily unless you can surprise me with it in some way. I know, I know, *The Wizard of Oz* is beloved (I actually am a sucker for it too) but in many ways, it's like the popular reality shows of today—they're predictable and full of down-home wisdom that I'd like to think today's storytellers are moving beyond. So as you write, think less about theme and more about story—and do me a favor, don't make Dorothy go back to Kansas.

New Media, Webisodes and TV: It's a New World for the Screenwriter

When I was first repped by Creative Artists Agency (CAA) in the mid-90s, I told them I had an idea for a TV series. My group of seven agents smiled and told me that I was a feature writer, that TV writers were repped by a completely different department because the two species—feature writers and TV writers—rarely mixed. Didn't I realize that all TV writers aspired to

write features? Surely, I didn't want to go backwards. Huh. Who knew? And for that time period, they were right. So I happily kept writing features and put my TV ideas on hold.

Boy, have times changed. Today, it's all about crossover. Fantastic writers, often known for their work in features, are developing television shows on networks that want new and exciting product—from Netflix to Amazon to good old HBO. And TV writers are writing features—that false ghetto that TV writers were placed in is pretty much gone.

So what's happened?

Today, it's all about content. Got a good story? Well, think about what venue would be best to tell it in—big screen, small screen . . . or even something else. Because it's not just film versus TV anymore, it's also webisodes, video games, all kinds of new media. And they all have one thing in common: they need stories.

Want to write a sitcom? Do it. Then get your friends together to act it out, film it with your iPhone and throw it up on YouTube. You've got a webisode. Somebody at a sitcom sees it and maybe you get an invite to write an episode of their show.

Have a burning desire to write a video game? Find a friend who's a computer geek and get him/her to write the programming while you write the story. Shop it around and if you don't sell it, maybe you'll attract the interest of a videogame company and they'll hire you as writer/programmer.

So the delivery system is there—no matter what you want to do. The question is, what do you put in the pipeline? What story will grab the attention of watchers of webisodes or players of videogames? If it's so easy to film your own webisode or design your own game, won't everybody be doing it? Well, yeah. So what will distinguish them—what will make one stand out over the other?

A good story.

Chapter 1 Exercises

1. Pick up today's paper and come up with three stories that could be a movie. Which of the three is strongest and why?
2. Make a list of three original stories that you could write. Don't stop at the one story you've been thinking about writing, really work to come up with two more viable stories. Wait a few days and then return to the list—which story now feels the strongest?
3. Take your favorite adapted idea from exercise one and your favorite original idea from exercise two and imagine it *not* as a screenplay, but as a webisode or video game. Would it work? Why or why not?
4. Looking at all six of the ideas you produced in exercises one and two, what would you say is the theme of each idea? Ask yourself, did you come

up with the idea first or the theme? And if you wrote the script, would you be able to let the story drive you or would the theme take over?
5. Go online and find films or webisodes filmed by amateurs. Critique them—ask yourself what you'd do differently. Really think about what makes one better than the other.

2
CONCEPT

Where do great concepts for films or novels or anything come from? Scientists who study creativity wire up the brains of writers to MRI machines to try and figure out where their creative ideas come from. And guess what? They still don't know.

It's funny, when you're five, you're not lacking in ideas—you'll try most anything, play most anything, make up outrageous stories... ideas are just toys in your mental toolbox.

Wouldn't it be nice to get back to that? To be able to tap into our brains in an elemental way and generate great ideas?

Is there a magic formula for doing that? Of course not. But there are... games. That's right—games. And the best one I know is brainstorming. You've no doubt heard the term or used it in a class in small group communication or on the job or something. It's where a group of people sit around and throw out ideas—just throw them out, no criticizing of anyone's idea, no discussion at all, the goal is just to get as many ideas down on paper as possible. This is used as a way for groups to solve problems more effectively.

I think you can use brainstorming all by yourself—no group involved. This means that if you're trying to come up with a great idea to write, you just sit in a room and start throwing things out and writing them down. Here's how it might go:

OK. I can do this. I have lots of interests. Cars. I like cars. A movie about cars—a car that can fly, a car that wins the Indy 500, a car that's about ready to go to the junkyard and wants to escape its fate, a car that's being sold and is going to miss the used car lot where it's been for

2 years. Or, if not cars, what about running? I love to run. I could write about a runner who makes the Olympic team. Or a runner who sabotages someone else to make the team. Or what if she succumbed to drugs to make the team—a new drug no one can detect? And what if she makes the team but falls and has a spinal injury for life? So she not only can't run anymore, she can't even walk?

OK, see what happened here? Ideas got thrown out—you can write the ideas down as you have them or you can do a voice memo to record them and transcribe them later. Either way, you get some ideas down on paper. Only after you've generated a ton of ideas, a lot more than I just did, can you go back and begin to examine them.

Take a look at the car ideas generated in our little exercise:

(1) A car that can fly
(2) A car that wins the Indy 500
(3) A car that's about ready to go to the junkyard and wants to escape its fate
(4) A car that's being sold and is going to miss the used car lot where it's been for 2 years and the shiny Corvette that's been next to it

What can you say about those four concepts? Well, they're all from the point of view (POV) of the car. There's no idea there about a teenager who wants a car for his birthday, for example. Additionally, three of the four ideas are fantastical—cars can't fly, a car that's going to the junkyard wouldn't know it because cars can't think, and a car doesn't have the capacity to miss its used car lot OR another car because cars can't feel. All three of those concepts would indicate that their writer is interested in fantasy—perhaps animation as well, as that's the easiest way for a film to tell such stories. And the other idea—about the car that wins the Indy 500—may not be fantastical but, again, it's from the car's POV, which would tend to make the car seem human.

So the writer who writes those four ideas might want to think about that. Why did he write about cars from their POV? Is he particularly drawn to animation? Does he like movies that focus on inanimate objects becoming human? Is that part of what drives his imagination?

And what about the running ideas?

(1) A runner who makes the Olympic team
(2) A runner who sabotages someone else to make the team
(3) What if she succumbed to drugs to make the team—a new drug no one can detect?
(4) What if she makes the team but falls and has a spinal injury for life? So she not only can't run anymore, she can't even walk?

These ideas are quite different than the car ones, aren't they? The first one is pretty general—not sure what the movie would be. But when we look at the other three, wow—look what they have in common. Something horrible happens in each one. Sabotage, drug-taking and a life-altering injury. We're not talking happy stories of a runner who overcomes all odds to go on to glorious victory as a just reward for all her efforts! The sabotage idea and the drug idea tell us we're dealing with a character who will do anything to win. But the injury idea becomes more a story of someone who has to deal with the fact that her dream has caused her ruin, or at least a change in her life that she certainly wouldn't have wished for, so what's she supposed to do now? Except for the first general idea, the rest deal with characters who are flawed—there's a bit of tragedy lurking in these three ideas.

So the writer who wrote these running ideas might wonder if he's into writing darker genres, or at least deep drama. Or is he into writing characters who deceive? Or characters who suffer loss?

If the same writer wrote the car ideas and the running ideas, what kinds of things is this writer drawn to? Do you see any patterns? Well, things happened to the cars in ideas #3 and #4 that were beyond their control—which is true of running idea #4 as well. The runner making the Olympic team and the car winning the Indy 500 both accomplish amazing feats. There's no comedy in any of these ideas—with the possible exception of the car flying, which could go many ways.

The point is, the more you brainstorm, the more patterns you'll see and the more concepts you'll generate that will lead you closer to the one you want to write. So sit down and brainstorm 50, 100 ideas—just write them down without censoring yourself and without stopping. Afterwards—maybe even a day or two later—you can go over them and evaluate. Maybe you brainstormed 99 lousy ideas, but if you managed one good one, well, that's all you need. You're on your way.

The Big Idea

In 1991, Jeffrey Katzenberg sent around a now-famous memo where he commented on the state of the film industry. This memo was sent internally to upper-level Disney staff, but quickly got leaked for general consumption and got handed around from friend to friend and then quoted pretty much everywhere. He said many interesting things in the memo but one part that hit me was his opinion that it's all about the big idea in film—that the idea is king. He bolded and italicized and underlined that phrase: ***the idea is king***. In his mind, actors, directors, writers and all the rest were there to serve the idea.

Let's not talk about where the idea's supposed to come from—if you're reading this book, you, like me, assume they come from a writer with

imagination. But you can come up with a good idea and not be a writer, no doubt about it. The thing to remember, as Katzenberg went on to say, is that people don't want to see what they've already seen. He was trying to motivate his studio to think outside the box, go for the great film instead of play it safe by just trying to replicate the success of another film by producing its clone. "When we fail," he said, "let it be because we tried to innovate, not emulate."

So where do your ideas come from? Are they new and exciting—ideas that you haven't seen done before—or are they just derivations of films we've already seen? What can you do to make sure they're the former and not the latter?

First, you need to be willing to follow your heart. This means you need to *understand* your heart. So do you? Are you aware of your emotional self and what drives you and makes you happy and gives you joy? If you can get inside yourself, perhaps you can tap into ideas that are unique—that only you could write. And that's a place to start—what idea do you have that you and only you can write? What movie would that be? Second, you have to be willing to take a risk, be willing to fail. Most people aren't. Most kids in school will only raise their hand to answer the teacher's question when they're sure they have the answer. Most adults play only the games they think they have a chance to win. Can you *not* play it safe when choosing an idea to write? Can you jump off the ledge and do something that's so off the wall that people could laugh at you for even trying?

Both following your heart and being willing to take a risk have one thing in common: courage. It takes courage to perhaps break away from the norm and follow your heart just as it takes courage to be willing to fail. And all you need to have courage is the guts to *try*. Try following your heart, try risking failure, what's the worst that could happen? If it doesn't work out, you try again. Or, you succeed in ways you never even dreamed.

So want to find that big idea? Just take a deep breath and summon the guts to try.

The Logline

Once you have that idea, you need to be able to express it—for yourself and for any agent/producer/studio exec/actor/director who might be interested in your idea. And that's what a logline is all about.

Generally, loglines are one or two sentences, tops. And they don't tell the whole story of your film. A logline is written to make that producer want to read your script. The logline should give us the gist of your story and leave us wondering how it will turn out. Like the coming attractions for new films, your logline should preview the script you're writing and make me salivate to read the finished product.

16 What You Need to Know to Write a Screenplay

Elements of a good logline include:

(1) Describing (in just a word or two) your main character
(2) What that character wants or needs
(3) What the character is up against in trying to achieve their want/need
(4) What will be fun/thought-provoking/interesting about this film

Let's look at a couple of examples:

Figure 2.1 Astronaut Ryan Stone tries to get home in *Gravity* [2013]

Gravity [2013]: After a catastrophe destroys their shuttle, rookie medical engineer RYAN STONE (35) works with her seasoned astronaut/colleague MATT KOWALSKI (50) to survive in space and make it back to Earth—but time looks like it's running out . . . could their future be to die in space, alone and adrift?

Bridge of Spies [2015]: Insurance lawyer JAMES DONOVAN, 55, can't believe the CIA wants him to negotiate the release of a downed U.S. pilot captured by the Soviets during the Cold War—is he woefully out of his league or is something else going on?

As you can see, these loglines are very short—each summarizes the essence of the story and leaves us up in the air to some extent—we want to hear more, we're surprised by the end of the logline, we feel a bit of suspense, etc. For *Gravity*, it's 'will they survive and make it home?' and for *Bridge of Spies*, it's 'why'd they choose this guy and what's he gotten himself into?'

The logline is written to tempt. When you send that query email to Tarantino to interest him in reading your script, you need a logline that will titillate him, make him think, surprise him in some way. You want him to have his agent call and say yes, he'd like to look at your script.

You also want to have a quick way to summarize your script to any producer, agent, star, studio development assistant, ANYONE who might be of value to you to read your script. Maybe you'll be stuck in an elevator with one of the above mentioned folks. You don't want to bore them by trying to summarize your script act by act, you want to leave them wanting more . . . you want to leave them wanting to read your script.

So work on the logline for your film and make us want to rip open the cover of your script to read it!

And by the way, a side benefit to writing a good logline? It helps you focus on what your story really *is*. Why is that the case? Because having to pare it down to a sentence or two forces you to get to the essence of your story, so writing a good logline can even help you in the writing process as you go forward. It doesn't lock you into anything—as you write, you can change your story to your heart's content, but it's good as you're setting out to have an idea of where you're going. You wouldn't start a trip without your GPS in hand and you shouldn't start writing a script without a logline. It's not the whole 'map' of your story, but it will get you in the car and on the road.

The Premise

While a logline is a sentence or two, a premise is a paragraph. A premise gives a bit more detail than a logline—it fleshes out a logline. Let's look at a logline and a premise for the film *Product Placement*, a script by Dan Cohen that's in development as I write this. Here's the logline:

> Product Placement *tells the story of a low-budget horror producer who figures he can save a lot of money on special effects by killing his actors on film. So, yes, it's a comedy.*

Think of the question that would prompt a writer to come up with this idea—'what would happen if a producer killed his actors in his horror movie instead of using special effects?' What kind of producer would do such a thing? And would this be a dark creepy horror film itself, would it be a drama, would it be a detective story where someone tries to catch whoever is killing these actors, or would it be played for straight comedy? The idea is so rich, it could go any way—thus, that last sentence (*So, yes, it's a comedy*) clears that up and tells us the kind of film this is—and it tells that to us in a casual, off-hand sort of way . . . which also underlines the tone of the film.

Here's the premise for *Product Placement:*

> *Slasher producer BOB REYNOLDS, 27, is having a bad day. He's got a killer horror script just dying to be made but his dad, the studio head, won't give him more than peanuts to get it going. So when his cocaine dealer begs to come on board and save the project, what's he supposed to do? But on the set, even the dealer's money isn't enough to save him— and the picture's going to go under, until Bob realizes that killing his actors will save him beaucoup bucks on special effects . . . and he never realized how cool real blood was on film. If he does this right, he's going to be huge.*

Look at how much insight we get into the main character just by reading this premise. He's not a *producer*, he's a *slasher* producer. This makes it very clear to us the kind of movies this guy makes. And his dad? Head of the studio. And is dad supportive? Not enough to make Bob happy—because dad won't fund his film to the extent he feels he deserves. Bob does cocaine, or he wouldn't have a dealer, would he? And that dealer makes it too easy—how can he turn down the money he needs to finance the film even if it comes from a drug dealer? But still, he has to cut corners. So you can almost see the moment when Bob realizes that if he could just dispose of this nobody-extra by killing him on screen, he'd get a great performance and wow, look how good real blood looks. You can almost see the smile on Bob's face when he realizes this is going to make him a giant in the industry because nobody else's kill shots will look this good. We also know that Bob has about zero sense of moral responsibility or this idea would never occur to him, let alone would he be the kind of person who could go through with it and be happy about it!

Look carefully at the language in the premise. Notice how full of active language it is, language that moves, evocative language, language that paints a picture: *killer* horror script; *dying* to be made; won't give him more than *peanuts*. The use of active language makes this premise jump off the page.

Like your logline, your premise needs to be carefully constructed. You need to write it as if you're selling your idea to someone and want that person to see how fantastic that idea is. And this takes time. Most people can't just knock one of these out in 5 or 10 minutes—it's the kind of thing you need to work on and keep coming back to so that you end up with a premise that makes me want to devour your script to see how old Bob fares.

From idea to logline to premise—it's all about choosing the concept you want to write about and making that clear to yourself and anyone else. If you're in doubt about what you want to write, or say your brainstorming session left you with too many ideas, why not take five ideas, write five loglines,

and then write five premises. *In the process of doing that*, you will discover which of the five concepts is the one you want to write.

Like all writing you do, this isn't written in stone. It's just words on a page. Don't like them? Throw them out and start over. Really hate one of the five concepts? Forget it—move on to one of the others. Just as with writing the script itself, it's always up to you. You decide what direction you go in, you decide whether the logline and premise you just wrote is worth keeping around to possibly write. So don't feel that if you start with a particular logline and premise you're 'stuck' with it. No way. It's fluid, it can change if and when you want it to. This is *your* story, you're in charge—they're your words and you can do with them what you will.

I mention this because writers are too often hard on themselves. Like if they produce something that's less than brilliant it means they've lost it or they never had it or something. But the truth is you may produce lots of material that's just so-so until you've had the practice of writing and start getting better. Did Yo-Yo Ma come out of the womb playing the cello? No. He practiced for years and years. So take a lesson, start brainstorming those ideas, writing those loglines and premises, and who knows—maybe it will only take you months and months.

Chapter 2 Exercises

1. Take a look at your top five favorite films of the last year. What's the 'big idea' in each of the films?
2. Write a logline and premise for each of the films you listed in exercise one.
3. Brainstorm 50 film ideas—that's right, sit down and throw ideas on tape or on paper and don't stop until you reach 50.
4. What are three ideas you'd like to write a film about? Why are the ideas distinctive?
5. Write a logline and premise for each of the films you came up with in exercise four.

3

GENRE

Movies fall into different genres, and understanding those genres—and what the audience expects when going to a film in a certain genre—is extremely important. If mom and dad bring their 5- and 7-year-olds to your film called *Fun with Woodland Creatures* expecting a romp in the woods with furry squirrels and quizzical owls and instead they find a group of unsuspecting college kids on a camping trip battling the bloody undead, and various bug-eyed zombies, well, that family is not going to be too happy. We go to films with expectations. We're 'in the mood' for a romantic comedy or we're in the mood for a fast-paced thriller—and if we go to one expecting the other, we won't be as satisfied. And if I want to spend an afternoon seeing great car chases carried out with my favorite action star at the wheel, I'm not going to be happy with a horror film. I might love horror films, but if I'm not in the *mood* for one, even if it's good, it's not going to meet my expectations.

What Kind of Movie Is This, Anyway?

Understanding genre is all about understanding expectations. If your new outrageous comedy script makes its way to a production company who has put the word out that they're looking to develop family films at the moment, even if your comedy script is terrific, it won't interest them. A good script should be a good script, right? Sure—and that's always true. But just because it's good doesn't mean that hot director you want to read your new thriller will respond to it *now*—she may have decided that as her last film was a thriller, she wants a change of pace and is looking for a comedy.

So moviegoers and moviemakers all think about genre—which means that you, the writer, must consider it as well. Think about what genres interest you most as a writer. What kind of movies do you like to see? That's often

an indication of the kind of movie you should think about writing. But really give this some thought because you want to choose carefully—chances are whatever script you 'break through' with is the kind of script you'll be writing for most of your career.

I started out writing comedy—had several close calls, i.e., 'almost' sales, one producer telling me he fell out of his airplane seat he was laughing so hard at a script I wrote. (This, of course, probably wasn't true. He was just overstating to make me feel good.) My first agent got lots of feedback about how funny I was, so I followed her advice and kept writing comedy, or sometimes dramedy (comedy and drama combined). But I never sold anything and spent a couple of years writing comedy after comedy because I was a good girl and followed my agent's advice. And then I broke through—made my first big deal—on a period piece set in the art world. Not an ounce of comedy. I thought at the time, "Hey, the comedy isn't selling—why don't I write something I'd like to *see* if I was going to a movie, something that would be both fun and a challenge to write, and then people can 'not' buy that . . . at least I'll have had the fun of writing what I want." But somebody did buy that and, henceforth, well, that's who I became—that writer who writes biopics and artsy pics.

You will be defined by the genre you write. Are there writers who break away from this? Sure. But just like most novelists, you pretty much write within a certain genre. Would the same audience that reads John Grisham novels read a new book of his that was a straight romance novel? Not on your life. It's devilishly hard to switch genres.

I remember wanting to write a thriller after I'd written several art-oriented dramas and my agents advised against it, telling me that you needed to make a name in one area, so that producers/studios could trust your track record and know they could count on you to come through with a good script in the genre they were hiring you for. They told me the story of another screenwriter they represented, a woman who was famous for being 'the chick who could write dick'—a female writer who could write films that appealed to an action-oriented male audience. After several films in that genre, and therefore a solid reputation, she presented her agents with a film based on a Jane Austen novel—and it was really good so they sent it around town. At that point, producers and studios who read it said, "Ah! Who knew! The chick who can write dick can also write this!" So my agents' point was that until you establish yourself as someone with a tried and true record in *one* genre, you can't jump from genre to genre. But when your reputation in one genre is firmly established, *then* you can try another genre and people might be interested. Eventually I broke out of my biopic/artsy pigeonhole—I wrote a couple of thrillers and, in fact, my newest writing assignment is an adaptation of a novel in the psychological thriller genre by Thomas H. Cook.

So genre is extremely important and it's something you should think about before you begin to write. Maybe the way to decide what genre you

want to write is to ask yourself this question: "If there was only one genre I'd be allowed to write in for the rest of my life, what genre would that be?" That way, you write in your favorite genre and if you get 'stuck' in it because you're that successful, it shouldn't make you too unhappy!

It would be a mistake to think that each script you write is completely in one genre. Most scripts, in fact, are combinations—sci-fi/comedy, horror/romance, comedy/drama, coming-of-age/drama, coming-of-age/comedy—the combinations are endless. But start with one genre and see where it takes you. If you know you want to write a horror film, super. Start the horror script and see where it takes you. Do you find yourself injecting some comedy in it? Is it a teen horror script or a very adult horror script? Is it gory-horror or just creepy-horror? It's perfectly OK to start writing a horror film and see how it feels—often your story will tell you where it's going to go *as you write*.

To begin to make some decisions about the genre you want to write in, let's look at the top seven genres in film today and see what those expectations are so that you can work to accomplish them in your script.

Understanding the 'Rules' of the Top 7 Genres in Film Today

While no one has actually written down a list of 'you better follow this or you're dead in this genre' rules, there are some basic 'rules' you probably should take note of and try to satisfy if you're tackling a particular genre. There are a lot more than seven genres, but here is an overview of the top seven. For each of the seven, let's look at just three of the expectations you want to be aware of if you're writing in that genre. (If you want more depth on genre, I highly recommend Jule Selbo's book *Film Genre for the Screenwriter*.)

Comedy

- Be sure you have something funny on every page. This could be something as simple as two characters making funny faces at one another, ala *Dumb and Dumber* [1994 and 2004] or it can be a satisfying laugh that comes in a sophisticated comedy like *Manhattan* [1979] when Woody Allen is having an argument with his friend who's taken his girl away and his friend tells Woody that he's just too perfect, and none of us is that perfect, I mean, you'd think he was God or something. And Woody shrugs and says, "I've gotta model myself after somebody." And we laugh—because he says it *so* matter-of-factly, because it's right on the money when it comes to his character, and because Woody's character wouldn't even *get* why we're laughing—he doesn't even see how funny he is. While you don't have to have a giant guffaw on every page, there should be something that produces a laugh or at least a smile *on every page*.
- Write your narrative with as much fun as your characters are having on screen. If you're doing slapstick humor about a couple of vaudevillians,

when one throws a pie in the face of the other, you don't want to say, "Harold carefully lifted the pie from its pewter stand, walked purposefully over to Gerald, and confidently threw it into his face." You'd want to have the language of your narrative reflect the moment and the action that's taking place, perhaps something like "Harold turned around, his back to Gerald, looked at the pie and smiled. He grabbed it and whipped around before Gerald could see it coming and let it FLY into his face. SPLAT." And your comedy should continue in the way you write Gerald's reaction to being hit by the pie as well as Harold's satisfaction at throwing it.
- Remember that a lot of comedy comes through surprise—we're looking one way and the humor comes from somewhere else. A self-important guy's walking down the street on the way to a big meeting and he slips on a banana peel—classic humor-producing moment, neither he nor we saw it coming, and it's the surprise of it that produces a little laugh.

Romantic Comedy

- Much of the humor in a romantic comedy comes about because our characters are thwarted in their initial attempts at getting the girl or the guy, or in the stupid things they do in the course of trying to win them over. When Tom Hanks' character in *You've Got Mail* [1998] waits outside the restaurant before first meeting with the girl he's been emailing, he has his friend look through the restaurant window and describe the girl to him. When his friend says the girl is very pretty, Hanks jumps around with delight and says "She had to be" over and over again. We laugh at his silliness and the way he shows his excitement.
- Often in romantic comedies, we laugh simply at how lame or messed up the characters are but we also feel for them—we like them so much we want them to succeed in romance and we feel like *we* know before *they* do that they belong together. In *Silver Linings Playbook* [2012], we laugh at main character Pat's obsession with his ex-wife and the lengths he'll go to in order to get her back. And we love that Tiffany agrees to help him reconnect with his ex if he'll do her a favor. The favor allows the two of them to interact and gets the romantic comedy firmly underway.
- The boy and the girl, the woman and the man, the two lesbians, whatever couple your film is about, need to get together by the end of the film. If they *don't* get together by the end of the film . . . or if there isn't at least hope that they will, you haven't written a romantic comedy.

Action

- Pacing is hugely important in writing action films. Pacing is, of course, important in all films, but in action, it's a big part of what the film is all about. If you want to see the mother of all car chases, take a look at

The French Connection [1971]. The chase in this film elevated the 'old-fashioned' car chase to a whole new level. This is also a film that's a good example of combining genres—it's an action/crime/thriller film, and it delivers on all levels. When you're writing action, whether it's a car chase scene or a shoot out or two characters meeting up at a diner, you want quick, fast-moving scenes that always work to *get us back to the action*.

Figure 3.1 Wade Wilson as his alter ego *Deadpool* [2016]

- The best action films also have great characters. The comic book film *Deadpool* [2016] has a very *Bourne* sort of plot—a special forces guy who is subjected to an experiment that leaves him with really fast healing powers when injured. The film combines action, adventure and sci-fi elements. *Deadpool's* main character, just like Jason Bourne in the *Bourne* series, seems like a real guy—at one point, in the midst of a car chase, he says, "Shit. Did I leave the stove on?" And even though you wouldn't call this a comedy by any stretch of the imagination, there are comedic moments that showcase *Deadpool's* wicked humor. The *Star Wars* series of films is another example of the importance of character—we don't just want action, we want action that's taking place in an effort to save people we care about. People who go to *Star Wars* conventions don't dress up like the spaceships, they dress up like the characters.
- As important as character is in an action film, you really need nonstop action to make your script qualify for this genre. Something that moves the action aspect of the story forward needs to be happening all the time.

Hardly a page should go by without a fight or chase or surprising fall or whatever—we want to see stuff that takes our breath away.

Thriller

- If you're writing a thriller, you want to make people gasp. Traditionally, we think of names like Hitchcock when we think of classic thrillers. He was a master of keeping us on the edge of our seats. His films like *Rear Window* [1954] and *North by Northwest* [1959] both demonstrate the master at the peak of his career. Of course, he didn't write those films, but he directed them as they were written—so the scripts stand out, the *story* is what they're all about. And both films leave you breathless with anticipation of how the main character is going to get out of his dilemma without getting killed. And that's the traditional thriller plotline—can our hero survive the circumstances that are threatening to do him in? That's the plotline your thriller audience will expect. Looking at a film made more than 60 years later, *The Revenant* [2015], it's the same plotline—can our frontiersman survive bears and everything else he's up against to get out of the rugged countryside he's trapped in . . . when at every turn it looks like this guy's going to bite the dust? It's a thriller, and though it's a rugged, outdoorsman plot versus *Rear Window*, which was a refined, erudite guy plot, a thriller is a thriller is a thriller.

Figure 3.2 *The Revenant* [2015]—a thriller? You bet.

- A thriller doesn't always have to be about action. *Spotlight* [2015] leaves you breathless to find out what the investigative reporters are going to uncover next—the thrill is all about whether the investigative team can do it—or will they get stopped from achieving their goals. One of the interesting things about this film is that everyone going to it knew the ending—everyone knew the true story, that the reporters had uncovered evidence of widespread molestation of young boys by priests in the Catholic Church. And yet, we were riveted to this film—it was truly thrilling to watch them uncover the evidence, step by step, against all odds. *The Imitation Game* [2014] is another great example of a thriller that's all about uncovering info—in this case, cracking a code that will help us win WWII. And when you can bring the 'cracking' down to its human form, those who actually find the culprit or crack the code help us along the journey because we so admire their resourcefulness.
- Thrillers always have a bit of an unsettling feeling to them. You're on the edge of your seat as you watch the action unfold at a fast pace because you *feel* danger around every corner. Particularly with more cerebral plot lines, it's the potential danger that's more thrilling than any actual villain.

Horror

- Just as comedy requires you to have a laugh on every page, horror requires you to scare us on every page. It doesn't have to be jump-out-of-our seat scaring, but we should be panicked or at least anxious. Horror is all about scaring your audience, so that's what your script needs to do.
- There are different ways to scare people—some horror films like *The Shining* [1980] or *The Blair Witch Project* [1999] take ordinary people, put them in circumstances they didn't count on, and therein lies the horror. Others like *Pride and Prejudice and Zombies* [2016] take a tried and true scary group of people—that would be the zombies—and put them in a situation where they're out of place and are going to scare both us and the other characters.
- Great horror films often go beyond just scaring us in a physical sense, they scare us in a larger sense, one that encompasses society and the potential end of the world. *Night of the Living Dead* [1968] put the fear into us not just of these creatures but of the very downfall of society. And it came out at a time—the height of the Vietnam War—when it seemed to a lot of people like society really *was* falling apart. So yeah, horror movie as metaphor.

Sci-Fi

- Great sci-fi films can take us to other worlds—and that's the hardest part of writing them because you have to create those worlds. Creating a

fictional world that is all new can be tough because you need to know everything about it—from what people look like to how they procreate to what they do for work to how they exist in the galaxy. This is a ton of work, but work that must be done if we're to believe the world you've created.
- Great sci-fi films can also take us to other times—*Back to the Future* [1985] does this and it also shows us that a movie with a sci-fi concept at its heart doesn't have to be super-serious and larger than life. It can be a small story about one guy trying to use his knowledge of the future to change one thing in the past.
- Sci-fi also needs to give us new stuff and sometimes that's the thrust of the film. *Inception* [2010] gives us this thing called dream-sharing software that allows a thief to steal corporate secrets from a CEO; the thief is then faced with adapting that technology to *implant* ideas into the mind of the CEO. In this case, we could imagine the world we know with the addition of this technology and therein lies our story.

Family

- Recently, family films (films *for*, not necessarily *about*, families) are on the rise. I think it's because financiers realize that a family film will always have a future life as future generations of parents have their kids watch it and they watch it along with them—often for reasons of nostalgia. This means that a family film needs to have universal appeal for not just this generation but for generations to come. In addition, the right kind of family film will allow for a sequel. The *Free Willy* series [1993, 1995 and 1997] probably won't die out anytime soon. Kids will always be drawn to this universal story—and if kids like the first one, they'll want to see the two sequels. So family films have legs—that could help the studio make money for not just years to come, but generations to come. Make your family film one with universal appeal across generations and you might have a good shot at getting it seen.
- It's hard to go wrong with animals—especially animated, and if the film isn't about animals, it better be about kids. The *Kung Fu Panda* series [2008, 2011 and 2016] has been a huge hit with kids and, to a large extent, it's because Po the panda isn't perfect, and kids relate to that. That's also true of *Inside Out* [2015] where main character Riley spends the film trying to reconcile those parts of herself that are less than perfect. So whether it's animals or kids who take the stage in a family film, it's a good idea to make them imperfect—for therein lies both the comedy and the drama. And, generally speaking, *Bambi* [1942] being a big exception, you don't kill the animal or the kid!
- The family film normally has no swearing and no sex—if your film does, it's not a family film but a wry look at families, which is a totally different

animal. *The Family Stone* [2005] is a fun movie about your normal dysfunctional family—it's hilarious and touching but it's really for adults, not for kids. And it's important to realize it's a comedy/drama—not a family film. Good idea not to confuse the two!

Breaking the 'Rules' of the Top 7 Genres in Film Today

Hey, maybe you can defy the odds and pull it off—kill off the dog the movie's been all about. Maybe it will be emotional and heartbreaking for the audience and they won't hate you and bad mouth your movie. Or maybe you'll have the romantic comedy end with them getting a divorce . . . all is possible. So, sure, you can break one of the rules. I'm just not sure why you'd want to. If you want to write a romantic drama, then do it—don't try to make it a romantic comedy or it won't feel right to the romantic comedy audience, and vice versa. The whole point of understanding various genres is to understand the expectations of each genre. It's always possible that you'll turn readers/viewers off with what you do in your script, but in terms of genre, it's a good idea to know what the audience is expecting and not to disappoint them, or you'll never have a chance. It's very much like music—if I'm going to a rock concert and I turn up and it's a blues concert, I'm not going to be happy—I wanted rock! The blues band may be great, but it ain't rock and never will be so it doesn't matter how good they are. So when it comes to writing, play the music you know your genre-audience wants—you can be as wild and creative and amazing as you'd like, you just need to do so within the parameters of the genre, or genres, you're aiming for.

Chapter 3 Exercises

1. What are your favorite genres to watch as a moviegoer? Do the stories you want to write as films fit into those genres? If they don't, why don't they?
2. Write two loglines for a film about a family trapped on an island in the middle of the Pacific Ocean. Make one a sci-fi film and one a horror film.
3. Write two loglines for a film about life on another planet where they've just discovered that there's life on Earth. Make one a family film and one a comedy.
4. Write a logline for a film where a teen drag racer kills another kid in a fight and then moves his body into a rival's car, thus trying to make it look like he died in the drag race. Combine genres to make it an action/family film.
5. What genre(s) do you think will be the most prevalent in the upcoming years? Why?

4
CHARACTER

A truly great piece of writing—whether it's a novel, screenplay, play, or short story—is all about character. You can give me the most beautiful setting with the most intricate plot and if I don't care about the main character who *inhabits* that beautiful setting and who is *caught up in* that intricate plot... well, I don't care about your story.

So before you write FADE IN, you need to know who you're writing about.

Whose Story Do You Want to Tell?

What comes first, the story or the character? An interesting question—and the answer varies. Do you have a creepy-cool serial killer in your head—someone unlike anyone we've seen on screen before—who is telling you to write his story? Or do you have a great idea for a creepy-cool way people are being killed and you need to find the twisted character who could pull off these murders? There's no right answer—creating your serial killer film can happen in both ways. However you, personally, approach this process, the bottom line is that you still have a main character who needs to be created. But are you sure about your main character? Is the serial killer your *main* character?

Think about it. With the possible exception of *Dexter* [2006], most serial killers actually aren't the main characters of their stories. *Silence of the Lambs* [1991] gives us this amazing character of Hannibal Lecter, but the main character of the film is the FBI agent who interviews and pursues him—Clarice Starling. Both characters are rich, interesting, and keep our

attention, but the story would be quite different if it was told from the point of view (POV) of Hannibal Lecter than it is told from the POV of Clarice Starling.

This is a huge decision. And it's a decision you'll make whether you're writing a thriller or a buddy pic or a romance. Even when you have a group of people who are on screen together for most of the film, it's always someone's story. There's always one person in the ensemble who's the center of the action, around whose life/needs the story swirls. Your task is to find that person. Ask yourself, which of my players will be the center of this story? And how best will the story be served by choosing one person over the other as the main character?

One thing you should do is think about your story from the POV of two or three people. Could your serial killer have a twin brother and *he* is the main character? And what if the twin brother is a politician in town and is breathing down the neck of the police chief—a woman—to find the killer? Oooo, maybe the police chief could be the main character. And what if she'd had an affair with the politician before he was married so they don't get along? And maybe she's best friends with the serial killer's wife. Ah! Maybe the serial killer's *wife* could be the main character.

See what I mean? If you start thinking about your story and the people who could inhabit it, you come up with different scenarios. You make the twin brother the main character, you have one story—could be great . . . what if evidence points to *him* in the investigation so he comes under suspicion. He's caught in a web not of his making and has to spend the movie trying to prove his innocence . . . and when he realizes the killer could be his own twin . . . could be powerful. But if the serial killer's wife is the main character, maybe you create a story about a woman who slowly comes to the realization that what's wrong with her marriage is something worse than she could ever have imagined—and when she realizes this, her husband *knows* that she knows, and she then has to fight hard not to become his next victim. And don't forget the chief of police. Having once dated the twin brother, and maybe lost him to a rival, she could either take great pleasure in proving he's the serial killer or become his biggest champion, swearing to find the evidence to prove his innocence . . . maybe his own wife deserts him and when the chief doesn't, he realizes he never should have let her go. What if the serial killer has a teenage daughter and she's obsessively following the case in the papers and begins to suspect her dad . . .

Oy. You can do this for a *very* long time. And you should. You're going to spend hours and hours and hours working on this screenplay—why not try out all the permutations?

This process is called spit-balling—and it's something screenwriters do all the time—throwing out ideas to see what sticks. You can do it on your own or, even better, with a friend or a writers group. When a group of people get going on an idea like this, *so* many thoughts come to the surface and people build on one another's ideas and you often get to a place you could never have gotten to on your own. And if you like the story, it's so much fun to spit-ball. You feel refreshed and super-charged after a good spit-balling session. I can't say you'll actually work off calories, but you'll feel a bit like you might after a good run. Of course, I personally don't actually run, but I *imagine* the spit-balling high is similar to a runner's high.

You do this, you go to all this trouble, because you realize that who you choose to become your main character will be the person through whose eyes you see the story as you write. You're going to go to bed thinking about this person and his/her motivations and you're going to wake up having dreamed something he/she will do in your story that surprises even *you*. This could be the most intimate relationship of your life for awhile.

What a minute. Did I just say that? This is a fictional being—a step up from a child's imaginary friend—and I'm telling you to have an intimate relationship with this person? Am I cracked?

Maybe. Maybe just a bit. For a writer, hearing voices isn't always a bad thing. In fact, if you *don't* hear voices, it could be a problem. Because this main character of your creation should seem as real to you as your sister or father or best friend. In your mind, this person should live and breathe and drive you crazy and make you care for them. If your main character is real to you, then—if you use your skills well—your main character will be real to us.

Getting to the Heart of Your Main Character

In the 30s/40s, there was a famous writer/cartoonist named James Thurber. If you've ever heard the name 'Walter Mitty', you've been touched by Thurber—for he created this character who's become an archetype... the guy who dreams his way through life. Thurber also wrote for *The New Yorker,* and several early television specials and plays were built around his work.

He was a fascinating guy in real life too—something I discovered when I read his collected letters. In those letters, edited by Harrison Kinney and Thurber's daughter, Rosemary Thurber, there are a few drawings here and there. And on one page is a drawing that Thurber did of his heart. It's a large heart that he doodled on a piece of paper—and it's broken up into these sections. Here's a reproduction:

Figure 4.1 Writer/artist James Thurber's doodle of his heart

James Thurber illustration "Heart Analysis" copyright © 1934 by Rosemary A. Thurber. Reprinted by arrangement with Rosemary A. Thurber and the Barbara Hogenson Agency. All rights reserved.

Fascinating, isn't it? To look inside a human heart. Having read the letters, I know a bit about what some of the sections mean.

Could you do that? Could you draw your heart and lay out what, basically, makes you tick? Give it a try. Take a piece of paper—come on, tear it out of your notebook or grab it from the printer tray—and draw a giant heart on it. Then start filling it in—what's in your heart?

I'd encourage you to take a good 24 hours to do this. Spend a few minutes on it now, then put it aside, come back to it before you go to bed and fill in a few more details, then go to sleep. Pick it up first thing in the morning and see what you can add to it. And during all of this, *show it to no one*. And when you're finished, *still* don't show it to anyone. This is your secret, your secret heart, and if you think you're going to show it to someone, it will alter how you draw it. Trust me. So keep it to yourself.

Once you're satisfied with your heart, you can move on to the next step—drawing the heart for your main character. Why didn't I just let you start with that? Why make you go to all the trouble of drawing your own heart—after all, you're not a character in your screenplay, right? Well here's the thing—as a writer, you need to be able to understand the human psyche. Most writers aren't shrinks so our insights have to come from our gut. The heart you know best, at least on

the surface, is your own—so if you start by dissecting your own heart, you'll have a better chance of breaking down the components of your character's heart. And your main character's heart should be just as real and just as detailed as yours. Plus, it will have something more—where you couldn't get into your own subconscious when drawing your own heart, you *can* get into the subconscious of your main character because you've created that character. So the heart you draw can be an even deeper profile than you could do of yourself.

I urge you to draw a heart for not just the main character, but all of your characters. Getting to the heart of your main character means getting into the deepest, darkest recesses of their heart. You get to the heart of your character, and your story will have more heart, it will resonate on a human level, it will make us care.

Five Character Questions

To get you to a place where your main character jumps off the page for the reader, here are five questions to ask yourself about your main character:

(1) Who Is This Person and What Does He/She Want or Need?

If you can answer this one question, you'll be well on your way to defining your main character. But it's not an easy question to answer. To understand who someone really is, you have to be able to see below the surface of the person they present for public view and into the parts of themselves they keep hidden. And then, if you work very hard, you might be able to get into their subconscious—the parts of themselves that even *they* don't know about.

So there are three levels you need to go through to define and understand people:

> *Level 1*—the persona that each of us presents to the world.
> *Level 2*—the hidden part of ourselves that we don't let anyone see.
> *Level 3*—the subconscious self that even *we* don't know about.

Once you understand your character on those three levels, you then have to answer the second part of the question: what do they want? What is it that's driving your story? What does this character want out of life, love, business, etc. What's pushing your main character out into the world of action to get what he/she needs and desires? Whether you're writing an earth-shaking story of someone who wants to save humanity or a fun romp about a girl who wants to win over the boy in the seat next to her in biology class, you must be clear on what your character really wants, and why.

After you figure out what's motivating them—what they want—you then have to ask yourself what they need. The character may not realize what he/she needs—but as the writer, as the person who gave birth to that character, *you* should know what they need. A 12-year-old boy whose

father was killed in Afghanistan when the boy was 8 may think he wants to stop his mom from marrying her new fiancé because he thinks that means his mom is forgetting his dad—but you know that what he *needs* is a father, and that if he gives in to liking the fiancé, he's worried, subconsciously, that he will forget his dad. After all, if he allows himself to be happy with this new guy as a father, what does that say about his love for his dad who died? So wants and needs are different. People often think they want money in life to be happy—but studies have shown that lottery winners are usually *less* happy than before they won the money. So what did they *need* to be happy if it wasn't money? Love? Acceptance? What we *want* is one thing, but what we *need* is often something else—and if we're human, we often only know what we want and not what we need . . . which creates many daily dramas, doesn't it?

(2) What Is the Emotional Life of Your Main Character?

Who does he/she love or hate? What are his/her deepest fears? What do they yearn for? What makes them sad? Angry? Happy? What makes them feel alone? What's their strongest desire? We are what we feel, and getting under the skin of your main character to his/her feelings is crucial.

Even before you start writing, imagine your character in various situations—in the woods alone and needing to get out, for example. This won't happen in your movie—it's just an exercise to see how well you know your main character. So how would your main character react upon finding herself lost in the woods? Would she call for help, cry, be frightened of every sound she hears, or would she seemingly feel nothing, not letting herself give in to emotion of any kind as she marched through the woods, determined to find her way out? What's going on inside her? Is she afraid about not finding her way out, angry for getting lost in the first place . . . what does she feel? And let's say things aren't looking good—a couple of days and nights go by and she's dehydrated and irretrievably lost. Would she stop and sit under a tree and write a note to someone important in her life? Would she daydream about when she was young and all the fun she had with her brothers playing basketball outside on a hot summer night? Or would she daydream about her own funeral and what people would say about her? Would she sing a song from her childhood, or a song she once sang to a boyfriend? Or would she use up the last of her iPhone battery to make a movie of what she sees and how she wishes she had time to share this with someone?

Once you start exploring the emotional landscape of your main character, you'll be able to write her with more clarity and real emotion. We'll be able to feel her pain or joy or anguish because *you* know her on such a deep level that you can find ways to portray those emotions on screen.

(3) Why Should I Care About Your Main Character?

Now, this is quite different than saying I want to *like* your main character. Chances are, not too many moviegoers "liked" Hannibal Lecter, but boy oh boy did they find him interesting! What's unique and special about your main character that I will be happily caught up in his story for an hour and a half? Remember, I don't have to like them—I just have to be fascinated with them.

Have you noticed that there are some actors who tend to always play the same part? Some always play villains or get typecast in that role because of their looks, and that's the kind of character they're no doubt always going to play—not really their fault. But there are other actors who have nondescript looks—they're not limited by body type or facial features to play a narrow group of characters—but they pretty much have made their career playing the same guy . . . the good guy. Not to name any names, but this isn't that uncommon. They like playing the hero. They like the public liking them. They have zero interest in playing some lowlife, they want to play someone we're going to like. So be aware that there are a fair number of people—actors and agents and studio executives—who think that way. But I don't think they're in the majority. I don't think most of us just want films about likeable people—I think we want to see all sorts of characters from someone like a drug addict in *Reservoir Dogs* [1992] to a jerky boss who's full of himself in *Bridget Jones's Diary* [2001]. I may not want to know these guys in real life, but on a movie screen? Well, movies are a really safe way to dip my toe into another world and imagine what life for that sort of person is like.

So as much as you might find it tempting to just create a likeable character, which is easier, of course, take the more challenging route of creating a character who is not all Mr. or Ms. Perfect. Make them fascinating, yes—but don't feel restricted to making them likeable.

(4) What Was Your Main Character's Life Like Before the Story Starts?

For example, if you begin your script when your main character is 30, what happened to him/her before that point? You should be able to sit down and write a complete bio of everything from what this character wore as a Halloween costume when he/she was 7 to how the character lost his/her virginity at 17 to how he/she felt when the twin towers came down on 9/11. You see what I'm getting at? You need to know this person as well (probably better) than you know yourself. Will you use all the info you write in this bio? No. Please don't! Then your script would be like a term paper from 7th grade where you wanted to show the teacher how much research you did so you found a way to shove it all into the paper! This character bio is just research for you. Maybe an incident from the character's past will be a part of the

script as a flashback, but maybe not. But all of this person's past will impact how they behave in your script ... and the better you know them, the more real their actions/choices will seem.

Imagine you were in the attic of the house where your main character grew up and you find his childhood diary. You open the dusty cover ... and what's on the first page? As the creator of this guy, you should be able to write that diary—you should know him that well. In many ways, you *become* him—you think about how he'd react to things in the news, you imagine what kind of vacation he'd want to take, you feel his attempt to connect to the world.

Actors do this sort of thing routinely. If given a part to play where the character is 35, they sit down and write a character bio for the person they're playing. Knowing this person on a deeper level helps them play the part more effectively. I'd encourage you to take a lesson from our acting friends and do the same—dig into your character from the time they were born until your story starts. Know everything about them and you'll create a rich, vibrant character who really pops for us as we read.

(5) How Does Your Main Character Talk?

Remember that nearly everything I know about your character will come to me through dialogue. So how does he/she sound? What are the unique quirks of language that your main character employs? His/her style of speech is going to reveal a great deal, so make sure before you begin writing that you *hear* his/her voice very clearly in your head. Does she speak in long, drawn out sentences or short staccato ones? Does she listen intently to others or interrupt them before they finish? Is her voice loud or soft? Does her voice grate on your ears or is it like music? Is she hesitant as she speaks or does she plow through what she wants to say?

And, most importantly, how does her voice differ from the other characters around her? This is crucial. Think about it, once we see the characters on screen, we have the value of appearance to tell them apart and make them more distinctive. But in the script, there are only the words you write that do this. So can you? Can you write voices that are different? Can you make your main character speak in a distinctive way so that all of her lines could have been said only by her?

As you live with this main character over the next weeks and months, her voice will become more and more clear to you. It's quite possible that when you start writing, you may not have her voice nailed down—but as you write, she will become more distinctive; in effect, she'll come into her voice. So no worries—let yourself discover her voice by writing, and if that voice evolves during the script, you can easily go back and tweak her voice in the early parts of the script to make it as distinctive as it is in the latter parts of the script.

These five questions aren't the only ones you'll find yourself asking about your character, but if you can answer these five, then you're in good shape to start writing and there's a good chance your character's distinct voice will come through and reveal for me, the reader, a multi-layered character who I'm going to enjoy reading about.

You'll notice I said "reading" and not "watching" ... because though you're writing a script for actors to read their parts and for filmgoers to watch, the truth is that you're really writing it for its very first reader. That could be an agent, a producer, a studio exec or—much more likely—a reader for one of these people whose job is to read, summarize and evaluate script submissions.

So although you're writing for the screen, you're also writing for the *reader*. Because if you can't interest the reader, your script will never get to the screen.

Supporting Characters: Please, No Stock Types

You've seen it many times, haven't you? The crusty old man who gives the hero the advice he needs to win over the girl ... or the manic mom who spirals out of control in a crisis ... or the drunk dad who likes the booze more than his family ... or the boss from hell who treats his employees like dirt ... or on and on and on.

The 'crusty old man' and the 'manic mom' and the 'drunk dad' and the 'boss from hell' are all character types. As the writer, you need a character who will give the hero a hard time in just a certain way, so you come up with someone who fits the bill. The problem is, we've seen all that before. We've seen the manic mom and the crusty old man time and time again. Nothing new there. You pepper your screenplay with stereotypical supporting characters like this and your reader will lose interest—the great, original work you're doing that interested them with your cool main character will be lost in the morass of stereotypes of your supporting characters. How to combat this? Think DVD—distinctiveness, variety and depth.

Distinctiveness

If there's a crusty old man you want to have in your scene, how can you make him different from every crusty old man we've seen before? Could he be disabled or could he have some physical characteristic that makes him stand out, that makes him different? Could he be young instead of old—I mean, why does the wise person always have to be 90? Hey—what if he was 8? What about your hero getting the crucial piece of advice he needs to change or win or whatever from a kid? Even if you're adamant that you want a crusty old man, think about how you could make him different. Most crusty old men are a bit disheveled in appearance—what if your C.O.M. dresses with

sartorial splendor? What if your crusty old man is a crusty old woman? Whatever this character is, make him just as real and idiosyncratic as your main character.

Variety

Make sure your supporting characters are diverse. They need to come from a variety of backgrounds, socio-economic groups, parts of the world—we're done with movies about all white guys in a room. We need a variety of people in that room—whether it's the President's ready room or the locker room of a girls' soccer team, give us a variety of human beings—*real people*—inhabiting that space. Even if you're doing a film about a bunch of 15–17-year-olds at a fancy prep school, make sure at least one of them is a scholarship student from a poor background, make another one from another country, have one or two from Manhattan and very old-money backgrounds but have some of the other kids from California new-money backgrounds. Make sure they're every combination of skinny/fat, tall/short, gorgeous/ordinary-looking—give us diversity on all possible levels.

If you start adding many different kinds of people to your script, it will begin to feel more realistic to the reader—more like real life and not just something you made up for a movie. The world is full of assorted geniuses and doofuses and everything in-between. Show that in your script and no one will say your characters all seem alike.

Depth

While you can begin talking about a character by calling him a doofus, you'd better not end there. You want every supporting character in your script—even your doofus—to have depth. How do you achieve that? Pretty much by treating every supporting character just like a main character—which means you do the work. You write up a bio, you do a character heart for them ... you get under their skin and discover what's inside them. Your knowledge of that supporting character from the inside out will then come out as you write him. You won't just be skimming the surface of this person, you'll be plumbing the depths.

Characters. They are your brushes and your paints—they'll make your story work and they'll grab our interest. We'll care about what happens to them and we'll keep turning those pages to see what they're going to do next. So take care—make sure you know who you're writing about, make friends with them (even if they're a despicable human being), find out how they got to be who they are. And if you let all of that knowledge about them permeate what you write, believe me, I'll want to keep turning those pages.

Chapter 4 Exercises

1. Draw a heart for the main character of your film.
2. Answer the five questions for the main character of your film.
3. Write a detailed bio for the main character of your film.
4. Draw hearts, answer the five questions, and write a bio for the two most important supporting characters in your film.
5. Come up with at least three ways in which you could dramatically change the main character of your film and look at how that would impact the story you want to tell.

5
CHARACTER/STRUCTURE

Character and structure aren't mutually exclusive—they have this kind of weird, symbiotic relationship. If you think of them as elements of your screenplay that work together, you'll begin to see how they impact one another.

Let's Talk Arcs

A 'character arc' is one of those terms that I hate. I feel like we're trying, as screenwriters, to add mystique or something to what we do by talking about a character *arc*. Maybe it's just me, but I feel like I should know a secret handshake or something when I start talking about a character arc. I'm more inclined to want to talk about character.

But for those arc-lovers or arc-neophytes out there, here's what everyone's talking about when they talk about character arcs—they're talking about the character's journey in the film. The character no doubt moves from point A to point B in the film—he starts out as a lonely bachelor and ends up a gregarious married guy, or she starts out as a cop on the run after being framed and ends up a cop in the news for arresting the person who framed her. Characters move from point A to point B emotionally as well—an anxious man who has to pop Xanax at the beginning of the film learns how to deal with his emotions and by the end of the film doesn't need Xanax at all. And a dad who can't experience love at the beginning of the film meets someone who breaks through his wall and shows him love *does* exist by the end of the film.

So whether it's actions a character undertakes during the film or emotional changes he/she goes through during the film, a character starts in one place and ends in another . . . like a rainbow, or an arc.

I prefer to lose the word 'arc' and just talk about a character's journey—so let's do that. And let's start by talking about the relationship between character and structure.

Why Character and Structure Aren't Mutually Exclusive

It would be logical to think that character is about the people in your script and structure is about what those people in the script *do*. But it's not that cut and dried.

A character's journey has, in itself, a structure. A character grows and changes as the story unfolds—and that growth and that change happens as the story itself unfolds and grows and changes. And it's this dance—this amazing symbiotic relationship—that is why character and structure are so intertwined. When a character changes in your story, it's because something has happened to provoke that change—and that 'something' has to do with a change in the story itself.

Character. Structure. You can't have one without the other. That's a truism about many things—you can't mention Abbott without mentioning Costello, they're a team. Bread and butter go together. Champagne and caviar. And I'd contend that the same should be said of character—it can't stand on its own, it's inextricably tied to structure in film. What would a movie *be* that's only about character? A camera focused on a person for 2 hours? And what would a movie be that's only about structure? A camera moving from location to location following a story . . . but without people?

Narrative film is about a character faced with obstacles who must work to overcome them. The nature of that person is tied to how he/she does that. So his/her character determines the structure. Like twins, there's a tie that binds.

Using Subplots: A Major Crossroads for Character and Structure

Once you've determined your main character and where they're going in your story, you start thinking about how to get them there. Sometimes it seems daunting—you finally figure out the story you want to tell, like how you want to take your main character from her inability to fall in love at the beginning of the film to the end of the film where she not only falls in love but discovers it's different than the fantasy, that, in fact, it's better . . . before you do all of that, you somehow have to fill 100 pages showing us *how* she does all of that! As I said, daunting.

Certainly, you will determine what obstacles will be in her way that will stop her from reaching her goal, from discovering love. You'll pile on the roadblocks and twists and turns in your story so that her journey is riveting for us. In addition, you'll be sure to surprise us with unexpected moments

that make us wonder if she'll ever achieve her goal. But the other thing you can do is think about things happening in her life that aren't really about her main journey, but stories (and people) that *impact* her and her journey.

For example, in the beginning, we find out our main character, let's call her Kimberly, is the youngest of three sisters. Her oldest sister, Ginny, just went through a divorce and Kimberly saw what this *did* to Ginny. Perhaps Kimberly even remembers (via a flashback) Ginny's wedding and how happy she and her husband seemed . . . how it seemed like they were made for each other. And 7 years later? Ginny's divorced, living with her two young kids and facing going back to work to be able to afford to stay in the house she and her ex shared. Ginny's adamant that keeping her kids in their house will provide them with a little bit of security now that they see their dad only on weekends. And then, when Ginny's ex announces his marriage to the woman he left Ginny for, well Kimberly tries to support Ginny emotionally as best she can but she's mad as hell at Ginny's ex.

That story of Ginny's problems is a subplot—it's not the story that we're watching the film for, that story is Kimberly and her avoidance of/quest for love, but Ginny's story impacts Kimberly. Through Ginny's experiences, Kimberly's opinion that there's no such thing as love is reinforced. During the film, whenever Kimberly might be inclined to change her opinions and give love a chance, she can look to Ginny's experiences and decide she was right after all. And when Kimberly meets a guy who truly loves her, she keeps thinking about Ginny's ex . . . and Kimberly pulls back from the person that could be the love of her life.

The great thing about a subplot like Ginny's is that it's not just a diversion for us in the telling of Kimberly's story—it's not just showing us Kimberly's family to give us background on her as a character—it's a window into Kimberly's family, sure, but it's also a window into Kimberly's emotions when it comes to living her own life and trying to figure out this love thing. So the subplot is not just another story in the film, it's a story that overlaps and infuses Kimberly's *own* story.

That being said, for your screenplay to be rich and vibrant, Ginny's story needs to be thought out as thoroughly as Kimberly's own story. And perhaps, in the end, it's Ginny who sits down with Kimberly and convinces her that love is worth the risk, and that as down on love as she is after her divorce, Kimberly should go for it. OR maybe it's Kimberly's new love who sits down with Ginny and convinces her that he's nothing like Ginny's ex OR maybe Ginny has a surprising confrontation with her ex that convinces her that a second love might be waiting out there for her OR maybe Ginny's 1st-grader fixes her up with his gym teacher at school, or, or, or—that's the 'or' method of brainstorming, of trying to come up with multiple plot scenarios. But however you resolve Ginny's story, even though her story is just a subplot, it, too, must feel resolved by the end of the film.

So let's take a look at this *OR* method of brainstorming.

Whether it's the main story of your film or a subplot, just say **OR** and you'll get to the best story possible.

One of the keys to getting to that fantastic story that is innovative, surprising and fresh is to never settle for your first idea. If you're trying to solve a story problem, big or small, even if you're just trying to come up with the next step in your story, never come up with an idea and say, "That's it! That's how I'll solve it." No. Resist the temptation to think that your work is done. Instead, you're entitled to be excited about that possibility, but that's just your first idea—write it down, and go on. Come up with a second way to solve the story problem—trying to make it just as plausible as the first. Then come up with a third. And a fourth. Stop at five if you must. But get AT LEAST to five decent ways to advance your story. Now you go back and dispassionately look at all five. Which one advances your story the best? Which one is the most unexpected? Which one shows us another side of your main character or his/her journey? Which one is the most dramatic? The funniest? The most shocking? All along the way, keep the main thrust of your story and your character's journey in mind, and ask yourself how each direction you're thinking about taking it would add to that story.

In many ways, this is like chess . . . or a video game. Each move you make determines the possible choices for your next move. And it also limits those choices. So it's super important that you choose wisely. Don't be dumb. Don't take the easiest move, take the best one. Maybe it will take a while of game-playing (or writing!) to win the game by choosing the tough move, but maybe the tough move will add to the excitement of anyone watching the game (the movie!) and thus make for a more satisfying story. Will that make it more difficult for you to write? Quite possibly. But if your goal is a great story, you do the work.

Subplots aren't necessarily about friends or relatives of your main character. Subplots can be super-diverse. A subplot can be about something else going on in your character's life that might not relate to your character's overall goal but just shows us another dimension of your character. Of course, it might not *seem* to relate to your character's goal, but when looked at carefully, it actually might relate. So Kimberly, while consumed by her love problem, might also be starting a new job and she wants, of course, for that job to succeed. She could be super-excited about it and happy that it will take her mind off of her love dilemma. But the job could end up not being perfect. She could struggle with the idea that there IS no perfect job, that there's ALWAYS going to be problems and obstacles stopping her from doing the best that she can at her job. And this idea of the perfect job could mirror her idea of the perfect love.

Alternately, Kimberly could find herself fired from a job she loves and thus lacking intellectual purpose in her life as well as emotional purpose—this could leave her open to a guy who she sleeps with, perhaps at the beginning of the story, who seems to give her the affection she desires. And just when she thinks he's someone she might love, she discovers he was just after sex . . . love was the last thing on his mind. This reinforces her feeling that love is a myth and that it's something she needs to stop dreaming about. So the subplot about losing her job *could* impact her overall goal.

Or maybe, in losing her job, the only thing Kimberly can find to pay the rent is some substitute teaching. Yuk. Totally not her thing. But maybe she bonds with one of the little girls in class who is clearly neglected at home. So her relationship with this child, her attempt to show the girl that good people exist in the world who will nurture her, even if she's not getting that nurturing at home . . . maybe in that attempt, Kimberly realizes that losing the high-powered job she so loved was maybe the best thing that ever happened to her, that now she's found something important to do with her life. That's a subplot—it's not dealing directly with Kimberly's personal love life, but it does deal with another part of her life and as we watch the film, we're interested in how that part of her life works out too.

Subplots add texture and interest to your main story. They give your film dimension and, as a bonus, they're really fun to come up with!

What If the Journey of Your Main Character Mirrors the Trajectory of the Film?

One way to think of this process is to think of your overall film structure and to compare that with the personal story of your main character. Just as a story has a first, second and third act—more on that in the next chapter—your character's emotional journey has a first, second and third act as well.

Let's say your film is about Jenny, 25, who is caught up in the middle of a financial scandal at work. She's falsely accused of masterminding a stock manipulation and fired. She's livid—someone has clearly framed her and they've gotten away with it! So the only way she can clear her name is to find out who really did manipulate the stock—if she does that, maybe she has a chance of getting her job back. In Act I, she's accused and fired; in Act II, she goes undercover to ferret out the real culprit and by the end of the act, she's been caught trying to do this and things are even worse for her than when she got fired because now she's arrested as well! Then in Act III, she's able to unmask the culprit and is offered her job back—with a promotion.

So that's your story. Once you're satisfied with that overall trajectory, you can also map out the emotional journey your character takes. And while that emotional journey might be driven by the plot, it could also end up *driving* the plot.

Let's say that Jenny has a crush on Beau, 30, a guy at her office who she's great pals with but who always seems to date showier women. So in Act I, she's feeling like a relationship-failure, always coming in second to classier women when it comes to cute guys like Beau. Then, when she's fired in Act II, Beau becomes virtually the only ally of her former work colleagues—so while she's incredibly bummed about being fired, she feels like Beau and her becoming closer is the one positive that came out of the thing. By mid-Act II, she sleeps with him and decides that not only is she going to unmask whoever framed her, she's going to end up with the most attractive guy in the office and when she gets her job back, all the girls he dated are going to be *soooo* jealous. But by the end of Act II, when she's arrested, she realizes that Beau was the only person who could have done this, who could have set her up to get caught... so Beau never loved her at all. Plus, he must be the reason she got fired in the first place! She's an idiot, clearly not lovable, clearly unable to tell a slimy player from an earnest boyfriend. So in Act III, she's mad as hell at Beau and is going to bring him down and make him feel as bad as he has made her feel. In the process of doing this, she realizes she has an ally in another guy at work, a guy who was so plain he was almost invisible to her... and the film ends with her agreeing to go out on a date with him, in addition to getting her job back with that promotion.

If you can do this, if you can mirror your character's journey with your character's emotional journey, you'll be grabbing us on two levels—we want to find out what happens in the story AND for the character as a person.

How Understanding This Symbiotic Relationship Can Take You to a Higher Level of Storytelling

Haven't you seen movies that were all action, all car chases or space fights but you never got into the characters? Or even worse, you never even understood the characters! And the day after you've seen the film, you can describe this great gun battle but you don't have much to say about the guys who were on opposite sides of that gun battle. Action can carry a film—as can plot—but if I'm really *into* a movie, it's usually because it has both—great characters as well as great plot.

A good example of this is the film *Die Hard* [1988]. How much fun is this film? A guy has to outsmart a bunch of terrorists to save himself while his wife and lots of other people are being held hostage by the bad guys in this L.A. skyscraper. It's a simple plot but there are twists and turns all along the way, there are surprises around each corner and the tension level is amped up so high you're on the edge of your seat for the entire film. But there's something else going on here too. This movie is about a guy—an ordinary guy, so ordinary his name is John—who's come to L.A. from New York to see his kids for Christmas and try and get his wife back. So when the bullets start flying, we feel for this guy—what if this is it and he never gets to see his

kids or even try to get his wife back? Another aspect of his character is his sense of humor—it's wry, self-deprecating and vicious when applied to the bad guys. He's not full of himself, he's not perfect, and we like him even more because of that. We want this guy to succeed not just because the terrorists are so horrible but because we want him to have the chance to try and win his wife over—he deserves that chance and we don't want to see him die before getting it.

Figure 5.1 John McClane will do anything to save the day in *Die Hard* [1988]

In *Die Hard*, John McClane is taken on an amazing action ride that we wonder if he'll get out of alive. Additionally, when he's at risk fighting the terrorists, we see that his heart is in saving his wife and getting back to her and his kids—he's emotionally committed to this fight because of them and the fight *shows* him what's really important in his life. We have fun watching him battle the wily bad guys but we also are moved by what he's going through inside. We're doubly interested in John McClane—we care about what happens to him and we care about him.

That's your goal—to create both a story that's going to rivet your audience and a character whose personal journey is going to interest them just as much. If you can do that, your screenplay will move from ordinary to exceptional.

Chapter 5 Exercises

1. Pick three story ideas you're thinking about using for your screenplay and ask yourself what the journey of the main character is in each of the three storylines.
2. Of the three storylines you focused on in exercise one, pick your favorite two and write a description of the three acts of the story and the three

acts of the emotional journey your main character takes in that story. How are they alike? Different?
3. Choose two bombs from the last year—two films that you think were total failures. Did the failure of the films have to do with structure or character? Or did the failures have to do with *both* structure and character?
4. For the two favorite storylines from exercise two, come up with the three most important supporting characters in the story.
5. For the two favorite storylines from exercise two, come up with three subplots that we'll follow for the course of the film.

6

STRUCTURE

The great screenwriter and author William Goldman said there are three things you need to know about screenwriting—structure, structure and structure. His book *Adventures in the Screen Trade* is one of the most inspiring books about writing for the screen that I've read. And he was right—screenwriting is, first and foremost, all about structure.

So whence cometh this structure dictum? Or, in modern parlance, *sez who*?

Obligatory Thanks to the Greek Guy: How Aristotle Made It All Clear

That would be Aristotle. The Greek philosopher and rhetorician wrote some very cool books—among them *Poetics* and *Rhetoric*—where he examined plays, poetry, physics, philosophy, the physical world and pretty much everything. The part of what he said that's of interest to storytellers is his laying out of the three-act structure. Stories, he tells us, have a structure. And what is that structure? They have a beginning, middle and end. This translates into act one, act two and act three. Not too tough, is it?

Why is it, then, that so many people rail against the idea of a screenplay having structure? "I don't want my film to be some cookie-cutter Hollywood piece of schlock," says the new screenwriter. Like, somehow, saying you have a beginning, middle and end is a bad thing. Honestly, I don't see how you can NOT have those things. Even if your film starts with the end of your story—like some films have—that's still the beginning of your film, your act one. It's just common sense and Aristotle was the first person to write that down for us. So calm down and realize that ALL stories follow this structure.

Still doubtful? Next time you're around nieces or nephews at some holiday, sit one on your lap and tell them a story. They will FORCE you to have a beginning, middle and end to that story. They want things to start out like normal life and then cool, fun, or maybe scary stuff to happen, then the main character is in trouble and it looks like he'll never get out, then oh my gosh—something surprising happens, then you begin to wonder if it will all work out and then it does! And the child gets off your lap, satisfied.

Stories have structure. All stories. It's impossible to find one that doesn't. If you think you have a story that doesn't have a beginning, middle and end, email me at diane@dianelake.com and I promise you, either you're talking about something that *isn't* a story or you've found what Aristotle and I and millions of others could never find.

While I don't want to belabor this point, I do want you to understand the importance of structure. It's organic to stories—Hollywood didn't make it up and *impose* it on stories, stories have built-in structure. Once you realize that, you can use that structure to help tell a better story.

Act I: Setting Up Your Story and Main Character's Journey

Act I is the most crucial of all your acts. If it's well-constructed, acts two and three will fall nicely into place. Well, it might not be quite that easy, but that good first act will certainly make your job easier as you go forward into the script.

Most writers will tell you that when they get to problems in acts two and three, they're usually traceable back to a problem in act one. So it's vital that you spend your time constructing as perfect an act one as it's in your power to construct.

The Tyranny of Page One

Every writer faces it, that blinking cursor on the blank page. You flex your fingers, you think about how best to begin, you look out the window . . . and realize a lot more thinking needs to happen. Time for a break. Definitely.

DON'T DO IT.

Seriously, you're not alone. I don't care how seasoned a professional you are, you know that this first page is important and you're ambivalent about exactly how to begin. And you should be—because the reader who's paid to read spec scripts brings home 15 or so any given weekend and he's only human. If yours isn't top of the line, he'll just skim it to get the gist of your story so he can write his reader's report (called 'coverage') on your script. Believe me, if that first page doesn't wow him, you're toast.

When we're staring at the blinking cursor, we know the first words we put down on the page are important—because it's like a chess game, isn't it? The first move you make leads to the next and the next . . . and you worry that making the *wrong* first move will screw up the entire game. Or a video game—you walk through door #1, you're in the middle of one story, you

walk through door #2 and you're in the middle of another. Which door do you take? And what if it's the wrong one? Well, one of the things you learn from video games—and chess—is that you can always play again and try to vary that opening move. What if you could translate that knowledge to the writing of your screenplay?

I think you can—if you can do two things:

1. Realize that this is just words on paper . . . they're not written in stone and you can change them at will, and
2. Accept the fact that the way you might want to begin is not the *only* way to begin.

This second point is crucial to being a screenwriter in many ways. You need to be flexible about your story—you need to see it from all angles. If your script is put into development, you'll be meeting with producers, directors, studio executives . . . and they'll all have an opinion about what should be in the script. You have to learn not to be petulant and say what you might really be thinking, like 'You guys aren't writers! What do you know?' and open your mind to seeing your story through someone else's eyes. Film is a collaborative medium and a writer who can only see it her way will soon be shown the highway. Remember that while those studio execs and producers may not be writers, most of them got into this business because they love movies, they love storytelling—and you'd be wise to listen to their thoughts. You don't have to always agree, but think about their ideas, maybe they'll lead you to something you hadn't even considered and in the end improve your story.

So work on that flexibility right now to help you write that first page and get rid of that blinking cursor. How can you do that? What if you didn't write just one first page, but wrote three?

Think about it—can you come up with three completely different ways to start your story? Sure, you might be leaning in one direction, but what if you did a different opening than the one you've been mulling over? What harm is there in that?

I do it with every script—I write three first pages. And guess what? When you know you're going to write three first pages, it's much easier to get going!

For example, let's say you're writing a family film about MARK, 16, and his sister ANNE, 15, who can't stand each other but are forced to work together to save their family home when their dad dies. Here are a few ways you could begin that story:

1. Anne and Mark at ages 6 and 7, fighting over who gets to wear the Batman costume at Halloween.
2. Anne and Mark at their dad's funeral.

3. Anne and Mark at school being called out of their classes . . . and mom is there to tell them the bad news that dad has died.
4. Anne and Mark at a high school dance—each trying to sabotage the other so that they have a lousy time.
5. Anne and Mark at ages 1 and 2—sharing a playpen and not happy about it.
6. Anne and Mark being told by their mom that dad's death is going to force them to sell the house.
7. Anne and Mark discovering that their dad was having an affair before he died.
8. Anne and Mark trying out for the debate team—and taking great pleasure in skewering the other during the debate.
9. Anne and Mark at 12 and 13 on a camping trip with their parents—and they fight so much dad sends them on a 5-mile hike together hoping they'll bond . . . but they turn it into a competition.
10. Anne and Mark the Christmas before dad's death—each glorying in the hideous Christmas present they've gotten the other.

The first thing to realize is that if you don't know your characters really well, you won't be able to come up with really good potential openings, so getting to the bottom of those characters is the first step, isn't it? Then, after brainstorming possible openings, pick three to write—and give each of them your all. One of the things you may discover is that the way you thought you wanted to open isn't the best opening for your story at all, and in the process of writing multiple openings, you've landed on one that's even better.

The best part about this system is that by knowing you're going to do multiple first pages, the tyranny of the first blank page loses its power completely and you've triumphed over that blinking cursor!

Writing a Killer First 10 Pages

Remember your reader? The one who brought 15 scripts home over the weekend? Let's say he loved your first page and quickly flipped to page two to see what came next. When do you know you *really* have him? When can you relax and be sure he'll finish reading your script with the same care that you wrote it? *Relax?* Are you kidding? Never! But while every single page in your script is super important, the first 10 are *crucial*. You need to grab that reader in those first 10 pages and not let him go.

Much of the success of these pages will have to do with character—have you created a main character who we can't wait to follow through this journey you've laid out?

Why would a reader lose interest in these first 10 pages? What are some common mistakes? Here are the top five.

(1) Being Too Predictable

If I can predict everything your characters say and do, you're not surprising me—and to be interested in turning those pages, I need to be surprised.

(2) Telling Too Much Backstory

This is so easy to do. You want your reader to know what's going on in your story, which is only natural, so you start having characters talk about how they got to this moment or what happened last year to get them wrestling with this dilemma or whatever. But the fact is, we like nothing more than jumping into the middle of a guy's life and trying to figure out for ourselves what his deal is—so don't feel you need to spoon feed us, throw us into the middle of the action and we'll have a lot more fun.

(3) Having Narrative Passages That Are Too Dense

There's a tendency—especially at the beginning of the script—to overwrite the narrative. When you first have your husband and wife arguing in bed, you might describe the bedroom in way too much detail. Sure, you want us to get the feel for the environment they live in, but that doesn't mean describing the wallpaper pattern and going into detail on what they're wearing and telling us all about what we see out their bedroom window. You could definitely do all of that in a novel, but you don't do it in a screenplay. You choose your words carefully and you say as little as possible before you get on with your story. For example:

```
"Walter sighs as he looks at the sweeping
city view out the window—which contrasts dra-
matically with the garish wallpaper in the
room and the tired panties his wife wears."
```

See how that's done? You get to comment on the wallpaper, the view out the window, and what Walter's wife wears in just one sentence. And note that it begins with Walter's sigh . . . so we know he's moved in some way by that view but NOT by the "garish" wallpaper. And his wife's "tired" panties? Wait a second, panties aren't alive—so how can they be tired? Well that's the point, isn't it? By giving them human characteristics, their image is more vivid, more alive, and that's exactly what you want—really cinematic images that will help the reader to SEE the movie that's in your head.

So though you can certainly include important narrative, you do so in as few words as possible.

(4) Introducing Your Main Character Too Late

While there are screenplays where the main character doesn't show up until page five or something, they are the rare exception to the rule—and the rule

is that we need to see your character right up front—top of page one if at all possible. Your reader needs to become invested in this character and if you wait to introduce the character, there's nothing for them to grab on to. So until you become a famous screenwriter who can violate all the rules, make sure your main character appears on page one.

(5) Errors

What's a spelling error or two, you might ask. Nobody's perfect. After all, shouldn't readers be reading your work for the content and not be so concerned with style?

Wow. Great rationalization.

As any script reader will tell you, errors indicate a lack of respect for the person who's reading your script and they indicate a lack of professionalism. Why should a reader bother to have to figure out a sentence you've written where a word is missing? They have that stack of 15 scripts to read, remember? They don't have time to be your remedial English teacher.

And the thing is, all you have to do is proofread. Yeah, I know... boring. Well, tough. Do it anyway. Don't know how to proofread? Aren't good at it? Let me clue you in—you look at the first word, ask yourself if it's spelled correctly, then move on, looking at each word until you've finished the first sentence. Then you go back and read that sentence over for context... are there any missing words? Have you mistakenly used an *it's* when it should have been *its*? Done with that sentence? Then you move on to the next. Time consuming? No kidding. Boring? To the max. But it's *necessary*. It separates the amateurs from the pros, and when that reader is reading your script, you want to be seen as a pro. This is such an important element of what it means to be a professional writer—believe me, you'll find me addressing it more than once.

Ending the Act with a Bang-up Finish

By the time we get 25 pages/minutes or so into your script, something big should happen and the act should end on a surprising twist, a scary development, a mind-boggling turn of events, a hilarious moment of discovery, a mysterious development, a realization for the main character, etc. And what do all of these have in common? To some extent, they are unexpected. When you get to the end of act one, your main character should be on her way to getting the guy she's dreamed about or formulating a plan to solve the mystery or capturing the criminal, or accepting that her mother's going to die or deciding a road trip with her friends is the answer.... But whatever it is, the end of the first act is the time we settle into your script for the long haul—because this is where you've given your main character a real complication that will change her and her life in ways that she probably can't imagine—and we can't wait to see how she deals with that.

Act II: Taking Your Main Character on a Wild Ride

Act two can be death. Seriously. It's half of your movie. And it can drag. Think about it, how often have you been in a movie and started to drift in the middle? Act two is where we get to know your characters better, where they get thrown into dilemmas and face roadblocks that make their journey difficult, where the action builds and builds and builds, where if you're not careful, your whole movie can derail.

So what can you do? How can you keep act two on track? Here are five ways you can keep act two so riveting that your reader will happily keep turning those pages:

(1) Keep Your Scenes as Short as Possible

Remember that film is a visual medium and you don't need to tell us lots of stuff through dialogue or long bits of narrative—you can tell us what we need to know through one image, one visual painting you paint for us with a small number of words. Quick scenes mean a faster pace, and that's exactly what you're going for here.

(2) Keep Your Main Character on Her Toes—i.e., Keep Up the Tension

How do you do this? Give her things to deal with that we—and she—didn't see coming. Doing this will up the tension—and tension makes a script impossible to stop reading.

So keep your main character at odds with achieving his goals, make us think he's on the right track then pull the rug out from under him so that he has to completely change course to get where he's going. Make us want to keep turning those pages to find out how he's EVER going to get out of this.

(3) Flesh Out a B and a C Story

Every film has a secondary story that's being told along with the main story. If your film is about a 12-year-old boy, Sam, who is bullied at school, your B story could be about the inner workings of the gang who's bulling him. And your C story could be about the fight between Sam's mom and the principal to get the school to do something to stop the bullies. And scenes that advance both your B and C stories are interspersed with the scenes that move Sam's story forward.

Your B and C stories aren't always thematically linked, though. You could have a B story in your Sam-being-bullied-film that's about his mom being pregnant and a C story that's about his kitten that gets lost.

Watch some of your favorite films and see if you can pick out those secondary stories—and note how much they add to the film.

(4) Stay Focused

I mean you—you, as the writer, stay focused. Remember as you write the 50 or so long pages that make up the second act, that you're writing about a character who wants something and is trying hard to get it. You could go off into other tangents concerning your main character, but don't. Keep your eye on the prize—getting your main character to the end of the act.

(5) Make the End of the Act as Dismal as Possible

The end of act two should be the time when we as an audience wonder if your main character could ever reach her goal. If you've done your job, we should think it nearly impossible, we should be almost certain that she's not going to get what she wants—no way. This is the point you've been driving toward in act two and all your work in building this story comes to fruition at the end of the act when she seems to have lost.

Don't worry, you'll turn it all around in act three (or you won't if it's a tragedy . . . but if it's a Hollywood movie, it's probably not a tragedy).

Act III: Making the Impossible Possible—Bringing It All Together

"I was with it right up to that stupid ending." That's something I've heard more than once as I headed out of a movie theatre. An ending that an audience (or reader!) thinks is unsatisfying is the last thing they'll remember about the story and will dramatically affect their opinion. All the good work you did to build to the climax will go out the window.

So what can you do to ensure a satisfying ending to your script?

(1) Don't Have an Unrealistic Ending

I hope your ending surprises me or satisfies me or delights me . . . I just don't want it to seem unreal. It needs to be organic—it needs to come from the heart of your story. If you're writing a murder mystery and the ending gives us some new character who was never discussed in the script as a suspect, your audience—and reader—will lynch you. But don't write your ending to please your reader/audience—write it to do right by your main character and your story.

(2) Beware the Curse of the Happy Ending

OK, nothing wrong with a happy ending—in stories as in life we probably all prefer happy endings. They let your reader smile as he reads the last page and they let an audience walk out of the theatre happier than when they came in. So why did I use the word "curse"? Well, it has to do with expectations. If you're writing for Hollywood, you need to know that

a happy—or semi-happy—ending is expected. The feeling is that people don't want to pay good money to be depressed. I'm not saying that you must have a happy ending, I'm only saying be prepared for some fallout if you don't. That shouldn't stop you from writing the ending your story needs—happy or sad or somewhere in-between. Your first master should be your story.

(3) Don't Be Afraid to Be Bold

I know, I know, I just told you not have an unrealistic ending and now I'm telling you to be bold. So I guess what I'm saying is "surprise me"—but in a good way—a way that makes me nod and go, "Ah, didn't see that coming but I like it" not frown and yell "Are you kidding me, that would never happen!" Remember that a twist at the end can be sweet—so give us that twist, just make sure it's bold and not ridiculous.

The 7 Steps

Pick up a book on screenwriting and you'll see the author's *system*—a series of steps that lay out how your film should be structured. One book has 15, another 11, another 20, another 5 . . . and on and on. Which one is right?

Well, I'm not sure that any of them are—including my 7 steps. The point is, stories *do* have structure, events do follow patterns when we tell stories, and if you can find a way to easily get your head around that, the better off you'll be as you construct your story's structure. So there's no *right* way, there are just different ways of thinking about screenplay structure. I like my 7 steps because they're logical and easy. Here they are:

ACT I
1—**Catalyst**
2—**Big Event**
3—**Major Complication**

ACT II
4—**2nd Major Complication**
5—**All Is Lost**

ACT III
6—**Can It Be?**
7—**Resolution**

In many ways, they're just signposts that help you break up your acts on the path to finishing your script. And like anything else in life—if you're building

a house or sewing a dress—if you follow the process step-by-step, if you can break it down into smaller tasks, it becomes easier to finish that final product ... the house, the dress, or in our case, the screenplay. A broad overview of the 7 steps, with a page number guide, follows.

Table 6.1 A Broad View of Structure: The Big 7

Dramas	7 Steps	Comedies
Page 1–2	1. **Catalyst:** This is often a character's dilemma or concern	Page 1–2
Page 8–10	2. **Big Event:** Perhaps a way to deal with the dilemma?	Page 7–8
Page 25–30	3. **Major Complication:** A twist, a problem usually affecting our character's concern	Page 22–25
Page 50–55	4. **2nd Major Complication:** Usually a roadblock of some sort for our character	Page 45–50
Page 75–80	5. **All Is Lost:** Crisis moment	Page 70–75
Page 95–100	6. **Can It Be?:** Could things work out after all?	Page 85–90
Page 100–110	7. **Resolution:** Problem solved, character's dilemma over, character is now happier/wiser/screwed	Page 90–95

NOTE: Comedies tend to be shorter scripts, so note the different page numbers in the right-hand column. Obviously, all page limits are *approximations* and you shouldn't feel restricted by them ... just know that the studio types who read your work will tend to expect your script to conform to an outline with a breakdown like this.

One of the best ways to understand the 7 steps is to look at some films—from old classics to contemporary films—to see how they follow the 7 steps. Again, I'm not saying that anyone consciously sat down and said, "Hey, heard about Diane's 7-step system? I'm going to plan my movie out based on it." Instead, I'm saying that any storyteller has to think about the major points in her story and how to map them out—and using the 7 steps is using parts of storytelling that are universal, so old films, new films, independents, studio blockbusters, they're a logical way of looking at film structure.

Let's take a look first at the traditional teen comedy *Mean Girls* [2004]:

Mean Girls: 7 Steps
1. **Catalyst:** Cady, 16, raised and home schooled in Africa, is totally out of place in suburban Illinois.

2. **Big Event:** Cady agrees to 'infiltrate' the plastics (so-perfect-they-can't-be-real girls) and report back to her two new friends... all the while trying to manage her crush on Aaron.
3. **Major Complication:** Cady and friends plot to bring Regina down after Regina lies about Cady and steals Aaron out from under her.
4. **2nd Major Complication:** Cady becomes the new queen bee.
5. **All Is Lost:** Cady incurs the wrath of the school—and her only two true friends—when Regina papers the school with the burn book... leading to Regina being hit by a bus and Cady's parents being disappointed in her.
6. **Can It Be?:** Cady, fresh from winning the math competition, is made Spring Fling queen and tears up her 'plastic' crown and shares it with everyone... at which point her two best friends take her back and she and Aaron dance.
7. **Resolution:** Wrap up of everyone's life in the next school year.

Or the classic drama/thriller Hitchcock-directed film *North by Northwest* [1959]:

North by Northwest: 7 Steps
1. **Catalyst:** Ad exec/playboy/loyal son Roger Thornhill is mistaken for a George Kaplan and kidnapped.
2. **Big Event:** When Thornhill won't admit to being government agent Kaplan, a Mr. Townsend has his henchmen pour lots of liquor down his throat and throw him in a car, planning to drive him off a cliff.
3. **Major Complication:** While 'playing' Kaplan to try and get to the bottom of why Townsend and friends are trying to kill him, Thornhill goes to the U.N. to confront Townsend... and learns that the man last night was not the real Mr. Townsend... and within moments, the real Townsend is stabbed and Thornhill's falsely accused of the crime.
4. **2nd Major Complication:** Thornhill finds himself betrayed by Eve Kendall—the one person he thought he could trust—when she sends him out to an Illinois cornfield where he's almost killed by a crop-dusting plane.
5. **All Is Lost:** Arrested at the auction, he tells off Eve for betraying him... then finds out she's an agent working for our side and had no choice.
6. **Can It Be?:** Thornhill and Eve escape the bad guys in a harrowing adventure on the face of Mount Rushmore.
7. **Resolution:** Thornhill and new wife Eve on a train into their new life together.

Or how about one of the best Woody Allen films—the dramedy *Manhattan* [1979]:

Figure 6.1 The iconic Woody Allen film *Manhattan* [1979]

Manhattan: 7 Steps

1. **Catalyst:** 42-year-old Isaac is dating 17-year-old Tracy, and her age bothers him.
2. **Big Event:** Isaac meets—and is repulsed by—Mary, his married best friend Yale's lover.
3. **Major Complication:** Isaac walks around NY with Mary one night and falls for her a bit, but doesn't do anything about it because Yale is still interested in her.
4. **2nd Major Complication:** Isaac *almost* kisses Mary in the planetarium, then keeps his date with Tracy and pushes her to go to London to study . . . since their age difference precludes them being a real couple . . . and before too long, dumps Tracy.
5. **All Is Lost:** After having become a couple with Mary, Isaac is shocked to find out Mary's been seeing Yale and is still in love with him.
6. **Can It Be?:** Realizing he loves Tracy, Isaac runs across town to tell her that . . . but she's heading out the door to go to London—something he now tries to talk her out of.
7. **Resolution:** Tracy goes to London—reassuring Isaac that 6 months isn't that long and that not everyone gets corrupted . . . so maybe there's hope for them after all.

Here's Michael Arndt's Academy Award-winning family film comedy *Little Miss Sunshine* [2006]:

Little Miss Sunshine: 7 Steps
1. **Catalyst:** Richard's book proposal, a 9-step system for winners, is going to be his ticket to fame and fortune . . . and it's how he evaluates everything in the lives of his astoundingly dysfunctional family.
2. **Big Event:** When Richard's 7-year-old daughter Olive gets a chance to compete in the Little Miss Sunshine pageant, Richard asks her if she can win . . . she says she can . . . so the dysfunctional family piles into the van for the road trip to California.
3. **Major Complication:** The van breaks down . . . and they have to push it every time they start it up to get it going—a group activity that results in all of them smiling.
4. **2nd Major Complication:** Not believing Stan Grossman turned down his system, Richard tracks him down in Scottsdale late one night—only to be told to his face to give it up, there's no way. Then, the next morning, Grandpa's dead.
5. **All Is Lost:** After they narrowly escape a cop finding out Grandpa's in the trunk, and after Dwayne has a meltdown, it looks like they'll never get to the pageant. When they do, they're 3 minutes late—and the bitch in charge doesn't want to let Olive in.
6. **Can It Be?:** Olive's going to compete, but when she does, she's doing a striptease kind of dance, so the bitchy organizer woman wants to throw her off the stage. But Richard jumps up on the stage, with the family soon following, and they all support Olive.
7. **Resolution:** The family escapes the police and heads back down the road, their shared experiences making them all feel like winners.

I'd encourage you to watch these films and behold the 7 points unfolding before your very eyes! The reason *every* film follows these 7 points is because storytelling is a natural art and stories have these beginnings, middles and ends—which are populated with the highs and lows that go with telling a story. If you were able to time travel back to the cavemen sitting around a campfire, I guarantee you that they, too, would be telling their stories like this.

From now on, as you watch films, you'll see this structure pop out at you. You may have been aware of it before but you might not have given names to these roller coaster points in telling a story. Now you know the names and can more easily think about how to use them to help you tell your own story—which is the point, after all.

One of the best things you can do as you begin to structure your film is to write out the 7 points—and do multiple versions. What you're doing is hitting the major points in the action of your film. All you need to do is write a half page that lays out the 7 points of your film—just as in the examples above. But don't stop there! Lay out a couple versions of those 7 points. In other words, outline your film in a few different ways. Because that's all the 7 points are—a mini-outline of your film.

At some point in the writing process, you may decide to do a longer outline—often called a treatment—and if you get a writing assignment, your contract will most likely require you to write a treatment. A treatment can be 5 pages or 35 pages—it really varies. It's a much more detailed outline of your script. Personally, I don't like to work from *too* detailed an outline because it limits the spontaneity of the writing process, and it's those serendipitous discoveries as I write that are the most fun. Seriously, sometimes I can't believe a character did or said something! Sure, I just wrote it down, but it's almost like the character told me to go in a direction I hadn't planned . . . and if I had written a very detailed treatment, I'm not sure I would have had that moment of discovery.

That being said, don't proceed with NO idea of your story. Very few writers can sit down with a blank page in front of them and just write a screenplay that's structurally sound. So best to do the 7 points and have a broad idea of the structure you want to follow. It won't limit your creativity, it will enhance it. Promise.

Page Numbers: Why Nearly All Scripts Are Around 100 Pages

So is it a conspiracy? Well, the thing is, it is kind of true—so what does that mean? Well, it means that your script should be around 100 pages.

Seriously? I'm Supposed to Follow Some Cookie-Cutter Formula?!

Calm down. It's descriptive—the 100-page script—not prescriptive.

It used to be that all scripts were around 120 pages—and all movies were around 2 hours long. The algorithm is, roughly, that a page written in screenplay format is equal to 1 minute of screen time—so 120 pages is 120 minutes in a movie. But movies have gotten shorter. Occasionally, a drama is 2 hours, or a sweeping spectacle is 2 to 3 hours, but for the most part, movies are about an hour-and-a-half long or a bit more . . . so around 100 minutes, 100 pages.

You'll note that page numbers are on the 7 steps outline—page numbers for dramas are listed in the left-hand column and page numbers for comedies

are listed in the right-hand column. These page numbers are ONLY there as guides . . . they are approximations, nothing more. You're in charge of your story and you can veer from these guidelines whenever necessary to tell your story in the best way it can be told.

Why It Works: The Discipline of Storytelling Construction

As any screenwriter will tell you, screenwriting is all about structure. A script is like a building—get one brick out of place and the whole thing could eventually topple over.

Are there exceptions to the 100-page rule? Of course. *Titantic* [1997] was 3 hours and 14 minutes—which is about 194 in screenplay pages (though the actual script is 173 pages—it just filmed 'long')! If we look at 'epic' films through the years, generally, they're quite long. And if we look at films from the last century, they are often quite a bit longer. But epic films are nearly always written and/or directed by major players with great track records—and they have the power to convince the studio that it's worth spending the extra money to make an overlong film. Most films are around 100 pages because that's an hour and 40 minutes . . . about the right amount of time for an audience to sit still and pay attention. We'll talk about maintaining an audience's attention when we talk about pacing, but in terms of the overall script, the closer you can be to 100 pages, the better chance you have of keeping your reader/audience focused on your story.

Going Your Own Way: When to Break Ranks with the 7 Steps

You can break ranks with the 7 steps anytime you want. But why would you want to? Remember, we're talking about the most organic kind of storytelling there is—three acts broken up a bit to make them easier to explain. But if you feel the 7 steps are in any way restrictive, hey, knock yourself out and come up with a new way of formatting—the bottom line is, if it works for you, if it helps you create a more cogent story, then it's right for you.

Structure. It's a bear. When the Writers Guild of America (WGA) evaluates scripts to see which of the 17 or so writers who wrote drafts of a script gets credit for the film, the #1 criterion used to determine authorship is structure. An actor can change a line of dialogue on the set—doesn't make him a writer. But a *writer* has put together the intricate puzzle that makes up a film—and that's the hardest part, therefore deserving of the most credit. I've been an arbiter for the WGA in credit disputes and believe me, structure is the key to getting credit. It's hard to come up with a viable structure but, hopefully, the 7 steps will give you a leg up in this most difficult part of writing a screenplay.

Pacing and How to *Feel* It

Pacing is one of those things that's hard to pin down. When a script does have it, every script-reader knows it—it just moves, it zips along and you don't want it to stop. When a script doesn't have it, every script-reader knows it—because it just lays there and it's a chore to keep reading.

When a script-reader takes those 15 scripts home over the weekend, they're definitely not going to waste their time reading a script that drags. But how are you supposed to fix it? How are you supposed to write so that the reader eagerly keeps turning those pages?

What Makes a Story Move

Generally speaking, audiences have a hard time paying attention. And it's not just *today's* audiences. As William James, the famous psychologist, wrote in 1890, "There is no such thing as voluntary attention sustained for more than a few seconds at a time." Notice he said *a few* seconds. And James is not alone—experts agree that the human animal can't sit still for long because we're wired to respond to motion. I think it's probably a primal thing—we were wired to keep our eyes darting around the jungle to check for predators. We knew if we stood in one place too long and didn't keep scanning the horizon, we'd be somebody's lunch. Nothing like survival as a motivator! Most of us don't need to do that anymore but we still have brains that are built to look for the new, brains that are wired to keep watch, and brains that need stimulation. So the task of the screenwriter is to take the viewer/reader down a path that's riveting enough that they'll pay attention for a few seconds, then a few more, and then a few more. And this won't happen by accident. It will only happen if you keep the excitement coming—and that can be emotional excitement just as easily as car chases.

So here's the hard truth: every single word you write is crucial to maintain the pacing of your screenplay. Your goal should be—constantly—to pare down. If you can replace four words with three words, do it. If you can cut a two-line description of a room that a character enters to a one-line description, do it. If a character can break down and finally confess to a crime in a four-line speech... could he do it in three lines? Could you combine two sentences into one? Whatever you can do to keep the script moving along, that's what you do. Obviously, you always want to stay true to your story, but you want to take out every excess *syllable*. This is a screenplay, not a novel. You're not allowed to go inside a character's head and give us paragraphs about what she's thinking and feeling, you have to tell it all to us in dialogue or specific, descriptive narrative.

Think about it this way—if you're at home reading a novel, you kick back, put your feet up, and luxuriate in the language of the book. You imagine the

forest that the author has taken a page to describe, you feel with the main character as he worries he'll never make it out of the forest and thinks about the possibility of never seeing his fiancée again, and for 100 pages, you follow him through that forest. And when he gets out of the forest, there are still 400 more pages of the book for you to read—because that's the point of this novel, how being almost lost in the forest changes this guy.

In a screenplay, you can't spend 100 pages following this guy through the forest—are you kidding me? That would be your entire screenplay! If you ever want to get to him emerging from that forest and getting to his wedding and everything else that happens in the 500-page book, you don't have time for lyrical descriptions of the forest, you can't spend a page on just that description. It's a forest—give it a descriptor or two—a dark and gloomy forest, or a magical, dreamy forest, or a sun-drenched, overgrown forest—whatever the descriptors, we'll get a feeling for the kind of forest your main character is in . . . and then let's get on, *quickly*, to what happens in that forest and beyond.

The importance of pacing can hardly be overstated, the goal being to make it impossible for the reader to do anything but want to quickly flip to the next page. And sure, how to do that is incredibly elusive—this is screenwriting, and it's an art, not a science. But there are a few things you can do to help your odds of creating a fast-moving script. One of the most important things is to work on the narrative portion of your script. When I say narrative, I'm talking about the description—all that stuff between the dialogue. One of the biggest mistakes writers make is to go into too much detail in the narrative. Consequently, the narrative portions of the script become too long.

And I hate to tell you this, but there are readers (producers, agents, development execs) who 'read' a script by reading only the dialogue. In other words, all that angst you sweated over writing the narrative was for naught.

But here's the thing. That agent who takes home those 15 scripts for the agency's 'weekend read' also has a life of some sort. So how much attention is actually paid to those 15 scripts? Thus, the tendency to skip some of the narrative. Thinking about this makes me ill. So if you have any chance of interesting that reader in the narrative portion of your script, it better be tight. Clean, to-the-point sentences, written to move the action forward.

How hard is that?

Well, it's hard. And you probably already know that.

A few guidelines:

(1) Always Try to Keep Your Narrative Paragraphs on the Short Side

Try and keep all instances of narrative under four typed lines. What that means is that if you need *more* than four lines for an instance of narrative, you need to break it down. Have a narrative sequence that's seven lines long? Divide it

into two paragraphs and have a character do something visually between those two paragraphs if you don't want them to speak. For example, on page 76 of Stephen Gaghan's screenplay for *Syriana* [2005], he's setting up a new scene on a boat we haven't been on yet. Here's how he could have written it:

> Prince Meshal's yacht, the SONG OF ROLAND, is one of many beautiful boats anchored off Juan Les Pins. On the yacht, a dinner party is in progress. People drink champagne against the backdrop of this exclusive setting. Music sets the mood and the boat has been decorated with candles that reinforce that mood. The people at the party absolutely glisten. At one table, Mary Alice talks with somebody who has a bit of the look of an older, well-worn JAMES BOND.

But here's what he wrote:

> "The fantail of Prince Meshal's yacht, SONG OF ROLAND, one of many beautiful boats, anchored off Juan Les Pins. A dinner party in progress. The tinkle of crystal and music. Candles flicker. Glowing people. At one table Mary Alice chats with somebody like ROGER MOORE."

I love the way he abbreviates his sentences. He uses phrases instead of complete sentences. We move along in the flow of his mind, we see what he sees and we see it as quickly as he does. Nice writing.

(2) Use Words Sparingly and Elegantly

Again, looking at what Stephen wrote above, look at that second paragraph: "Candles flicker. Glowing people." Now, dissect that. Candles do flicker . . . but they also glow. So when he says 'glowing people' right after putting the image in our mind about candles . . . well, it's subtle, but it makes both the flickering candles and the glowing people seem more vivid. If we wanted to be literal, we could point out that, unless they're full of radiation or something, people don't actually glow. But how cool is the scene in my mind because of the way he used words so well to paint this picture?

(3) Edit, Edit and Edit

After you've printed out a page of your script, give yourself a challenge: cut two lines. In other words, cut enough words from the narrative portions on the page to save yourself two actual lines of typing. I first did this kind of cutting once when I needed to make a script shorter. But guess what? I soon realized that my script became tighter because of those cuts. The descriptions moved along more quickly, etc., and thus made the script a better read. So always pay attention to the narrative portions of your pages and see how 'tight' you can make them! Cut two lines a page and see what happens. I think one

of the reasons this works is because editing is hard. You get very close to your work and it's difficult to see what you *should* cut, even when you're trying to be as spare with your language as possible. So forcing yourself to cut two lines a page makes you look really carefully at every word and cut what you can.

Writing Action: More Words Means More Care

Action scenes are unique—usually, they're a lot more about narrative than dialogue, and that means you need to take care. Several pages of narrative makes your reader groan. Why is that? Well, there's this thing in the world of screenwriting called 'white space'. White space is something screenwriters aim for—and, in essence, it's the idea that any page of a screenplay should have more blank, white space than it has typed lines. If it has more white space, the conclusion is that it will move along at a quicker clip—that it will have good pacing.

So action scenes become tough. Think about it, spaceships fighting out in the cosmos... the excitement *is* the battle, so that's a lot of narrative, and even if you keep each narrative sequence to four lines, you're going to have a lot of four-line narrative paragraphs in a row. So how do you handle it?

Additionally, action sequences *are* fast-moving on screen because of all those great special effects and camera movements. So how do you convey that fast pace on the page? While there are plenty of ways to write action, let's look at a scene that employs one that can be used for almost any action sequence.

In the following scene, CIA agents CHIP, 38, a handsome womanizer, and CORK, 32, a tenacious fire-cracker, have used info from a dead terrorist named Rico to get to his contacts at the famous Clignancourt flea market in Paris.

EXT. CLINGANCOURT METRO STATION—MORNING

Cork and Chip come up the metro steps where they are greeted by a flea market that stretches for blocks.

 CHIP
 She called Rico from a shop
 called Enchanté. But I checked
 and the owner's here every Thursday.

 CORK
 Yasmin you said her name was?

Chip nods. They walk down the stalls looking at the various names, finally seeing one with a banner that says Enchanté. A MAN, 60, and a WOMAN, 40, stand behind their wares.

 CHIP
 (southern accent)
 Howdy. I sure hope one of you
 folks sprechens a little English?

 MAN
 A little.

 CHIP
 Well, I'm Beauragard T. Ringsrud
 and this is my little wife Eula Mae.

 CORK
 (southern accent)
 How do.

 WOMAN/YASMIN
 I'm Yasmin and this is my father.
 What can we do for you?

 CORK
 A mutual friend told us to look
 you up.

 YASMIN
 And what friend would that be?

 CORK
 His name was Rico, wasn't it honey?

Yasmin is silent.

OLDER MAN

immediately pulls a gun on them and motions for them to come behind the stall.

 CORK
 Well, I declare . . .

CHIP

immediately pulls his gun, but

YASMIN

knocks it out of his hand with the laser beam that comes from a palm-sized weapon, burning a hole through Chip's gun.

THE LASER

shoots another blast at Chip's arm, burning a hole right through his jacket as

CORK

slowly comes around the table—showing the Old Man she's no threat.

CHIP

cringes at the pain in his arm but still manages to KICK the laser from Yasmin's hand.

CORK

continues to follow orders from the Old Man—but just as she turns the last corner to come around the table, she PUSHES with her knee from under the table and it goes toppling on the man—and his gun falls to the ground.

YASMIN AND CHIP

lunge for the gun.

 CHIP
 (to Cork, no southern accent)
 Go! I'll be right behind you.

CORK

runs for the metro station.

YASMIN

gets the gun and CRACKS Chip over the head with it.

CHIP

crumples to the ground.

YASMIN

helps her father out from under the table.

 YASMIN
 Guard this one.

YASMIN

gives her father the gun, pockets the laser for herself, and runs after Cork.

INT. CLIGNANCOURT METRO STATION—DAY

The station is not too heavily populated as

CORK

bolts down the metro steps and JUMPS over the entrance kiosk.

She runs for the end of the station, which is bare except for a cigarette machine.

YASMIN

looks first one way down the platform, then the other. No Cork.

A TRAIN

blows its whistle as it approaches the station.

YASMIN

eyes the cigarette machine and walks slowly toward it.

THE TRAIN

pulls into the tunnel heading to the station.

PEOPLE

waiting for the train step up on the platform.

CORK

hides atop the machine, hoping Yasmin will think she's lost her.

Big mistake.

YASMIN

stands on the benches near the wall to get a better view and looks right into Cork's eyes. She threatens Cork with the laser.

 YASMIN
 Down. Slowly.

THE TRAIN

gets louder and its whistle BLOWS as it enters the station.

CORK

jumps down and

YASMIN

grabs her by the arm, laser to Cork's back.

 YASMIN
 Who are you?

Cork says nothing. She looks around but there's no one to see what's going on.

Yasmin inches her toward the platform and the oncoming train. Soon one more step would put them on the tracks.

 CORK
 Rico wouldn't like this.

 YASMIN
 Well he's dead, isn't he?

THE TRAIN

comes down the platform.

 YASMIN
 Give me one reason why you
 shouldn't have a horrible accident.

YASMIN

shoves the laser more firmly into Cork's back.

CORK

watches the mass of steel approach. The SOUND is deafening.

YASMIN'S HANDS

begin to push Cork and then stop, abruptly.

CORK

feels the hands simply drop away. But she has to work quickly to regain her balance and not fall forward onto the tracks.

THE TRAIN

passes in front of her with a WHOOSH and

CORK

falls backwards, over the body of Yasmin, which is now crumpled on the platform.

YASMIN

is on her back, eyes frozen open, the laser still clutched in her hand. Slowly, BLOOD begins to form a pool under her body.

CORK

looks up and sees Chip about halfway down the platform, pocketing his gun.

CHIP

runs toward her and grabs her.

> CHIP
> Come on.

THE TRAIN

SCREECHES to a halt, its noise having covered up Chip's gun.

> CORK
> Wait.

Cork reaches for Yasmin's hand and pries out the laser device.

CHIP AND CORK

run out of the station as a DISEMBARKING PASSENGER nearly steps on Yasmin's body.
And with a SCREAM, the station turns into a madhouse.

Notice how, in the scene with Chip and Cork, each major action moment is broken out. Often an action moment begins with a character name or an object. This helps the reader follow the scene just as if he/she was seeing it—we move from something Chip does, to something Yasmin does, to the appearance of an object, like a laser, that really drives an action moment.

Reading action written out in this manner helps the reader's eye move quickly along the page (and gives the appearance of the ever-popular white space!) and that helps the pacing of the script to zip along.

There are various ways to write action—find a way that's right for you, that fits your story and your writing style. The aim of finding a good way to write action isn't just to improve the pacing, it's to make your script clear. You want your reader to follow every moment of a fight or a battle or a chase—and breaking that action sequence out into clear, shorter, visually compelling steps makes the action come alive and your script move along at a good pace.

Deviating from the Norm: Nonlinear Structure and the Anti-Narrative Film

When we talk about structure, we're generally talking about linear structure—events in the story happen in a straight line . . . A happens then B then C. Nonlinear structure usually refers to a structure where we jump around in time and/or POV—we consider a past event while looking at the present, we have multiple characters telling the story, etc. In *Citizen Kane* [1941], the death of Kane kicks off explorations of his past life that come as people tell stories about their experiences with him and flash back and forth between those moments in his life to the present moment to help us figure out what his dying word, *rosebud,* meant to this guy, and in *Pulp Fiction* [1994], while the film begins and ends in the same location, the meat of the film is three different stories told by three different characters, and in *Memento* [2000], the story is told, simply, backwards.

I love nonlinear films—and I like the challenge of writing using some of those methods of storytelling. But I wouldn't recommend them if you're writing your first screenplay. Get to know linear structure first, *then* play around with structure formats and go wild.

The anti-narrative structure is one that has no plot and pretty much nothing happens—at least in the way we talk about when we're talking about ordinary narrative film structure. Many experimental films are written by people who use film for something other than telling a story—oftentimes, scholars of film experiment in this area and push the boundaries of what film is. If you find yourself drawn to experimental films online or in festivals, this may be an area you want to study. But for our purposes of telling stories using a narrative structure, the experimental is beyond the bounds of what we're exploring.

Chapter 6 Exercises

For Exercises 2–5 below, pick a screenplay you know you want to write and then complete the exercises.

1. Take three of your favorite films and outline them using the 7 steps.
2. Summarize your main character's journey in 50 words or less.
3. Write three completely different first pages. All should include your main character on the page but each should launch your story in a completely different way.
4. Write three versions of the 7 steps for your film.
5. Take your favorite first page from exercise three above and work to cut out at least five lines from the page. Can you see how that's improved the pacing? Now cut out five *more* lines.

7
DIALOGUE

Would you believe there are people out there who actually believe that the actors make up their own dialogue? And when you look at film history, that's pretty much what actors did in the days of silent film because what they did say wasn't being recorded and someone else would write the actual storyboards like "Oh, John, tell me it isn't so" or other memorable bits of cinematic dialogue. So in many ways, the first film dialogue was improvised on the set between the actors based on a situation they were given by the director. Kind of nice, actually, for the actors—no lines to memorize! And my guess? The improvised lines on set by those silent film stars were probably much more compelling and real than what ended up on cards in the film.

Dialogue isn't easy—I've known writer friends to work for a day or two on a three or four line exchange between two characters, trying many, many lines between the couple until it sounded just right. And dialogue is certainly important—without good dialogue, your script simply won't get read. So this is a crucial step on that path to writing a good screenplay.

Writing Good Dialogue: Can It Be Taught?

You'd think it would be easy. After all, we all talk. How hard could it be to write down a bunch of dialogue? Oy.

Some people simply have 'an ear' for dialogue. And they're the lucky ones. A couple of you may fall into that category. But what if you don't? What if dialogue is tough for you?

Well, you're not alone. But by studying it, by observing people speaking, by going over and over it until it seems natural, you can get better.

A few thoughts on dialogue:

- *If You're Really into Your Characters, They'll Help You*

Seriously. They'll 'tell' you what to write for them. I said in a speech recently that I thought screenwriting was the one place where you were paid to be a schizophrenic. Because when it's really flowing, when you're into the scene and into those characters, they seem to 'speak' and you just write it down. Maybe you haven't had this experience yet. But the more comfortable you get with writing, the better chance that it will happen for you. This won't happen, of course, if you haven't done the hard work of understanding your character—but once you've done that, they'll be with you throughout your day. As you're talking to your significant other or driving your kids to school or partying with your friends on the weekend, a part of your brain will be working on your story and listening to your characters. As you do things in *your* life, you'll imagine how your character would do them. And as you talk to a boss who's a bully but he's your boss so you can't talk to him the way you'd like, you imagine your character talking to the boss and reading him the riot act. As you go to sleep at night, you dream of what your character would say in a certain situation—in fact, you may dream complete scenes where your character is talking her way out of a situation that you couldn't seem to solve when you were awake! This has happened to me many times—waking up and immediately grabbing a notepad to write down what my character said in my dream.

None of this will happen if you're not really close to your character. In many ways, you *become* your character. And that's not a bad thing—you want to identify so thoroughly with that character and what she's going through that it's easy for her words to come out of your mind.

The double/triple benefit of listening to your characters speak to you is that they can also help you with your plot! Their voice can be so strong that it takes you along to experiences and situations you may not have even thought about including in your film.

When you stand back and think about this logically, it's kind of weird, isn't it? Listening to people talk who don't exist? Who are only speaking in your head? Do all of us writers need serious therapy!? Well, maybe. But I guess it's an occupational hazard.

I remember hearing Annie Proulx talk about writing the short story that would later be adapted to become the film *Brokeback Mountain* [2005]. She had been to a bar somewhere in Wyoming or Montana and it was full of cowboys, and was very masculine, very macho. And she wondered what it would be like to live and work in this environment if you were gay. And two characters came into her mind and she wrote her story. Years later, the story was adapted into a screenplay by Larry McMurtry and Diana Ossana—and Proulx liked what they did with the film, was moved by it. But the downside for her? After she wrote her story, she'd gotten these two guys out of her head.

But after the movie came out... well, I remember her sighing and saying that they were back. And that's what it's like to be a writer. People whose stories want to be told come into your life, they speak to you, you listen to their voice, and you write down what they say.

So get to know your characters as well as you know your own parents or siblings—and I promise they'll help you write their stories.

- *Learn to Listen to How People Talk*

Most of us don't, really. So when it comes time to write dialogue for a character, it just doesn't sound real, natural. It sounds like it was written by someone who's putting words into this character's mouth.

So how can you really learn to listen? Here's one way: Go to a mall or a Starbucks, get on a bus or subway. Pick two or three people to observe. Then eavesdrop. Listen. Turn on a tape recorder or take good notes and transcribe everything that's said. I mean every sigh, pause, half-sentence, etc. Every word and every half-word. And guess what you'll see when you look at that transcript? You'll see one thing that's true of every single person you listen to: they don't speak in complete sentences. They speak in fragments, half sentences, shorthand that their friend will understand. And once you really understand this and apply it to your characters, your dialogue will improve dramatically.

You need to do this more than once. Listen to all kinds of people—a young couple sitting at a coffee shop, two older women on a city bus, teenagers at a football game... choose diverse locations and listen to all sexes, races and ages of people. Consider this a course in understanding human language usage. This course doesn't require cracking a book, it only requires going out into the world and opening your ears.

It's important that you don't do this with a censor in your head—you don't evaluate what people are saying or how they're saying it, you just write it down. Don't even think about whether it's valuable or not. Don't think about whether you're riveted by what the people are saying. Even if you're totally bored, just write it down.

Once you get back to your computer and have time to transcribe what you heard, do it carefully. Then sit down and read it. And what do you see? Look for patterns. How many of the people you overheard spoke in complete sentences? Not that many, right? And if they did speak in complete sentences, they were probably people who didn't know each other very well, weren't they? Which people had to fill every moment of silence with verbiage and which ones were comfortable with silence? How many people said 'uh' or 'um' or 'so' or 'like' between the actual words they were using to convey their thoughts? How often did they jump from one subject to another? What kind of shorthand did they seem to have in talking with

one another? Did they use correct grammar or incorrect grammar? How many people had a distinctive vocal 'tic' that made it easy to know when they were talking?

Then you move your listening to the next step. Pick a couple that you overheard and continue their conversation on paper. Write in the same style that each one of them spoke in during the part of their conversation that you heard. This will give you a chance to practice writing in different oral styles. Once you've had the chance to write in different voices, you'll begin to see the variety of options that are open to you as you write dialogue.

- *Read Over Each Character's Dialogue Separately*

Here's what I mean by that: Let's say you're 20 pages into your new script about Joe and Sally. Go back to page one and start reading only Joe's dialogue. And read it out loud. Then go back to page one and read only Sally's dialogue. They should be very different. A line of Sally's should be distinctively in her voice. She should have quirks and idiosyncrasies that are hers alone and that are quite distinctive from Joe's quirks and idiosyncrasies. Each of them should have a distinct voice. If you're in the unfortunate situation of having the characters all sound alike, then you know you have work to do. You have to try and get into the characters so that they can reveal their individual voices.

- *Write Dialogue Scenes That Won't Go into Your Script*

Sometimes you can feel under such pressure to get the dialogue right that you can paralyze yourself as you're trying to write an important scene—you can put too much pressure on yourself to get it right, to make the characters distinctive, and in the process, you lose the part of their voices you DID have. So what to do One possibility is to have done more homework—that can mean writing scenes with your characters that aren't crucial to your script. So before you even start writing your script, sit down and write some conversations with them—conversations that probably won't appear in your script.

For example, if your characters are a brother and sister and your script takes place when they're both in their 30s, write a scene between them when they were 15 and fighting over getting the front seat in the car on a family trip . . . something inconsequential. Point being, you want to concentrate on how they're saying what they're saying rather than necessarily having their dialogue lead to something that's an important plot point. Sometimes if you can trace the history of how people talk to one another by writing earlier scenes in their lives, by the time you get to writing that important scene in your script between the two of them, you'll have their voices down pat.

- *Read Good Plays and Screenplays*

One way to improve your own dialogue is to study dialogue that's well written by other screenwriters. This means looking for actual screenplays to read and study. While you can order them online through various services, most screenplays are actually owned by the studio that commissioned them, so they're not fair game for sale. Plus, what you 'buy' could simply be the result of someone sitting down with the DVD and 'writing' the screenplay as they watch the film! So what you buy might not be the real screenplay at all. I was walking in Times Square in Manhattan a few years ago and a guy had a card table set up and was selling screenplays—actual typed, bound, 8 ½ by 11 inch screenplays. I couldn't believe it at the time! People would spend money for a screenplay!? And as I looked at his table of 30 or so screenplays, there it was—the screenplay for *Frida* [2002], a film I had been a co-writer on. I couldn't help but pick it up and look at it—and you know whose name was on the cover page, purporting to have written the screenplay? No one who co-wrote it! Point being, you don't want to waste your time studying a screenplay that isn't the actual screenplay!

If you're lucky enough to live in the Los Angeles area, you can go to the Writers Guild of America (WGA) library or the Academy of Motion Picture Arts and Sciences (AMPAS) library and ask to look at any number of screenplays. In addition, many colleges and universities have acquired copies of famous and even not so famous screenplays and you can visit their stacks and read some of them. Last resort, if you live in the middle of Kansas or something, you can buy a published copy of a screenplay in book format. The problem with reading a screenplay in book format is that if a film was big enough to publish the screenplay, they publish the shooting script of that screenplay—and you won't learn nearly as much from the shooting script as you will from an earlier draft. So even if you're in Kansas, see if you can't get your local librarian to help you track down some screenplays through interlibrary loan.

Be sure to pick screenplays to study that are of films in your genre. Like screwball comedies? Want to reinvent them for a new generation? Read *Bringing Up Baby* [1939], *I Was a Male War Bride* [1949] and *Some Like it Hot* [1959]. Look at the cadence of that dialogue, and while they may all speak at about the same rapid rate, look at how each character is distinctive in tone and emphasis. The bonus of doing this isn't just improving your own ability as a writer of dialogue, it's that you get to read these TERRIFIC screenplays.

There's a website called www.simplyscripts.com that has the scripts of many famous films—and many of the films nominated for Academy Awards over the past few years. Lots of studios and production companies put the scripts on their websites to promote their film for Best Screenplay awards,

and thus they're accessible to everyone. They're often the shooting scripts, which can be less valuable, but hey—they're the real script, so definitely worth a look! And websites like www.imdb.com and www.script-o-rama.com can also be helpful.

Can you watch the films instead of read the screenplays? NO. Well, of course, you can—but you won't get the same benefit as you would if you read the screenplays. There's something about seeing those words in print, about realizing that someone who came before you put their fingers to a keyboard and put those letters on paper. In many ways, it demystifies the process of writing. It's not magic, it's not done by some chosen genius, it's just putting words on paper. But reading the scripts will show you that the *way* you put those words on paper is what it's all about—the *way* you make those characters speak is what will make your dialogue sparkle.

- *Aim for Dialogue That Moves*

One of the hardest things to do as a writer is to write dialogue that moves—and moves in two ways. The first is within each character's speech—each speech needs to move rapidly. And then in the back-and-forth between characters, it needs to feel really fast.

Problem is, it's very easy to write too much dialogue. There's a tendency to want to make sure your reader understands what you're going for, understands what your character is really saying. Consequently, a script can get dialogue-heavy really fast. But in contrast, when you see a movie where the dialogue just moves, that dialogue is invigorating and guess what—there's usually not much of it! Nicely paced dialogue usually means short exchanges between characters. And to readers of scripts (agents, producers, etc.) that dialogue better be fast-paced because they don't have *time* to read and therefore expect to zip through a script. So if you've got characters exchanging long speeches . . . believe me, your script won't get a full read. Once you're an established writer, this is a rule you can break—you can have longer speeches and they'll keep reading because they already like your work and are happy to cut you some slack. But as a new writer, you better not waste one word of extra dialogue. The rule? When in doubt, leave it out. Have a character say only what's necessary.

Look at dialogue from a favorite script and really take it apart. See how what each character says is a function of the character's personality as well as what content each of them feels they need to communicate. Do you see how good pacing isn't just about keeping your speeches short? It's about how one character's dialogue builds on or even challenges the dialogue of another. It's natural, it's easy to hear in your head, it moves.

In addition to movement relating to pacing, it also relates to how we're moved emotionally. And if the dialogue is good, we'll see the emotional

dynamics between your characters: they're crystal clear, even though they're almost completely below the surface.

I want to be captivated and intrigued by your dialogue, I want to know more—and not just about the plot, but about the people in that plot. Because it's the relationships that will keep me emotionally committed to this story, much more than plot ever will.

Working Like Crazy to Be Conversational

If you've done your homework, you've written down conversations from different kinds of people and you've looked at their pacing to see how their dialogue keeps moving, and you've studied the individual quirks each person has in speaking that make him/her unique. What you'll also begin to notice is that the conversation between real people sounds real—it's not forced or fake-y, it's conversational. It's not just *dialogue*, it's conversation.

Conversational. How can you make your dialogue so real that it seems like normal conversation? And what exactly does 'conversational' mean? After all, isn't all spoken speech conversational by definition? We open our mouths, we converse. Well, that's exactly the point. We open our mouths and words come out. Our best friend asks us why we're upset—do we go away and sit in an office for half a day and then come back out and tell our best friend why we're upset in the most perfectly constructed sentence ever? No—we answer the question in real time, instinctively. If we give it any thought at all, it's a momentary pause of no more than a second or two before we answer. Sure, we may search for the right words to say, there may be pauses in our explanation. But think about it. We don't say, "I'm upset because my husband left me this morning, he cleaned out our bank account, my kids hate me and my dog is dying." Someone might say all those things, but they wouldn't begin their sentence with "I'm upset because"—it's too formal. It's also unusual to repeat the question in our answer, we just answer the question. And if we're really upset, we probably aren't capable of giving a nice, neat list. Let's look at some 'conversational' ways a character might begin to answer that question.

>TAMI
>Why are you so upset?

>KENDRA
>It's . . . it's Tom . . .

OR

>TAMI
>Why are you so upset?

> KENDRA
> (sniffling)
> What makes you think I'm upset?

> **OR**

> TAMI
> Why are you so upset?

> KENDRA
> He . . . he just left.

> **OR**

> TAMI
> Why are you so upset?

> KENDRA
> (wry smile)
> You never think it's going to happen to you.

And we could go on and on with possibilities. One of the things that all of these examples have in common is that they invite conversation. It's rare that we give a speech or a list to fully answer a question someone has posed. Generally, we'll say one thing. If we're really angry, we might go into a tirade and reel off a list, but it probably wouldn't be focused and super coherent. Here are a few examples:

> TAMI
> Why are you so upset?

> KENDRA
> Because men are scum, kids aren't much better, and Fluffy (sniffles) . . . Fluffy . . .

> **OR**

> TAMI
> Why are you so upset?

> KENDRA
> Upset? I'm *way* beyond upset—try homicidal.

OR

> TAMI
> Why are you so upset?
>
> KENDRA
> They took his side! The jerk leaves me for some twinkie and the kids blame *me*!

OR

> TAMI
> Why are you so upset?
>
> KENDRA
> After putting him through med school, bearing his ungrateful kids, he cleans out the bank account! I'm broke!!

And again, we could keep going and come up with more ways Kendra could respond when she's angry rather than just upset. How Kendra responds will determine the direction the conversation will go in. Does she focus on the dog? The husband? The kids? The money? How she responds tells us about what's most important to her, what really bothers her—and all of her responses invite Tami to inquire further.

As you work on listening to how people speak—really listening—you'll begin to notice a few characteristics of oral speech between people who know each other:

1. They Use Fragments—Not Complete Sentences

Let's say you have tape-recorded a conversation and have gone back to your computer to transcribe it. One of the things you'll find difficult is getting it down on paper in an understandable way—because spoken language can be way different than written language. We tend to use only parts of sentences when we talk—so in an email, you might say, "I'll see you at the train station at 7:00" but in conversation, you might say, "7 tomorrow" and that will be it because you've already confirmed in the conversation that the two of you are meeting at the train station. You certainly don't need to say, "I'll see you at . . . "—in fact, if you did, it wouldn't seem as conversational. Of course, the more people speak in fragments, the more likely it is they know each other well—they don't feel they have to be formal. As you're writing, always keep in mind that the simplest way for a character to say something is probably the best—it will seem more natural, more conversational.

2. They Seem to Have Shortcuts That Perhaps Only They Understand

When you transcribe your recorded conversations, you can also notice that you're totally clueless about what's being said. Oh, you've transcribed it correctly—you've put down the words they said in the order they said them—but there's stuff there that just doesn't make sense. We all do this—when we know someone well, we speak in this sort of shorthand. Husbands and wives often seem to speak in a language only they seem to understand. They know each other so well that they have routine ways of saying things, pet words for things that only they understand. In the fuller context of their relationship and if you were following them around and listening to them for a period of time, all the shorthand they use orally with each other would begin to make sense. But by seeing just a snippet of their conversation, the shorthand can make what they're saying incomprehensible. The key as you're writing is to create shorthand people use when they speak that we get used to. A wife may talk about 'the bull pen' early in the film and we may not get what she's referring to, but as the film continues, we see that when she talks about 'the bull pen', she's talking about her husband's cronies down at the track. As you develop your characters, you can add these kinds of shortcuts that are distinctive to a person's individual speech.

3. They Interrupt Each Other Frequently

Not only do people who know each other interrupt each other, sometimes the interrupting is so pervasive they seem to talk right over one another. I still remember a dinner I went to with a college friend of mine—I couldn't hear myself think at that dinner table! I came from a family whose dinner table was relatively silent, but my friend's house? I don't remember anyone getting a complete sentence out for the course of the entire meal. It was absolute chaos! I felt like Alice at the Mad Hatter's Tea Party except that none of my dinner companions were of the animal variety. Seriously, I remember swiveling my head in every direction trying to simply follow the conversation. But I've no doubt that everyone at that table had no problem at all following along . . . I think they trained their ears to hear on multiple levels or something. In any case, this is a common characteristic of people who know one another well and it's something you can use whenever it's appropriate in writing your dialogue.

4. They Switch Subjects Frequently

In most written speech—novels, plays and films—people finish one subject before picking up another. But as you look at your transcribed recordings, you'll see example after example of people bopping around from one subject to another. Someone mentions their cousin's new job in advertising and the

person they're conversing with moves to their problem with their boss and the other starts talking about her kid's play that's coming up ... sometimes you begin to wonder, as you listen to humanity talk, how we ever *really* communicate. You'll start noticing the tendency for each person to talk about subjects of interest to THEM ... it's as if the other person is there to allow them to vent. If people in our screenplays changed subjects as much as people in real life, I fear the audiences wouldn't be able to follow our stories at all—it would simply be too confusing. So what's a writer to do? I think the answer is to understand the concept of switching subjects and use it when it's right in a conversation. Maybe you have one character who switches the subject back to his concerns all the time, maybe you have a husband and wife who always talk over one another—these kinds of verbal quirks don't just add variety to the dialogue in your script, they help *define* your characters.

Dialogue isn't something that separates plot from character—it's revealing of both. It's how we communicate our story and while it ought to flow as easily as normal conversation flows, it often takes a lot of work to make the spontaneous utterances of our characters seem natural.

Why Less Is Always More

One of the most common mistakes in writing dialogue is to write too much of it. There are many reasons it might seem natural to do this—you want the audience to understand your character's point of view, you have a lot of backstory to tell, you have plot points that you need to get out—all sorts of reasons for your characters to talk and talk and talk. Your job is to resist those reasons whenever you can. To help you do that, here are four of the heretofore unwritten rules that I'm now going to write.

- *Never Have a Character Say More Than Four Typed Lines of Dialogue*

And whenever possible, have characters speak only two or three lines of dialogue at a time. The point being, have your characters speak as quickly as possible. Here's an example:

```
INT. CAFE—DAY

MIRABELLE (39) sits in a chair, nervously
petting the DOG in her lap, and talks to a
gum-chewing JENNY (42).

              MIRABELLE
     You'd think he actually cared,
     wouldn't you? Giving me all those
     gifts and taking me to all them
```

 MIRABELLE [CONT'D]
 fancy places. And what for? For
 one thing, that's what's for. But
 dumb old me, I fell for it. I guess I
 always fall for it, you know?
 I must be slightly nuts—maybe I didn't
 get some vitamins or something when
 I was growing up, but I thought, well,
 I thought maybe this was it. Crazy, huh?

 JENNY
 Nah—he's just a jerk.

While I particularly like the vitamin reference in Mirabelle's speech, overall it drags. It's 11 lines long, and it feels it. Ask yourself what happens in that speech. She laments having had an affair with a guy she thought loved her but clearly didn't. But we get that right away—why go on and on about it?

Let's look at the scene another way:

INT. CAFE—DAY

MIRABELLE (39) sits in a chair, nervously petting the DOG in her lap, and talks to a gum-chewing JENNY (42).

 MIRABELLE
 Am I that dumb? Believing all the gifts
 and fancy dinners meant he . . . he . . .

 JENNY
 He looked good, though. Nice suits.

 MIRABELLE
 I feel dirty, you know? I let him
 do things to me—I'm so lame. Think
 I'll ever find a guy who isn't . . .

 JENNY
 Twisted?

Instead of 11 lines from Mirabelle, we get only five in this scene. Jenny gets one extra line to make it a back and forth conversation instead of just a speech from Mirabelle, but overall, the second version is way shorter.

But the crucial point is this—which of those two scripts do you want to keep reading? In the first version, I'm less interested in what Mirabelle's

going to say next—feeling she wore the subject out in her speech. But in the second version, I want to hear what Mirabelle says to Jenny because I'm not sure how she'll respond. And I feel like Jenny has a personality too, and having her bounce her dialogue off of Mirabelle's makes me more committed to seeing how the scene plays out.

Just remember that the four-line rule isn't there to stop you from having a character have a long speech if it's necessary, it's just usually not necessary. And if you keep it in mind as you're writing your dialogue, you'll have a better chance of those scenes moving along at a rapid clip.

- *Use Parentheticals Only If You Must*

Parentheticals are the short lines after a character's name that tell us how the character is looking or speaking at the moment. Here are some examples:

```
              SANDRA
          (harshly)
      Don't even start.

              HAMID
          (smiles)
      Don't be like that sweetheart.

              SANDRA
          (eyes rolling)
      Sweetheart? Seriously?

              HAMID
          (pleading)
      You have to let me explain.
```

Here's the problem with parentheticals—they unnecessarily slow the reader down. I say 'unnecessarily' because we often don't need them. If the line is written well, we'll get the right tone it's being said with. When Sandra says, "Don't even start" in the conversation above, we can pretty much figure out that she's saying it in a harsh manner just by the tenor of the line. And when Hamid responds with "Don't be like that sweetheart," we can almost feel his conciliatory smile—so we don't need the line TELLING us he's smiling! The same is true of almost all parentheticals—they slow down our reading of the dialogue and we'd get the tone of the line without them.

The one exception to the get-rid-of-parentheticals rule is irony or sarcasm. If you have a conversation where a character says, "I love you more than life itself" and it's being said sarcastically, that's the time for a parenthetical

because you need to make it clear to the reader that the character doesn't mean that at all and, in fact, means just the opposite.

Parentheticals are a great tool—just use that tool sparingly.

- *Have Characters Speak Using Contractions*

It's a small thing, really, but sometimes when writers write dialogue, they tend to be a little too formal. It's as if we think by committing words to paper, they have to be cleaned up or something. But the best dialogue sounds natural. And most people wouldn't say, "It is raining outside," they'd say, "It's raining outside" because it seems more ordinary. While this *is* a pretty small point, if your characters routinely *don't* use contractions, your entire script will sound more formal. And that formality can seem quite stiff and make your dialogue less accessible to the reader/viewer. Certainly characters might speak in contractions to their friends and speak more formally to their parents, for example. And if you're doing a script about English royalty, then you might *want* that sort of formality so your characters would speak without contractions. The same can be true of period pieces—people in other times often spoke more formally than we do today and avoided contractions.

The key is to understand the world in which your characters live. And if they're living today, they would be using contractions most of the time.

- *Don't Interrupt a Conversation with Too Much Narrative*

As I've already mentioned, there's this thing readers call white space—and it's of paramount importance to script readers. Think of a script page as a canvas—on that canvas, you have two things, typing and blank (white) space. The more white space you have on the page, the less a reader has to read. So the more white space you have on the page, the quicker 'read' your script is for the reader. It's also indicative of your pacing—if you have lots of white space, there's a better chance your pacing is on the quick side. It's kind of funny when you think about it, a script is all about the words you put on the page but the fewer the words—whether dialogue or narrative—the faster your script will move along. So readers look at a script, see lots of white space, and feel that it will be a faster read for them. To you, that means that you want to limit not only the dialogue but the narrative as well—and you especially don't want to interrupt the dialogue with too much narrative. Let's say you have an argument between a husband and wife—let's look at how that could go:

```
INT. LIVING ROOM—NIGHT

MARGO (28) sits on the sofa, her head hanging,
and looks away from an angry JONATHAN (35).
```

JONATHAN
Hector? You had to go back to that . . . that . . .

Jonathan walks over to the fireplace.

MARGO
It's not what you think.

She looks up at him.

JONATHAN
Don't lie to me.

He looks at their wedding photo on the fireplace.

MARGO
Hector just . . . well, he needs me but not that way.

He gives her a 'yeah right' smile.

JONATHAN
Just friends, that the story?

Margo fingers her wedding ring.

MARGO
Can lovers ever really be friends?

Jonathan arches his eyebrows.

JONATHAN
We're not friends?

She almost smiles.

MARGO
We're married.

He lights a cigarette and shakes his head.

JONATHAN
How do you do that? Almost make me forget that you had lunch with your ex.

She walks over to him and puts her head on his shoulder.

MARGO
It's OK—we didn't have dessert.

As you can see, every line in that conversation is broken up by a line of narrative. The lines of narrative tell us what the character is doing while the other talks. Those lines are helpful to the actors—they provide a sort of blocking that the director could follow for the scene. You might think they're a good thing.

But they're not.

They break up the dialogue in that scene—so we lose the flow of the scene and instead our picture of what's happening between these two people is broken up by bits of what would be called, in the theatre, stage business.

The fact is, if you've got dialogue that's strong enough, that dialogue will tell the reader what the demeanor of the character is—the narrative won't be needed.

Let's look at the same scene without the narrative:

```
INT. LIVING ROOM—NIGHT

MARGO (28) sits on the sofa and looks away from
an angry JONATHAN (35) who stands by the fireplace.

                    JONATHAN
          Hector? You had to go back to
          that . . . that . . .

                    MARGO
          It's not what you think.

                    JONATHAN
          Don't lie to me.

                    MARGO
          Hector just . . . well, he needs me but
          not that way.

                    JONATHAN
          Just friends, that the story?

                    MARGO
          Can lovers ever really be friends?

                    JONATHAN
          We're not friends?

                    MARGO
          We're married.
```

```
                    JONATHAN
            How do you do that? Almost
            make me forget that you had
            lunch with your ex.

   She walks over to him and puts her head on his
   shoulder.

                    MARGO
            It's OK—we didn't have dessert.
```

See the difference? The back and forth of the conversation, the ease of it, stands out in the second version because it's not broken up with narrative. And do we really miss the narrative? Is there anything important in that narrative that isn't communicated in the dialogue? Can't you just *hear* the tone of voice these characters speak in? And when there's a line of narrative before the last line, it stands out and adds to the scene—provides a moment of tension as we wonder what she's going to say as she walks over to him.

The fact is, all of the narrative in that scene might be done by the actors in the film, either of their own accord or because the director directed them to do so. But it's the *lines of dialogue* that inspire those expressions and movements.

And a side benefit of losing all that narrative is—ta da!—a page full of white space to keep all the readers happy!

Subtext: Saying What's Not Being Said Says It All

Subtext refers to what's being said below the surface by a character. A similar term becoming more popular these days is metamessage. Just as subtext refers to the meaning underneath the stated text, metamessage says there's a stated message in our communication and then there's the real message underneath that stated message.

Here's how subtext works in our everyday life. Let's say someone asks you what you think of your new boss. You might say, "He seems OK," but you might really *want* to say, "I have no faith this guy is any better than the last one," but saying that isn't a possibility—what if that got back to the new boss? Your job could be history. So you say something noncommittal and hide your real feelings. Think about it. Take a day—one day—and see how many times you resort to not saying what you really think.

Take a look at the following scene and see if you can tell what's wrong with it:

```
   SHEFALI (19), a dark beauty, pushes away her
   uneaten quiche and looks at MARCO (21), who
   wolfs down his food.
```

 SHEFALI
 I'm just miserable.

 MARCO
 Hair dye not the right shade?

 SHEFALI
 Hair dye? You think I'm that
 shallow? You know, you're the
 shallow one for thinking that.

 MARCO
 Typical. Lashing out at me
 instead of facing the truth
 about yourself.

 SHEFALI
 And what truth is that?

 MARCO
 That you're a spoiled little
 rich girl who expects the world
 to solve her problems.

The characters use contractions, they don't speak in long speeches, the narrative isn't dividing up the flow of the dialogue—what's the problem?

The problem is, everything each of these two say to the other is way too on-the-nose. They're saying what they're really thinking. There's zero subtext.

So wait a sec, you could respond, what's wrong with that? What's wrong with saying what you're thinking? Why *wouldn't* we expect people to say what they think? Well, psychologists throughout time have grappled with that one. The problem is, most of us find it difficult to come right out with it—whether it's saying "I love you" or "I hate you" or "That dress makes your butt look huge" or even something as simple as "I'll see you later." When I say, "I'll see you later," it could mean "I never plan on seeing you again" or "Please tell me you'll *let* me see you later" or "I can't wait to see you later but I'm afraid to tell you that because you'll think I'm super needy."

What this says for you as a writer is that you need to understand your characters on the very deepest level. You need them to be human—to be ruled by their emotions, and therefore not always say exactly what they think or feel. Keeping that in mind, let's do a rewrite of that scene between Shefali and Marco:

```
          SHEFALI (19), a dark beauty, pushes away her
          uneaten quiche and looks at MARCO (21), who
          wolfs down his food.

                          SHEFALI
                Not having the greatest day.

                          MARCO
                But your hair looks great.

                          SHEFALI
                Sometimes you . . .

                          MARCO
                What? What'd I say?

                          SHEFALI
                I thought you'd be more
                understanding.

                          MARCO
                So what do you want me to say?
                How can I make your day sparkle?
```

Compare each line in this scene to the first one between Shefali and Marco. Notice how every single line in the second version covers up what each of them really wants to say. So instead of saying what they feel, both Marco and Shefali absolutely DON'T say what they feel but cover their thoughts and feelings. Look carefully at the first exchange—at the words that reflected their true feelings—and you'll notice that if the people said those lines, the conversation would be over, they'd so alienate each other that that would be it. So Marco and Shefali must both want their friendship to continue or they *would* say what they're thinking.

How many times does someone ask you if you like their new dress/car/boyfriend and the truth is you don't. You think the dress is ugly, the car is ostentatious, and the boyfriend is an idiot. Do you say that? Of course you don't. Doing so could harm the friendship, so you cloak your real opinions in platitudes or you outright lie.

People don't always fail to say what they really think and feel, but there's no doubt that subtext is a staple of our lives. The meaning of what we say—much of the time—is below the surface of the language symbols we speak with. Write that way and your dialogue will be as real as it can be.

Dialogue. It should be easy—after all, we say things all day long, don't we? Our lives are filled with our own personal dialogue—it comes naturally. And that's what you want to aim for in your writing—dialogue that's natural, easy and *real*.

Chapter 7 Exercises

1. Transcribe an exchange you hear somewhere out in the world between two people you don't know. What are the differences in the way each person speaks?
2. Imagine the conversation from exercise one continuing and try and write it in the same voices these people used.
3. Write down an argument you've had with someone in the last week, putting it on paper as accurately as you can remember it. Then rewrite that argument as you wish it had gone. After that, rewrite the argument as the person you're arguing with probably wishes it had gone. Note the differences? What do they tell you about each of your personalities?
4. Watch a film you think has poor dialogue and choose a scene to rewrite—can you turn it around and make that dialogue effective?
5. Do some improvisation with a friend. Create a scenario with two characters and act out the part of one of those characters. Note how, when forced, you just speak—as quickly as you would if you and your co-improvisation friend were talking normally. Use the improvisation technique to work on dialogue in any number of scenes you write—it can help you go for more natural-sounding speech.

8

WRITING THE ADAPTATION

Most beginning screenwriters think they'll break into the business with an original script they write—called a 'spec' in the business, a script you write on speculation. But the truth is, that spec screenplay will probably never sell. It would have to be the perfect genre for today's market, and as you're not a proven commodity, it would have to be so fantastic that there would be no doubt it could be a successful film—and, alas, there's almost always doubt.

That original spec script can, however, be a great sample to show people your work. Studios buy books, short stories, comic books, etc., and they need to find just the right writer for each one to bring it successfully to the screen. If you have a spec script that they like, it could be in the same genre as the book they've just bought and they could bring you in to talk about having you adapt that book. Screenwriter Michael Arndt, who won the Academy Award for his script for *Little Miss Sunshine* [2006], was not a well-known writer before that script. He next wrote *Toy Story 3* [2010] but he got that writing assignment because the producers liked his script for *Little Miss Sunshine*. So having that script for *Little Miss Sunshine* told the *Toy Story* producers that Arndt had the qualities in his writing they were looking for in a writer for *Toy Story*. When Arndt was hired, *Little Miss Sunshine* hadn't even been made yet—they'd only read the script. That's a great example of how having a good writing sample can lead to a writing assignment.

So as much as you enjoy writing your own ideas, you need to remain open to writing ideas generated by studios and producers. For that reason, you should take a stab at writing an adaptation or two, so that you know what's involved. If all you've ever done is original specs, the nuances of adapting someone else's story rather than writing your own from scratch could be lost

on you. So that means you've lost your shot if you don't know how to adapt material from other sources.

This is key. Since more adaptations are made every year than originals, you need to be prepared to write a script adapted from other material, anything from a newspaper article to a video game.

Adaptations, especially ones from books or longer source material, are tougher than originals. You might think that shouldn't be—after all, if you have a book that's laid out the story, it should be less work than if you have to come up with the story yourself, right? But it's just the opposite. If I'm writing an original, I can do anything I want, go in any direction my thoughts take me. But with an adaptation, I'm bound to a story that wasn't mine and I have to make choices that may be really difficult. It's a big job to take, say, a 500-page novel and turn it into a 100-page screenplay. And it's a job you should only undertake *after* you've written several original scripts. You need to understand how to write a screenplay *before* you tackle an adaptation.

But once you're ready to tackle an adaptation, there are a few things to think about. Because being able to show a studio/producer that you *can* do an adaptation might be a nice thing to add to your screenwriting portfolio to draw attention to the fact that you understand what's involved in writing that adaptation. But before we get to that, let's look at a few other interesting facts about adaptations.

Why Adaptations Are Favored Over Originals in the Industry Today

It's important to realize that the people who make movies aren't just in the business because they love movies—they're in *business*, and they expect to make a profit from running their business. It would be nice if studios and producers could just think about making movies that were important to make or movies they particularly loved, but they are driven to make movies that the public will like. Of course, they don't always *know* what the public will like—and that's one of the reasons adaptations are often preferred.

Think about it, if I'm a studio and I'm going to risk millions and millions of dollars to make a film, wouldn't I want to minimize my risk? If I had the chance to make a film from a proven commodity—like a successful novel or comic book—wouldn't I be more inclined to risk my millions? I'd know there's an audience for this story—an audience who bought that book, an audience who reads that comic strip—and knowing that audience already liked the story, I might feel my movie would have a better chance at making a profit. "It's all about getting the butts in the seats," a studio executive friend told me. And from a business perspective, that's absolutely the case. Those of us who love movies—and write them—might romanticize the idea of bringing a story to life, but for the people who make the movies, it's all

about producing a product that will bring the people into the theatre—that will get the butts in the seats.

Understandably, studios are constantly on the lookout for proven commodities that could translate well into film. These stories can come from a myriad of sources—current events, newspaper stories, video games, novels, nonfiction books, television shows, board games—truly, the list is almost endless because whatever the medium, *someone* can probably figure out a way to make it into a movie. But how does that work? How does, say, a news story evolve into a movie?

As I'm writing this chapter in late 2015, the Paris attacks have just happened. Most of us look at them and see the horror, the human loss, the pointless nature of these attacks. My husband and I own a house in France, we have many friends there, and my husband knew one of the men killed. So we were particularly moved by this horrible story. But if you're a studio exec? Sure, you might have just as many normal, human feelings about the event, but the business side of you is imagining what sorts of films people will make about this event. You watch the news coverage, you hear of an interesting story that happened that night—either a victim's story or a hero who helped save someone's life that night—and you imagine which of those myriad of stories might make a good film. So you send someone to Paris—pronto—to talk to people there, to negotiate getting the rights to a story or two that has caught your fancy (i.e., a story you think people would want to watch) and you empower your emissary to make deals. I guarantee you, within 48 hours of this tragedy, there were people on the plane from Los Angeles going to France to secure rights to particular stories of interest. I could be wrong about that—after all, when an event is SO horrific, the studios don't kick in that quickly—but it wouldn't surprise me if that was the case.

I was in New York City when the twin towers came down. Like everyone else, I was numb from the sheer terror of that event and all it implied about how our world was changing. I remember thinking at the time that I had to write better stories, more human stories that really *said* something about humanity. I told my agent that I wanted to write about that day—and she quietly told me it wasn't a good idea, that I could be seen as exploiting the tragedy to write such a story. That was the last thing I wanted to do, so I put it out of my mind and instead took a writing assignment for a small, family film—it was just the kind of life-affirming story that I told myself I should be writing. Nothing ever happened with the family film and, looking back, I wish I'd never accepted that writing assignment and had instead followed my inner writer and worked on a story about 9/11. I was moved to do that, but didn't because I didn't want to be seen as disrespectful. But it was in my gut, so I should have written something right then. But my agent was right—VERY little was written about that day in any kind of fictional way for quite some time. I guess it's our way of paying respect to those who died

in the tragedy. So there are some things that can be seen as just too horrific to write about until some time has passed—so factor that into your writing choices.

Another way films based on current events come about is through magazine and newspaper articles. A reporter does an investigation of something in their hometown and writes an article about it for their newspaper—that's their job, that's what they do. In a lifetime of doing that job, though, there may be just a handful of stories that are movie-worthy.

What makes a story movie-worthy? I think it has to do with universality. A story has to have broad appeal, it has to be a story that we all want to know about. It has to stem from an event that most people care about and at the center of it, there has to be a person or two who is either relatable or interesting. It can certainly be an event that occurred around the world but that, no matter where we live, we'd be interested to know more about it. It also, generally, needs to be timely.

That last one bothers me—why does a story have to be timely? Why can't an audience be shown an event from 100 years ago and learn how important the event was? Won't they then see the story? Won't the film then make money? Well, it's possible. It certainly does happen. But, alas, it's rare.

Take a film like *L.A. Confidential* [1997]. This is a film—fictional, sure—but it's based on the reality of corruption in the Los Angeles police department in the 30s and 40s. And it was almost impossible to get made. The director, Curtis Hanson, who already had a good track record, took his storyboards all around L.A. trying to convince people to fund it. Everyone turned him down. But his persistence finally paid off and the film got financed. And it's a fantastic film—on absolutely every level. But the industry didn't think of it as a success when it came out because it spent more money than it made back in ticket sales. Great reviews? You bet. But it didn't make money for its backers... that is, until it was nominated for the Academy Award for Best Picture—THEN it went into profit. Great, right? An example for similar films, a reason to make other good stories that might not seem profitable on first glance, right?

Wrong. And the reason is all about the money. It wasn't profitable *until* it got the Oscar nomination, and as most studio execs will point out, only a few films a year win that honor—what if something else had gotten nominated in its place that year? The studio would be stuck with a film that was a negative on their bottom line. And if your studio just makes great films that garner fantastic reviews but don't make money, your studio will be out of business. So it's not just crass commercialism that causes the studios to be so mercenary—it's that they need to preserve their studio and all the jobs it provides, and doing so can then let them make projects that they aren't so sure will make money. So, for the most part, studios aim to make films that are sure things. They will then go to any lengths to make the film successful.

That's true of everyone from the writer to the producers to the actors to the people who write the PR.

Figure 8.1 Best picture winner *Spotlight* [2015]

The 2015 film *Spotlight* tells the story of how the *Boston Globe* broke the story of the molestation scandal and cover-up within the Catholic Church's Boston archdiocese. Breaking this story caused international waves for the Catholic Church. The studio bought the rights to the stories and then went to work. A couple of the *Globe* reporters talked about how friendly the actors on the film were who were portraying them in the movie—they took them to dinner, hung out, really became friends. Then, inevitably, after filming, the actors left Boston and went back to their lives. But the reporters had great memories of their time with the actors—and then they saw the finished film. The actors walked like them, talked like them, dressed like them—the actors had used those dinners and hanging out with the reporters to be able to be more like the reporters and thus enhance their characterizations on film! Welcome to show biz. The point is that the filmmakers will do whatever it takes to make a film that succeeds at the box office. In the best of worlds, that means studying the event and trying to bring it to life. And that's a good thing—kudos to actors who care enough to talk to and get to understand the people they're portraying. But often, much will change from the real event by the time it gets to the screen, and that provides a bit of a dilemma for screenwriters. *Spotlight* stuck to the real story—and like *All the President's Men* [1976], it makes us see the incredible importance of investigative journalism—they didn't add a love story or fudge the truth, they told the real story, without embellishments and they did it *so* well.

Figure 8.2 *The Social Network* [2010] doesn't give us the real Zuckerberg

Thinking about what filmmakers will do to make a successful movie, let's take a look at the film that won the Academy Award for screenwriter Aaron Sorkin. The film is *The Social Network* [2010] and it told the story of the founding of Facebook and the litigation that came after between those involved—but it's also the story of Mark Zuckerberg and his personal life. And as Sorkin structured the film, it's the personal story that *leads* to Zuckerberg dreaming up the concept of Facebook. But, in reality, that's not true. You're going, "What? How could they put it on film if it wasn't true?" Ah, the naiveté. Reminds me of my mom (a very trusting Iowa woman) who was an avid reader of the tabloids and when I tried to tell her they were pretty much fabricated—that the three-headed baby from outer space didn't actually exist—she just brushed away my cynicism. "They couldn't put it in the paper if it wasn't true!" she replied with absolute certainty. I could do nothing to sway her from this point of view. She believed that what she read was somehow vetted by the truth-police or something and that if it wasn't true, the paper would get in trouble if they printed it. As we know, with the very rare exception, people who have been misrepresented by the tabloids don't sue, so the outlandish stories continue, and there IS no truth-police who comes down on tabloids for making things up. In this respect, film is like the tabloids—it's a business of stories, and even when those stories are based on fact, they're not always true.

Confused? Well, let's examine *The Social Network* a little more closely. When it opened the New York Film Festival a week prior to its October 2010

nationwide opening, it did so with, per Reuters and others, "controversy." That controversy stemmed from the hype of the moviemakers—whose publicity purported that the film told the "true story of the birth of the website." Based on the book *The Accidental Billionaires*, a book itself criticized for being a bit light in the fact area, the wonderfully entertaining film might have overstated its veracity. In that Reuters article [Sept. 27, 2010], director David Fincher "declined to say if he views the movie as a true story or a work of fiction, saying only that fact-based movies have to take the perspective of certain characters." And as producer Scott Rudin said to the *New York Times* [August 20, 2010] prior to the movie's release, "There is no such thing as *the* truth." His point was that there are always different points of view in any story. In that same *Times* article, Zuckerberg stated his point of view very succinctly: "Honestly, I wish that when people try to do journalism or write stuff about Facebook that they at least try to get it right.... The movie is fiction." Four years later, in an article in *The Independent* [November 15, 2014], Zuckerberg was quoted as saying that Sorkin "made up a bunch of stuff that I found kind of hurtful." The most important hurtful fact would have to be what kicks off the film.

If you've seen *The Social Network*, you know it begins with the story of how Zuckerberg got the idea—the film says a girl broke up with him and he was so pissed at her that he created it as almost a kind of revenge. Additionally, we hear right from that initial break-up conversation that he's obsessed with getting into final clubs. The premise of the film is that those two elements of his character—both having to do with a need for acceptance—are what drove him to create Facebook.

Now, if you don't know this, I'm sorry to burst your bubble, but neither of those things appears to be true. Most importantly, Zuckerberg was dating his now wife, Patricia Chan, *before* he founded Facebook! The girl at the beginning of the film who supposedly caused him to create Facebook? Total fabrication. She begins and ends the film ... but she's fiction. And his obsession with final clubs, which is raised in that breakup conversation and is a thread through the entire film? Well, even the book the film is based on, *The Accidental Billionaires*, doesn't mention final clubs in relation to Zuckerberg.

Sorkin countered some of this criticism by saying, "It's not a biopic, it's the story of a lawsuit." But if it was just the story of a lawsuit, why begin with the premise that Facebook was created out of the main character's break-up and obsession with final clubs? My opinion—it's easier. Think about it—where do creative ideas come from and how can you interest an audience in the birth of those creative ideas? Facebook came out of Mark Zuckerberg's genius as near as I can tell—and that's a story I'd like to have been told. What *actually* led him to his 'aha!' moment if it wasn't the breakup with the girl? Couldn't the movie be about the lawsuit and *also* get the personal facts about Zuckerberg's character right? Or, if you choose to not portray Zuckerberg as

he actually was, why not just change the name and call the film what it really is—fiction? Well, once again, it's all about money. A fictional film about a fictional online service wouldn't have the built-in hook that Facebook does.

The multi-billionaire Zuckerberg ended up not suing—and even got into the spirit of fun with the film by appearing on *Saturday Night Live*. But years later? He's still hurt by what the film said about him that was simply not true. And I don't blame him because, forever after, most people will believe that this is how Facebook was founded—and think about it . . . if you'd created Facebook, wouldn't you want the *real* story told, not the Hollywood version?

What does this say for the screenwriter who is adapting a true story? I fear it says, "Aw, do what you want—anything for the story—and you, too, might win an Academy Award." Yeah, that could be true, but it's not *right*. Don't we have to have some integrity? Shouldn't we *want* to get to the bottom of the real story? And if we have a better story, well why not then just call it fiction and not try and pass it off as truth?

Understand, when adapting a true story, you will make changes to what happened—you might create a character, for example, who's a compilation of several characters in a person's life just to save time. Some of those things are totally understandable and totally necessary—but in my view, without the permission of the people you're writing about, you shouldn't create their lives out of thin air just to suit your story.

Permission is the key here. Getting permissions in doing true stories or biopics can be very important. Writers/studios/producers/production companies buy the 'life rights' of a person to portray and tell that person's story on film. When a person signs a document allowing a film to be made using their life and likeness, that document also says the producers can do anything they want in the person's portrayal onscreen to enhance the story—it doesn't have to be true. The person signing this document is paid to allow his/her life to be used. And they agree that the portrayal doesn't have to be accurate. So if that's you, they could make you into a child molester if they wanted and you couldn't do a thing about it because you've been paid for your rights and have agreed that they can do whatever they'd like in portraying you on screen. Needless to say, in the case of *The Social Network*, Mark Zuckerberg signed no such agreement. There's certainly the idea that if you're a public figure, you're fair game—that no one need get your rights. But if the public figure decides to sue, you as the writer could find out quickly enough that maybe you should have gotten that permission after all!

Spotlight, too, is based on a current event—the breaking of the story of child molestation by Catholic priests and the cover-up by the church of those events. It's a gripping, moving story by Josh Singer and Tom McCarthy. I challenge you to watch this film and not be surprised when it's over. The pacing is so incredible that the film just rockets along until you're almost breathless at the end. The film lasts over 2 hours—unusual in today's film

world—but it feels like it's maybe an hour, it moves that fast. I like to think of what the writers *could* have done—they could have taken the private life of one of the reporters involved in the story and made things up to enhance the story, but they never did. Almost like a true reporter, the film told the story of the reporters and their attempts to uncover the story and THAT was the film. It didn't need fabricated personal traumas to make it work—it told the real story, and did it with absolute finesse. It kept its concentration where it belonged—on this gut-wrenching true story. I think when you lose yourself in a story, in the reality of that story, you can't help but produce something worthy. Both *The Social Network* and *Spotlight* are fine films, both deal with real things that happened to real people—but, for my money, it's *Spotlight* that's the true work of genius because it shines that spotlight on the actual story, no frills needed, and certainly no fabrication.

But what about fabrication when the author does give you the right to do so? In the case of *The Orchid Thief*, the author of this nonfiction book, Susan Orlean, was paid for the right to use her book as the basis for a film. Her book was made into the well-reviewed film *Adaptation* [2002], and its writer, Charlie Kaufman, was nominated for an Academy Award and won the BAFTA for his screenplay. If you've read the book *The Orchid Thief*, good for you. But for those of you who haven't, the book began when Orlean got a writing assignment from *The New Yorker* to go down to Florida and cover the trial of a guy, John Laroche, who was arrested for poaching orchids on protected land. He'd been hired by the Seminoles—they have the right to be on the protected land—but was still being prosecuted for poaching. I'd guess *The New Yorker* saw this as a quirky little story that might be interesting. So Orlean went to Florida and her little article eventually grew into a book that told the story of John Laroche. In the course of telling his story, Orlean came to understand the depth of passion he felt for orchids and she began to deal with the lack of passion in her own life. So the book, though about Laroche, has Orlean herself as a character as well because some of her personal struggles were part of the book.

I was at CAA when Kaufman got the writing assignment for *The Orchid Thief*—I'd been interested in the book myself—and one of the agents told me that Kaufman was having trouble with the adaptation. I remember wondering if he'd give up and the job would then be open to other writers—because I loved the book. Instead, of course, in Kaufman's genius, he put himself into the story and created a completely different story than the one Orlean wrote—but as she was the author of the book, she became a character in his story. In fact, instead of Laroche being the main character, Kaufman and Orlean became the focal point of the film, with Laroche in a strong supporting role—and Orlean was beautifully portrayed by Meryl Streep. *Adaptation* became the story of a screenwriter (Kaufman) trying to adapt this book and not being able to do it—it became the story of a screenwriter's life, Kaufman's

life (or the Kaufman he created as a character in the film). I loved *Adaptation* but it wasn't *The Orchid Thief*, and I wondered about that choice—for the screenwriter to portray his own angst rather than adapt the actual book. But, frankly, that IS film. The screenwriter brings a different dimension to a novel or play or video game or whatever they're adapting and tells the creative story they've concocted. And that's OK—because the author, as in the case with Orlean, has been paid and has thus allowed the film's screenwriter to take any liberties he or she would like. When Meryl Streep won the Golden Globe for her portrayal of Susan Orlean, she apologized to Orlean "for the second half" of the film. She later clarified in an interview that she was apologizing because they'd made the real-life, quite normal Orlean into a sex-crazed drug addict in the film. When interviewed about this, Orlean just shrugged it off—she'd been paid for her book and she knew when she sold the book she was selling her right to have any say in how she was portrayed. No problem.

Once you understand all that's involved in an adaptation, it can seem daunting. The ethical dimension alone is a quandary, isn't it? I mean, could you live with the *New York Times* vilifying you for changing a fact of history just to make your script work? But when writing this kind of screenplay, there are some things beyond the ethical dilemma that you may want to know more about—the first might be where to go to *find* a story to adapt. To that end, let's look both at stories in the public domain—stories that anyone can tell because no one has the rights to them—and published stories that will require you to get the rights from their authors.

Public Domain: Stories Free for the Telling

There are two categories of public domain works—those published before 1977 and those published after.

If a work was published before 1977, the initial copyright period was 28 years, after which the copyright could be renewed for an additional 67 years. Such a work would then fall into public domain one year later. So for a work published in 1920, you just add it up: 1920 + 28 + 67 + 1 = 2016. So that means that any book published in 1920 or before is in the public domain and you could publish it and sell it if you wanted—and you can also use it as the basis for a screenplay. No fees would need to be paid to the survivors of the author, to the original publisher or copyright holder—the work is fair game and there are no restrictions on its use.

If a work is published after 1977, it won't fall into the public domain until 70 years after its author's death. So a novel published in 1980 that was written by a 30-year-old writer who will live until she's 90 won't be in the public domain until 2111 (1980 + 60 + 70 + 1). And for corporate works, anonymous works, or works for hire (many screenplays are works for hire, for example), the period before those works fall into the public domain can be

even longer because it's 95 years from the date of publication OR 120 years from the date of creation, whichever expires first.

Unfortunately, you have to understand public domain law in different countries if you want to be sure your script could be produced and shown around the world. Let's take the author Agatha Christie, for example. Since she died in 1976, any works by her that were published in countries where the copyright term is the author's life plus 30 years or less would be in public domain. Additionally, some countries that may have terms longer than 30 years *may apply* the author's home country rule, thus making it in public domain. So in the U.S., where the rule is 70 years after the author's death, if we apply the English rule of 30 years, some of Christie's works are now in public domain.

This is very complicated—and if you have the least doubt, be sure to consult an expert in copyright before you tackle that adaptation. Oftentimes, a local college or university will have such an expert in their law school or library who can help you make sure the work you want to adapt is fair game. It's super important to understand the public domain laws. You don't want to make the mistake of choosing a work to adapt, and perhaps working for years to do additional research and write and rewrite that script, and then find out it's not yours to sell without the original author's permission.

There are many websites that will lead you to public domain works—the biggest problem could simply be choosing! Do you go with a classic like a Shakespeare play or a Jane Austen novel or do you search for something more obscure? It's an important choice because you're going to be living with this story a long time as you work on adapting it into a screenplay.

Want to start with something simple? How about a fairy tale? Most classic fairy tales are certainly old enough to be adapted into screenplays. *The Three Little Pigs, Hansel and Gretel, Rumpelstiltskin, The Little Mermaid, The Snow Queen,* and on and on and on. The nice thing about fairy tales is that you can use one as the basis for your story but your imagination can take the story in so many different directions.

Little Red Riding Hood is a classic fairy tale—one every kid knows. If you go to www.imdb.com (a great source for movie cast/crew/production info) and search for "Little Red Riding Hood," you'll see over 100 adaptations of the fairy tale—beginning in 1913! Adapters have played it for fun in versions adapted for kids and even played it as horror in versions for adults. Think about the possibilities.

What about *Little Red Riding Hood in Space*? Here are three possibilities:

(1) You could give her a nickname of 'Red' and have the wolf be a hairy guy from another planet pursuing her while she tries to get home to be with her dying grandmother.

(2) You could put her on a spaceship crew as the newest recruit on the weapons team under a captain, an older woman who—unbeknownst to the crew—is actually her grandmother. She's pursued by an attractive guy—everyone else thinks he's a womanizer, a 'wolf' when it comes to women, but she thinks she really has something with the guy. But when she catches him watching her put in her password to the weapons array, she becomes suspicious and uncovers his plan to kill the captain (her grandmother) and take over the ship.

(3) You could have a guy who's stuck with a ship that's red—he's part of a group of recruits, each with a small spaceship, and in their training exercises, the recruit who comes last in each week's test has to take the 'red' ship—on which someone has painted a comic book-type version of Little Red Riding Hood—as a kind of punishment. When war breaks out in the galaxy because the leader of their home planet, Gram, has been taken hostage, he has to head out on the mission with everyone else and he's stuck with the red ship. The story becomes his attempt to get Gram back.

It's interesting to look at the possibilities for something as simple as *Little Red Riding Hood*. One of the things it forces you to do is break the simple fairy tale we all know down into its essential components. This then allows you to formulate a story in a completely different setting—in a multitude of genres—that uses those components. Why not try and come up with three ideas for *Little Red Riding Hood* as a western? Then three more ideas for the fairy tale as a thriller, then as a romantic comedy, then as a slasher comedy, then as gothic horror, etc. It's fun to see what you can come up with—and it's a great way to hone your storytelling sense.

Published Stories: Contacting Authors and Acquiring Options

If the story you want to write is not in public domain, then you need to contact the author or the author's representative to get the rights to the story. This MUST be done before you tackle your adaptation. It would be a mistake to think that you could take a novel that you love, write a screenplay based on it, and then use that screenplay to convince the author to give you the rights, or find a buyer for your screenplay to approach the author to obtain the rights. First, it will never work because most novelists will find fault with ANY adaptation because you'll leave things out or change them around and you might unwittingly leave out their favorite scene or something. Second, it won't work because if you approach a producer with your script and don't already have the rights to the novel, the producer won't even agree to read it.

Bottom line? You need to ensure that the work you do on the novel you want to adapt has a chance of getting read and bought. That means properly securing the rights to the novel. While this can be difficult, it might be easier than you think.

Let's say you read a novel that you like. You can get in touch with the publisher of the novel to ask about contacting the writer to purchase the rights or you can go to a website like www.querytracker.net to get an alphabetical list of authors and their agents. Then you can go to the website for that agency and see if there's a system for emailing each agent—email would be the quickest way to be sure your query gets to the agent. Once you've found the agent to contact, you need to communicate who you are, why you'd like to adapt the novel, why you think your adaptation will be successful, and how the author (and agent!) will make a sale because of your hard work.

Generally speaking, you have to pay for an option. The going rate for books that aren't just out or weren't best sellers is about $5,000 or under for a 1–2 year option. If the option is for a year, you want your contract to allow you to renew for a second year at an agreed upon fee. However, if the novel is older, you might try and ask for a 'free' option. You can certainly make the argument that you're not a company with a development fund but you're willing to put in a year of hard work writing and trying to sell your adaptation. If you find someone interested in buying your screenplay, THAT producer/studio will negotiate with the novelist for the purchase of his/her book. Obviously, the producer/studio has to be head over heels about your screenplay or they won't be spending a lot of money to buy this novel! They have to make sure your screenplay will get made. But at that point, paying the novelist isn't your problem—it's hopefully something the three sets of lawyers doing your deal and the novelist's deal and the producer's deal can work out.

As you can see, a lot has to happen for you to be able to get the right to write the script from that novel AND for the script you write to get bought AND THEN for that script to get made. And yet, every year, more adaptations are made than original scripts. Obviously, any way a film gets made is a pretty long haul.

Remember that there are lots of kinds of properties to option. From video games to poems to plays to newspaper articles to short stories, there are lots of stories out there waiting to be adapted for the screen. And some of their authors will be delighted to hear from you—just the thought that someone wants to write a screenplay based on their work can be very exciting for them. I know a college professor who published a short story and got a call from a Hollywood producer who was in love with the story and wanted to option it. The producer paid him a $5,000 fee for a one-year option on the condition he could renew for a subsequent year for another $5,000, if he chose to do so. When the first year was up, the producer exercised his option and renewed

the contract for another year—so the professor got another $5,000 for his short story. And guess what? The producer renewed that option for 20 years straight! This means that the producer really believed in the story, thought he could get it made . . . but wasn't successful. But for the professor who wrote the story? Well, he made $100,000 over the 20 years! That's a great story to tell someone when you're trying to option their work. After all, their novel or short story or play is sitting on the shelf—studios are not fighting over the rights to try and get it made into a film. It takes a screenwriter to *show* those studios and producers that the property could be an amazing film.

One of the classic stories of someone with virtually no writing experience optioning a property that would lead to an Academy Award nomination is the story of *Capote* [2005]. Dan Futterman, the writer of the script, was/is an actor. You probably saw him in any of a number of TV series in the 90s and after.

Futterman decided, in his mid-30s, that he'd like to try and write a screenplay, and as he began to think about what he wanted to write, he was drawn to a biography of Truman Capote by Gerald Clarke. Clarke had been a magazine writer for most of his career and was a senior writer at *Time* for many years. His biography of Capote, published in 1988, was well received and he'd write another on Judy Garland, published in 2000. Futterman tracked him down and eventually went to see Clarke at his home on Long Island. Now imagine this—you're an actor, not super famous, not doing leading man roles, but you've made your living as a TV actor. You show up at the home of an accomplished writer, who is 30 years your senior, and try to convince him to give you the chance to adapt his biography of Capote into a screenplay. Have you written anything before? No. But you understand scripts, as an actor, and you have this idea that a particular portion of Capote's life would make for a good film. The only thing Futterman had going for him on that fateful day was his passion for the story. And he left Clarke's house with an option that he paid very little for. Why, you might ask, would Clarke agree to give Futterman that option? Certainly, Futterman's belief in the book and ideas on how to adapt it helped, but another way to look at it is . . . well, why not? The biography is over 10 years old at the point Futterman is talking with him, and if a studio had wanted to buy it, they probably would have. So why not let the kid take a shot at it?

That's exactly what happened. Futterman went off and wrote his script. While doing so, he got advice from his friend Bennett Miller. Miller and Futterman had been at theatre camp together when they were kids. Miller had directed one project—a documentary film on a Gray Line tour guide—and he longed to direct a narrative feature. But Capote? Miller told Futterman that getting a film made on Capote was such a long shot—did he really want to spend his time on this? Maybe there was something more marketable

that he could write. But Futterman stuck to his vision and while he wrote the script, he got comments from Miller.

When the script was finished, the two of them took it to Philip Seymour Hoffman. Miller told him he should play Capote—and Hoffman laughed—"I weigh 240, Capote weighed about 15," and there was the height difference—Capote was 5′2″ and Hoffman 5′11″. Hoffman thought it a ridiculous idea, himself as Capote. But Bennett didn't give up, and neither did Futterman. Hoffman, too, had been at that theatre camp when they were all kids, so the three of them were friends and had been for a long time.

So Futterman wrote Hoffman a letter—telling him that this was such a crazy business, and what was it all about, really, if you couldn't work with your friends. Hoffman said that he read the letter one night as he was walking up the stairs in his apartment and when he got to the top he said to himself, "Damn, I'm going to have to do this thing."

Hoffman lost some weight, they solved the height problems by hiring very tall actors to act around him, thus making him look shorter, and all three of them got nominated for Academy Awards—Hoffman winning for best actor.

What made Futterman think he had a shot at getting the rights to that book? Perhaps he was naïve enough simply to try—and there's nothing wrong with that. Why *not* try? What's the worst that could happen? The author could say no? Fine, you move on to the next book you love and try again.

Sometimes naiveté can be a real plus.

How to Know What Makes a Good Story for Adaptation

While there's no magic to choosing a property for adaptation—after all, a good story is a good story—there are a few things to think about as you evaluate possible stories to choose from when you decide to write an adaptation.

- *Does the Property Have Name Recognition?*

In many ways, writing an adaptation is like writing any story for film—it has to have a good plot, an interesting main character, and enough twists and turns to keep an audience interested.

The quality an adaptation can have that an original often doesn't is name recognition. If you're adapting a children's story, for example—perhaps a children's story that's 30 years old—every adult who read that story as a child might want to go see the film of it. And they'd take their own kids as well! The audience recognizes the film right away because they read the story. And the publicity for the film becomes easier because of that.

Imagine two films: both about a young woman, coming of age in her small, Texas hometown. One is an original that was written and bought by

the studio and one is an adaptation of a novel that did well. The public is more inclined to go to what they know—the film based on the novel.

This may seem like a small thing—after all, isn't a good story a good story no matter where it comes from? While that should be true, it often isn't. We're all motivated to go with what we know—advertisers know this very well, thus they work extremely hard to get the younger markets to start using the products their agency has been paid to advertise, knowing that will most likely commit those 20-somethings to a particular brand of toothpaste or make of car their entire life. We gravitate toward what we know—which is something that, as a writer, you need to understand.

- *Is There Enough of a Story to Fill Two Hours?*

If you're adapting a newspaper or magazine article, poem, children's book, etc., realize that the property you're working from is just a few pages long. Are you certain that you can flesh that property out so that it can become a film? This means you have to do much more than just tell the story you got from the source material—you have to expand that story, think about ways to underline what drew you to the story in the first place, create characters, add subplots, introduce twists and turns or new ideas that weren't in the source material at all. So what drew you to that story? What made you feel that it was a movie? Really try and hone in on that germ of excitement that made you so passionate about the story that you were driven to try and adapt it into a film. If you were drawn to a story in your local newspaper about a family whose house was destroyed after a tornado, what was it about that particular disaster and how that particular family reacted to it that made you think the story would be a great movie? How is this family's loss different/more interesting/more compelling than the loss of any other family who suffered a similar tragedy? There needs to be something universal and special about their story or it won't have much chance as a film.

- *Can a Book Be Cut Down to Tell the Story in Two Hours or Less?*

The one thing that most adapted books have in common—whether novels, biographies, or nonfiction books—is that they're longer than the normal feature film, and often three to four times as long. This means that if you adapt that book into a screenplay, you'll have to leave out 2/3 to 3/4 of the book. Can you do that and do justice to the book? Do you have some thoughts on a certain part of the book that you want to adapt that *would* fit into the 100 or so page limit for a screenplay? Or can you imagine using several parts of the book and leaving out several others—and still making a coherent film?

Do you have a chance of making the film as good as the book? Be sure you can answer that last question 'yes' or don't even try. How many times have you liked a film more than the book it was taken from? Hardly ever, right? That's not because every screenwriter who's adapted a book is lousy at it—it's because *so much* has to be left out in adapting a book that it's difficult to tell the story in as comprehensive a fashion as the book did in the first place. The last thing you want is the original author or the *New York Times* saying you did a hatchet job on the book!

Choosing the property you want to adapt is a huge step, one that brings with it a lot of questions and decisions. But it's important to ask those questions right up front to be certain you're choosing the right property. So much work is involved in adapting that you want to make sure you'll be putting that work into a project that has a chance to pay off.

Breaking Down a 400-page Novel into a 100-page Screenplay: A Daunting Task

If you go the route of adapting a shorter property, you'll have the problem of what to add to flesh it out, but that's a bit easier than trying to cut a long property down to the length of a film. The average screenplay today is 100 pages—that's about an hour and 40 minutes when filmed (on average, one page of a script written in screenplay format is equal to about a minute on screen). What are some of the challenges that you need to face?

- *Think Cinematically*

While a book tells stories, a screen *shows* us the story. Are there visual moments in the book that you think would lend themselves to film? Do things happen to characters that would be standout moments on screen? A big car chase in a crime novel would no doubt be cinematic, as would the moment the jury returns their verdict in a novel about a murder trial. But in smaller stories—stories about families or relationships—the choices can be more difficult. If the book is about a woman who has trouble coping with the death of her father, for example, how he dies could be something you want to show—it could be very cinematic. If the daughter *sees* him die, that could be an even more important moment cinematically. Where you put it in the film is your choice—it could begin the story, it could be something that happens but we don't see it until a flashback later in the film—but however you choose to use it, you know it's going to be in the film because it's not only a big moment in your main character's story, it's also an interesting moment visually. When we see the father die, we more clearly feel what the daughter feels. Those are the sorts of moments you need to search for in your story—moments that lend themselves to being up on the screen.

- *Establish a System for Choosing Scenes for Your Adaptation*

When I'm adapting a book, I have a pretty simple system—I think of it as my '3-star system'. If I read something that I know I want to include in the film—if I'm absolutely certain I can't tell the story without this scene—it gets 3 stars. If I see a scene that would be really good visually and is also important to the story, so I'd like to include it if possible, it gets 2 stars. And if there's a scene that would be nice to include if there's enough time, it gets 1 star. As I read the book, I mark these scenes as I go along. I don't think about whether or not I'll actually be able to fit the scene in story-wise, I just mark the scenes according to their cinematic potential. I'm pretty ruthless about this—a scene *has* to be cinematic to some extent to get a star. If it's not and if the scene contains info important to the plot, I'll find another way to include that info because I don't want a scene in the film *just* for information purposes—it has to be cinematic as well.

After I've finished the book, I make a list of the 3-star, 2-star and 1-star scenes. And guess what? Just in the process of studying this list, I often come up with how I'm going to tell my story. It may take some time, reading the list over and over again, but eventually the story reveals itself. In many ways, the crucial scenes will, themselves, tell you how they want to be told . . . sounds a bit mystical, but it's true. If you can just get close to the story and the main character, how you proceed to tell the story will sort of pop out at you.

- *Read Reviews*

In addition to making your own list of scenes that lend themselves to film, read reviews of the book you've chosen. This is an easy way to get the opinion of others who've read the book as to what they liked and didn't like. They may very well talk about scenes that stood out for them, and you can compare those scenes to your 3-star scenes. They might also focus on weaknesses of the book or things they felt didn't work, and those are things you could try to improve on in your adaptation OR they could be clues to parts of the book you want to leave out completely as, remember, you need to eliminate a lot of the book in your film.

Sample Option and Shopping Agreements

There's no 'one way' to write an option agreement. While an entertainment attorney will be happy to—for a nice fee—write up an option agreement for you, such an agreement is really pretty simple. Here's an example you can use with an author to option his/her property. So let's assume I've optioned a book titled *Skokie* from an author named Sandy Iglitz and I want the option to begin on December 15, 2016. While there are many forms this option could take, here's how one might look—so you know a bit about what's involved.

OPTION AGREEMENT

This agreement is entered into as of December 15, 2016, between Diane Lake ("Lake"), c/o [ADDRESS OF AGENT OR ATTORNEY OR SELF] and Sandy Iglitz ("Iglitz"), c/o [ADDRESS OF AGENT OR ATTORNEY OF AUTHOR OF NOVEL].

For good and valuable consideration, the receipt and the sufficiency of which are hereby acknowledged, the parties hereto agree to the following in connection with the novel entitled "Skokie" ("Work"):

1. Lake will have the sole and exclusive right for a period of 12 months commencing as of December 15, 2016 (the "Term") to set up a motion picture ("Picture") based on the Work with a third party financier ("Buyer"). During the Term if the Picture is set up, Lake will be attached to the picture as a producer.
2. In the event the picture is set up with a Buyer during the Term, each party will negotiate its own agreement directly with the Buyer (e.g., OTHER PARTY will negotiate her rights deal with the buyer and Lake will negotiate her producing deal with the Buyer).
3. If at the end of the Term the Picture has not been set up, then all rights revert to Iglitz, and Iglitz will have the exclusive right to set up the Picture without further obligation to Lake. Iglitz represents and warrants that (a) Iglitz is the sole author of the Work and is the sole and exclusive owner and proprietor throughout the universe of the Work; (b) Iglitz has the full right, power and authority to enter into this agreement and grant Lake the rights herein provided for; (c) Iglitz has not assigned or licensed to any other person or in any manner encumbered or hypothecated any of the rights with respect to the Work; and (d) to the best of Iglitz's knowledge, there is no outstanding claim or litigation pending against the ownership of the Work or any part thereof.
4. Any controversy or claim arising out of, or relating to, this agreement will be settled by arbitration on an expedited basis in accordance with the rules of the American Arbitration Association then existing and in effect in Los Angeles, California, before a single arbitrator experienced in entertainment industry matters. The arbitrator will have the power to order specific performance and judgment of the arbitration award, which may be entered in any court having jurisdiction over the subject matter of the controversy.
5. This agreement will be construed in accordance with the laws of the State of California applicable to contracts entered into and wholly performed therein. This agreement contains the entire agreement of the parties and incorporates all prior understandings (oral and written) pertaining to

the subject matter hereof. This agreement may only be modified by a written instrument signed by all of the parties to be bound thereby. This agreement may be executed in one or more counterparts, each of which shall be deemed an original and, when taken together with other signed counterparts, shall constitute one agreement, which shall be binding upon and effective as to all parties hereto.

If the foregoing accurately sets forth the understanding of the parties pertaining to the subject matter hereof, they can so confirm by signing in the appropriate spaces provided below.

AGREED TO AND ACCEPTED:

_____ _____
DIANE LAKE SANDY IGLITZ

This example of an option with Sandy Iglitz is an example of a free option, but if I had wanted to include a dollar amount for the option, it would appear in the second paragraph. Instead of "For good and valuable consideration," I'd say, "For $1,500" or whatever amount I was paying the author. If you wanted the option to renew the agreement for a second year, that, too, could be a clause in the document.

I've had option agreements that were shorter and less formal, but I think it's a good idea to include appropriate legal language so that everything is crystal clear. Obviously, if you have the least concern, you can go to an attorney and he/she can oversee the preparation and execution of an option agreement for you.

Another scenario that could come up is that you are friends with a newspaper writer or novelist or someone else you want to option a property from. Even though the writer is your friend, don't make the mistake of agreeing to an 'oral' option. Because even if the author is a friend, you could work your butt off writing the script to adapt the book and then if someone comes along who is interested, the author can let them have the book as you would have nothing in writing to have a hold on it. However, if the author is a friend, and you've got that written option, the person who came to the author and was interested in the book would then have to come to YOU. And if they're a person with connections/money, it's in your interest to try and work with them. They can read your outline/script and perhaps you can partner. That way, the powerful contact that the author sent to you becomes a force that might help you get your script in development!

Another situation you may run into is someone wanting to pitch a script of yours around town (which generally means L.A.) without giving you any

money, without optioning it. This is called a 'shopping agreement' and is becoming more and more common. In essence, the company/producer is saying, "Hey, we can't afford to pay you for an option but we'd love the chance to try and sell it . . . however, we don't want to spend a lot of time and effort doing that if you can come in at any time and pull it away from us and let someone else buy it. So give us the exclusive rights to shop it around."

Unless the studios are beating down your door and going into a bidding war over your script, I see nothing wrong with a shopping agreement as long as you're confident it's with reputable people. Hopefully, your agent can tell you that. If you don't have an agent, hey, having a producer interested enough in your work to want to shop it around can say to an agent, "There's interest in this writer, maybe I should represent them," and, voila, you have an agent.

Here's a sample shopping agreement on a script we're calling TASTELESS between me, the writer, and some producers we'll call Chuck Kane and Tracy Lord:

SHOPPING AGREEMENT "TASTELESS"

THIS AGREEMENT is made December 16, 2016, by and between Diane Lake (hereinafter referred to as "Writer") and Chuck Kane and Tracy Lord (hereinafter referred to collectively as "Producers").

Writer and Producers agree as follows:

1. **SCOPE OF AGREEMENT.** Writer hereby engages Producers during the term hereof to exclusively present her original, unpublished screenplay entitled "TASTELESS" (herein called "Property") for a deal between Writer and a Production Company.
2. **TERM.**
 a. The term of this Agreement shall be for a period of twelve (12) months commencing on the date executed by Writer below.
 b. If Producer is engaged in negotiations with a Production Company during which time this Agreement would otherwise terminate, then, upon written notice given by Producer, prior to the termination hereof, this Agreement shall be extended for a reasonable period of time, not to exceed three (3) months, to conclude said negotiations. In the event Producer brings Writer an offer from a Production Company, Writer agrees to promptly enter into good faith negotiations with the Production Company until Writer and Producer's negotiations are completed and an Option or Purchase Agreement is signed by the parties thereto or until the negotiations cease.
 c. If Writer rejects an offer from a Production Company during the term hereof, and subsequently accepts an offer from that

Production Company within a period of twelve (12) months following the termination hereof, it shall be deemed that an Option or Purchase Agreement was executed during the term of this Shopping Agreement.
 d. Producer will keep Writer fully informed about all solicitations. Producer will send to Writer a list of all solicited Production Companies and copies of all correspondence relating to the solicitations conducted in connection with this Shopping Agreement.
3. **COMPENSATION.**
 a. Writer agrees to accept as a purchase price for a feature film to be made from the Property 3% of the going-in cash budget with a floor of $240,000, all other terms of Writer's deal (including option price) to be negotiated separately and in good faith, by the Writer or the Writer's representation.
 b. Producer's compensation for services will be negotiated separately, by the Producer, and in good faith with the Production Company.
4. **MUTUAL WARRANTIES AND REPRESENTATIONS.** Both parties warrant and represent that no act or omission hereunder will violate any right or interest of any person of firms or will subject the other party to any liability or claim of liability to any person. Both parties warrant that they are under no disability, restriction or prohibition with respect to their rights to execute this Agreement and perform its terms and conditions. Both parties agree to indemnify the other party and to hold the other party harmless against any damages, costs, expenses, fees (including attorney's fees) incurred by the other party in any claim, suit or proceeding instituted against the other party in which any assertion is made that is inconsistent with any warranty, representation or covenant of that party. A party's obligation to indemnify shall be conditioned upon the prompt notice of an asserted claim for which indemnification may be sought and upon that party's right to intervene and participate, at its own expense, in defense of the claim.
5. **MISCELLANEOUS.**
 a. Writer and Producer each acknowledge that they have carefully read this Agreement and that they fully understand its contents.
 b. There shall be no change, amendment or modification of this Agreement unless it is reduced to writing and signed by all parties hereto.
 c. No waiver or any breach of this Agreement shall be construed as a continuing waiver or consent to any subsequent breach hereof.
 d. This Agreement does not and shall not be construed to create a partnership or joint venture between the parties hereto.
 e. This Agreement shall be construed in accordance with the laws of the State of California governing contracts wholly executed and

performed therein, and the parties hereto agree to submit to the jurisdiction of the Courts of the State of California and that service of process may be made by certified mail in lieu of personal service thereof.

f. This Agreement shall be binding upon and inure to the benefit of the parties' respective heirs, executors and successors.

g. In the event any provision hereof shall be for any reason illegal or unenforceable, the same shall not affect the validity or enforceability of the remaining provisions hereof,

h. Any and all notices, statements, requests, demands and other communications required or permitted to be given by this Agreement shall be in writing and shall conclusively be deemed to have been given if personally delivered to, or if enclosed in a stamped and sealed envelope, and mailed by registered or certified mail in the United States Mails addressed to the party to whom it is authorized to be given at the address first set forth above or at such other places as the parties shall designate in writing by certified or registered mail.

IN WITNESS WHEREOF, the parties hereto have executed this Shopping Agreement the day and year first above written.

WRITER

Date: _____

PRODUCERS

Date: _____

Between the option agreement and the shopping agreement, you're getting a taste of the legalese involved in writing these agreements—you can see the kinds of things people prepare for and try to guard against as they craft these documents.

And if you thought shopping and option agreements go into unnecessary detail, contracts are a whole other world of minutiae! Imagine 30 pages of

that kind of detail! A contract is what you'll get when your script is bought OR when you get a writing assignment (called 'work for hire' by the WGA).

The WGA has a boilerplate contract—developed for the protection of writers—that incorporates the important elements that should be in every contract. So it's important to remember that all this legal language is actually there to protect you as a writer. Somewhere along the line, someone pulled a fast one on someone else and that caused the creation of some clause that may seem, to you, to have no reason for its existence! But be assured, it's there for a reason.

Chapter 8 Exercises

1. Pick a film that you like that was adapted from a novel. Then read the novel. Compare the two and really study how the author crafted the film from the novel. Would you have done anything differently?
2. The studio wants to do a film that's a take-off on the fairy tale *The Three Little Pigs*. Come up with three possible ways of adapting the fairy tale.
3. Go to a website that lists public domain properties and find three that you think might make interesting films. Write loglines for them.
4. Take one of the three films you came up with in exercise three and write the 7 steps for an adaptation of the property.
5. Go to the *New York Times* bestseller list from 10 years ago and find a book that hasn't been made into a movie that you think sounds like it could be cinematic. Read the book and determine what you'd cut for your adaptation.

9

WHEN TO USE YOUR BAG OF TRICKS

If I'm a painter, I have lots of little tricks to paint in such a way as to make a tree look far away in a painting rather than close up, I can use shading and shadows to convey emotion or danger, I can surprise with a color that seems unusual for the location—I can do many things with my brushes and colors and canvas. The painter's bag of tricks all have to do with painting a picture—and a writer's all have to do with telling a story.

There are many ways to tell the story. Let's say you're telling the story of a young woman, Polly, who's getting a divorce from Max after 5 years of marriage. What are some possible ways you can tell this story?

(1) You can tell it in a linear fashion—which is the most common. This means beginning with the first important moment in your story and telling it chronologically. So for the Polly and Max story, you'd begin with the wedding and show us how the marriage unraveled over the 5 years, then end with the actual divorce. This would be a linear telling of the story.

(2) You can begin the film on the day the divorce will become final and then go back to when Max and Polly fell in love and trace how the marriage fell apart, ending with the day of the divorce. This would be called 'bookending' your film . . . the entire film is like one, big flashback, starting and ending with the same event.

(3) You can have Polly tell the story from her point of view (POV) by having her narrate it (voiceover).

(4) You can have Max tell the story from his POV by having him narrate it (voiceover).

(5) You can go even further than having Max or Polly narrate the story—you can have them 'break the forth wall'—which means talk directly to the audience, the camera.

(6) You can pick a point mid-story, like Max and Polly in year three, just when the marriage is starting to have problems, and use flashbacks to show how they met, how they married, their first fight, etc. So while the story is, generally, linear, you're using flashbacks to show the audience how the couple got to where they are in the present.

(7) You can tell certain parts of your story in more detail by using montages to show long passages of time in a short amount of screen time.

So let's talk about these techniques—montages, flashbacks and voiceover—in more detail.

Montages

A montage is a series of shots that helps tell the story. Generally, a montage is *only* visuals and no dialogue. Occasionally, a montage has a line or two, but not often. And a montage almost always has music playing in the background during its entire length.

Do you remember the opening of *The Devil Wears Prada* [2006]? There was bouncy music with lyrics about beautiful girls and the shots were of beautiful young women getting ready for work in the morning. Most of these women were stunning and we saw lots of shots of their morning routines as the music played—everything from them picking out their panties, to choosing their outfits, to putting on their makeup, to eating their breakfast and hailing their cab. Their panties were lacy and sexy, their outfits were chic and

Figure 9.1 *The Devil Wears Prada* [2006] lights up the screen

stylish, their makeup was mascara perfection, and the funniest breakfast was a shot of just the hand of a woman counting out about 10 almonds.

These scenes were contrasted with shots of our main character getting ready—white cotton panties, a generic sweater, Chapstick was the extent of her makeup, she ate a giant onion bagel with cream cheese—then she took the subway. What does this montage tell us? That this young woman is not like the other women out there—the other women she's going to come face to face with today at her interview for a job at a fashion magazine. And as to dialogue, there was one line in the entire montage—her boyfriend wishing her 'good luck' as she headed out the door.

That's an example of a well-crafted montage that does exactly what it's supposed to do. It shows us what the main character is up against as she moves into a world she knows nothing about. It saves time—imagine adding dialogue to all of those quick shots—it would really slow the script down. And by seeing her in her apartment, in her world, with her boyfriend, we see what she's like right now—so we, too, know a little bit about her when she has to face that interview.

The format for writing a montage is pretty simple. In the left margin, you simply say BEGIN MONTAGE. Then you let the scenes unfold—being as concise as you can. At the end of the montage, you note END MONTAGE. And that's it.

One way to enhance your montage is to name it. So if you have a montage where we see four different guys dating our main character, Jenny, you could label the montage JENNY DATES LOSERS MONTAGE instead of just saying BEGIN MONTAGE. When you end it, of course, you don't need to repeat the title, just say END MONTAGE. The nice thing about titling your montage is that it sets the reader up for what the montage is all about. You can do this with any montage. If you have a serial killer named Luke and you want to show us the murders he commits during the Christmas season, you could label it LUKE'S CHRISTMAS KILLS. Another great thing about labeling your montage is that you can have fun with the titles of the montages—make them funny, tongue in cheek, sad, whatever is going to enhance your reader's reading of that montage. In a way, you're setting the tone with your title so you're easing your reader into the montage . . . kind of like you've said, "Hey, come with me, you gotta see this" and you can almost see your reader anticipating reading that montage because it was so well set up.

But why use a montage at all? What advantage does it have over actual scenes with dialogue? The two most common reasons to use a montage are to show time passing or to show with more speed scenes that might otherwise be trite and drag if done in more detail.

- *Time Passing*

Whenever you want to show a year passing in the life of a family, you might show a series of scenes as the seasons change to indicate that time has passed.

Sure, you could just superimpose on the screen *One Year Later* or something, but the advantage of the montage is that we get to see a bit of what the characters did during that year. Maybe the daughter had her 16th birthday party and we see her blowing out the candles, and the son started smoking grass and we see him almost getting caught by his parents, and the father starts flirting with the next door neighbor, and the mother goes back to work and we see her thriving at the office . . . whatever you want to do, however you want to show us your characters evolving/changing during that year, the montage will let you give us those moments.

- *Avoiding the Trite*

There are only so many ways you can show a couple falling in love—and unless you come up with a new way, we've seen it before. Any attempt to show the evolution of their relationship could come off as tired and we might be bored and just want the story to move on. If you're writing a romantic comedy and the entire film is about them falling in love, that's another story . . . that *is* your story. But if their relationship is just something that has to happen before you can get on with the real point of your film, let the montage help you out. And within that montage, try NOT to have iconic scenes that we've seen again and again—like the couple walking on the beach and kissing. That's the epitome of trite and the whole point of a montage is to avoid tired scenes but still show them falling in love. So your job is to come up with at least four scenes for your montage that will show the couple falling in love as just this couple can—you want to make the scenes character-specific to *them*. That's always true, no matter what the subject of your montage.

An example of a montage that both shows time passing AND avoids the trite comes from *Notting Hill* [1999] when Hugh Grant's character is depressed over Julia Roberts deserting him and a montage is used to show him being depressed over that year. Think about how uninteresting it would be to have scenes with a guy depressed over a full year. It would freeze your film in boredom. Even a montage could be dull and boring if we saw, say, a scene of him alone in his house staring at the wall, and then another at his bookshop aimlessly leafing the pages of a book, then at a dinner with friends where he barely touched his food . . . not only is he depressed, but so are we because this is so boring! Instead, the montage in the film has Grant's character walking through an outdoor market in Notting Hill. During the whole thing, he looks morose. As he enters the market, it's summer, he sees a pregnant woman, and he carries his blazer over his shoulder. We see his sister at the same market, nuzzling her boyfriend. After a few steps, it's turned to autumn and he puts on his jacket and leaves begin to fall. Then it's winter and snow blows into the scene and he turns up the collar on his blazer. And finally, it's spring, the sun is out again, and we see his sister angrily breaking

up with the boyfriend, and the market ends in summer, he's back with his jacket thrown over his shoulder, and he sees a woman holding her baby—the very woman who was pregnant back at the beginning of the montage. This is all done in one continuous shot—no cuts at all. It's a gem of a montage—quick, not trite, does what it needs to for us to keep the story moving along at a lively pace. Plus, it's specific to *him*—the market is something he would do all the time, it's in his neighborhood, his world, and it's something we haven't seen before. That uniqueness is the best part of the montage.

Think about using montages where appropriate, but don't overuse them. A couple per script is generally enough. If you use this technique too often, the technique itself can come off as trite and you want your montages to invigorate your story, not the opposite.

Flashbacks

One of the best tools in your box should be the flashback. Like the montage, you don't want to overuse it, but when used appropriately, it can help tell your story in interesting ways.

There are films like *Memento* [2000] that are told as, basically, one giant flashback—with the whole film happening in reverse order, a scene at a time. And there are innumerable films, like one of mine, *Frida* [2002], that are told using the bookending technique of flashbacks. In *Frida*, we see the older, ill Frida being carried on her bed and put into a truck, then we flashback to her at 16, running through the halls at school. The film is then her life unfolding and ends with her on that bed in a museum where the truck took her to celebrate the opening of an exposition of her paintings.

Another use of flashback is to build suspense. In *Carol* [2015], the story begins with the two main characters talking in a restaurant then flashes back to a year and a half ago, to December 1952, and over the course of the film, we flashback four times from the present to December 1952. This use of flashback tends to titillate the reader/audience . . . making us wonder, 'OK, how's the stuff from December '52 going to play out?'

But flashbacks can be used, judiciously, at almost any point in your film—they have many uses. Whenever you need to tell us something about a character or why she's the way she is, you can use a flashback. Let's say you have a nurse, Allie, who is 'helping' older people in the nursing home to die. She seems normal, caring—we wonder why she's like this. After we've seen her do this for awhile—kill a few of her elderly patients—we go from her looking at a patient we know she's thinking about killing and *flashback* to when her grandmother was dying and we see her grandmother plead for Allie to help her die. "If you loved me, if you could only understand" And she doesn't do it—she watched her grandmother suffer through a long, painful death. We see how guilty this makes Allie feel. Then we *end flashback* and return to

her looking at that patient she'd been looking at as the flashback began—and we see her help this woman die, and we hear the patient's thanks. NOW we know why she does what she does. And that's the value of flashbacks.

If you were writing a novel about Allie and her mercy killing ways, you could have chapters about her thoughts and feelings and dissonance about what she's doing, helping these elderly patients to die. But in a screenplay, thoughts and feelings aren't allowed—as you know, if it can't be seen or heard on the screen, it can't be in your screenplay. So flashing back to Allie's experience in *not* helping her grandmother, we can understand how her feelings of guilt could make her think she's doing the right thing in helping these people to die. Whether she is or isn't can be the focus of what happens to her in your screenplay, but revealing the impetus for her current behavior via a flashback gives us an insight into the internal Allie that's invaluable as we watch her story unfold.

Flashbacks can also be used in a utilitarian way to remind your reader of something a bit complex that might be happening. In *Argo* [2012], the group is heading to the border at the end of act two in their big escape . . . and tensions are high. They have four checkpoints to go through, and as they begin their journey, we flashback a few times to the ambassador's residence where Mendez explained what would happen at each of the four checkpoints—his descriptions are broken up by scenes in the present and the flashbacks remind us of what needs to happen at each checkpoint, so we *feel* that tension more.

Just as it's a good idea to know when to use a flashback, it's a good idea to know when *not* to use one. A good example is *The Devil Wears Prada* [2006], mentioned before in talking about montages. Though the film began with a montage, it wasn't always that way. An earlier draft had the film opening at a French chateau where Meryl Streep's character, Miranda, is being introduced at a function full of the fashion elite. It quickly flashes back to Anne Hathaway who plays Andy, the main character, getting out of a subway on the way to her job interview. The first iteration of the script, at a French chateau, may seem glamorous and intriguing, and when we flashback to Andy 6 months ago going for the job interview, that's interesting—but not particularly original. And that version of the script has her going to the wrong office building for the interview and tries to play up the tension of her potentially not getting there on time . . . and while that's all OK, it's not riveting. I want to get into the main conflict here, not just have surface tension about her finding the right building. So though the flashback opening is a little intriguing, it pales in comparison to the amazing energy of the opening of the film with the montage. Plus, the montage version is more true to the story—about a young woman who is trying to fit into a world she's just not right for. So the flashback simply wasn't needed and was happily dispensed with.

The restrictions of the screenwriting format mean we need every tool we can get to help tell our stories. The flashback is definitely high on the list of those tools. It has a myriad of uses—but it's also subject to abuse. The key? Use it frugally, only where it's the absolutely perfect way to tell the story. So if you can tell the story well *without* the use of a flashback, then don't use it. The use of the flashback, like so many things in screenwriting, should be organic to your story.

Voiceovers/Narration

There's a pretty universal dictum in screenwriting to *not* succumb to using voiceover narration—VO for short. Why is that? Well, there are a lot of good reasons. Use of VO can take the reader out of the story because you've stopped telling the story and have started having someone talk *about* what's happening and why. That VO can thus be detracting from your storytelling rather than adding to it—something you're certainly not going for.

I think new screenwriters in particular should stay away from VO. Studio execs and producers often see VO as a crutch. Their reason is usually something like, "This writer couldn't tell the story without it, so she had to *resort* to voiceover." So ask yourself that question—are you resorting to voiceover because you can't figure out how to tell the story through dialogue or visuals? If so, forget it. Work on telling your story without the VO. Even if you're *certain* you want to use VO in your script, do yourself a favor and write the first draft with no VO. None. Because it's the easiest thing in the world to add but you don't want to be in the position of having used it to tell your story and then being unable to get rid of it because you depended on it too much.

Once you've written that first draft and you determine that using VO has the potential to strengthen your story, then you have a few more things to think about.

- *When Should the VO Begin?*

If you're going to start VO toward the beginning of your script, that's fine. But be careful about waiting too long to begin because once your reader gets used to the rhythm of your story unfolding, throwing in a voiceover all of a sudden can be jarring and can draw them right out of your story. Committing to beginning a voiceover within the first five pages is probably a good idea. In fact, most effective voiceovers begin close to page one.

- *When Should the VO End?*

Once you've begun the voiceover, you can't really end it suddenly or the reader will be waiting for it to come back again. The commitment to a voiceover is kind of an all-or-nothing thing—use it from time to time throughout the script or don't use it at all.

- *Who Should Be Narrating Your VO?*

Generally, the main character is the narrator because whoever is telling that story via the VO becomes a *big* character in the mind of the reader—they become important because it's their eyes that we're seeing the story through. If you're doing a *Rashomon* [1950] kind of story, it's possible to have multiple narrators. *Rashomon* tells the story of a crime from three different characters' points of view so there are three narrators that share the voiceover. And, occasionally, as in *Vicky Cristina Barcelona* [2008], the narrator is just that—a narrator who isn't in the story at all.

- *When Should You Use 'Fourth Wall' Narration?*

There are *very* few successful uses of narration that involve breaking the fourth wall. This 'fourth wall' term originated on the stage. A production takes place on stage, where there are three walls—the fourth wall being invisible, as it's the wall through which we, the audience, see the play unfolding. Rarely, a character in a play breaks the fourth wall by talking directly to the audience members. In many Shakespeare plays, a character turns at some point to talk directly to the audience, and in modern plays like *Spamalot*, this tradition continues. But in general, even in theatre, it's unusual for a character to break the fourth wall. In film, it's even rarer—and it's rare that it's done well. Woody Allen does it well—it's part of his style. But for the most part, breaking the fourth wall is a technique that's difficult to pull off—so for the beginning screenwriter, this might be something to avoid.

Once you understand the different ways in which to use voiceover and know who is doing your voiceover, hopefully you can use it to enhance your story to the fullest. Take the time to look at films that use VO particularly well and study what they do. From classic films like *Sunset Boulevard* [1950] to the fantastic *Shawshank Redemption* [1994] to the cultish *Fight Club* [1999] to the hilarious *Adaptation* [2002], there are films out there that use voiceover to enhance their storytelling for a variety of reasons.

Sunset Boulevard is amazing. The narrator is dead—something we find out about right at the beginning when he reveals he's the guy whose body is floating in the pool and then proceeds to go back to how he got there. So a dead man is narrating his own story *after he's died*. It's a gem of what VO ought to do. *The Shawshank Redemption* is narrated not by the main character, but by the main supporting character. In this case, that keeps us wondering, "Will the main character die in prison or has he already died and that's why the narrator is narrating this story?" So the choice of the narrator was perfect—because the supporting best friend knows and can say things that the main character couldn't.

The popular *Fight Club* is narrated by Ed Norton's character—and it's a good thing! The first act is so internal that it would be pretty silent if it wasn't

for the VO. So in situations like this, voiceover is almost a necessity. The narration in *Adaptation* is completely different. It's this frenetic main character who can't stop talking and we jump right into his mind. And the VO fits because he's a writer and we can see his brain working like a writer's through the voiceover.

In addition to looking at films where the VO works well, it's also important to watch films where the voiceover doesn't work. One of those is *The Great Gatsby* [2013]. The VO in this film is so bad that you have the narrator, Gatsby's friend played by Tobey Maguire, narrating stuff that we can *see happening on screen*! This is one of the big sins of narration—if we can see it happening, you certainly don't need to spend time having VO that's telling us it's happening! Interestingly, lots of bad narration happens in the adaptation of films from beloved novels. The novels are often so iconic that the temptation to use the words from the book is strong. Chances are, the novel got its iconic status because the narrative in the novel was good! But, bottom line, it doesn't matter how great the language was in the novel—in the film, the voiceover may not be necessary.

Film is, in many ways, *its own language*. It's a language you learn to use that's all about creating moments, images and dialogue that can be seen or heard on screen. It's a language with severe limits, for sure, and it's your job to stay within those limits to tell your story—that's the nature of the medium of film. But when there's a really good reason to stray outside those limits, voiceover can be the answer—just use it well and make sure it's organic to your story.

Montages, flashbacks and voiceover—three of the more handy brushes to have in your screenwriter's paint box. And the bottom line for all of them? Use sparingly, only when necessary, and only when they're organic to your story.

Chapter 9 Exercises

1. Pick a favorite romantic comedy that did *not* have a montage and write a montage that shows us how the two main characters in the film met.
2. For the romantic comedy you chose in exercise one, write a flashback that shows what each character was like with their first girlfriend/boyfriend around age 10.
3. For the film you're working on, write a montage that shows time passing.
4. For the film you're working on, write a flashback that shows us a secret the main character has that no one knows about—a secret that impacts your story.
5. For the opening of a favorite film of yours that had no voiceover, think about where voiceover could have been used. Why do you think the writer chose not to use it?

10

WHY IT'S THE LITTLE THINGS THAT COUNT

Sometimes it may seem like there are just so many things to think about with screenwriting that your focus can drift from your story to all the extraneous stuff you're supposed to do... or not do. Well, you're not wrong. There are a lot of things you need to be concerned about as a writer—but guess what, that's true of *all* writers, from novelists to playwrights to poets.

Whenever you're dealing with a creative profession—writing, acting, directing, etc.—there's an insane amount of competition. Seriously insane. In all these professions, the smallest thing you do can push you out of the running. It's *because* of all this competition that those doing the choosing—in your case, those reading your screenplay—can be picky. So it's not just your characters, structure and dialogue that need to be perfect, you also have to guard against annoying your reader by having bad formatting, doing a screenwriting no-no, or not proofreading carefully enough.

Think about it—you're working incredibly hard to make sure your script is written to the best of your ability, so why fumble the ball on the easy stuff? Why not spend time on 'the small stuff' to ensure that your script gets the attention it deserves?

Formatting

The way in which a screenplay is written is unique—there are specific rules about how the screenplay is laid out and you're expected to abide by those rules. While there's a myriad of software programs that will format for you, it's really not that hard to do it yourself. And since the industry standard in which your agent will send out your screenplay is a PDF, there's really no need to spend hundreds of dollars on formatting software. Some writers like to play with some of the features in the formatting software—like laying your scenes

out in card format—but it's not something you actually need unless the specific features you're paying for are helpful to you. The PDF is used because all producers and agents and studio people won't necessarily have the formatting software you're using, so even if you buy that software, you'll still have to convert it to a PDF before sending the script out. Some software can be valuable for budgeting if you're planning to shoot your own independent film, so you decide whether the money is worth it for you or not. Here's the nitty-gritty on how to format a screenplay without the fancy software:

- *Title Page*

The title of your script should appear about 1/3 of the way down the page and it should be centered. You can cap it or have it in a larger font or italicize it—whatever you like. After the title, double-space and put the word "by" in a smaller font, then double-space again and put your name. So a normal title page will look something like this:

JOURNEY

by

Diane Lake

While you can certainly have your name larger than normal type size, it should never be larger than the title.

In the lower right-hand corner of your title page, you'll type—at the right margin—FIRST DRAFT, or whatever draft it is. Your agent or the producer may want their name on the title page at the bottom left corner—they'll let you know if that's the case. You may also want to date your draft: FIRST DRAFT [11/15/2016]. If you're writing a script on spec—no producer or studio has hired you—I suggest leaving the script undated. A spec script might take months—or years!—to sell, and you don't want a producer you've met reading the script, looking at the date, and thinking, "This is 3 years old—this is old news." You want the script read and judged on its merits—you don't want someone assuming that because it's a couple of years old, everybody in town has read it and turned it down. So the safest way to avoid that is simply not to put a date on the title page.

- *Page One*

All scripts begin with two words at the top of the page in the left margin:

FADE IN

Why? It's just tradition. Not every film even opens with a FADE IN any more but it's still on most scripts. Personally, I like typing FADE IN as I begin a new script. I feel like, on some level, I'm following in the tradition of the screenwriters who came before as I attempt to carry on the art of screenwriting.

After those two words, you double-space and begin the script. The other thing you might choose to put on page one is the page number—it would appear in the upper right-hand corner. But quite often, the screenwriter doesn't start numbering the pages until page two, leaving the page number off of the first page.

- *Font/Margins*

The script font is Courier or Courier New. That's it—no leeway here, you're expected to type the script in Courier. Courier is what's called a non-proportional font—each letter takes up exactly the same space as every other letter. If a script is typed in Courier, one page of a script will equal approximately one minute of screen time. Sure, some pages have more narrative and less dialogue, so each page isn't always exactly one minute—but over the course of a script, it averages out. So a 100-page script will net a 100-minute film.

Margins are pretty set in stone as well:

- Left margin: 1.5 inches
- Right margin: 1 inch
- Top margin: .5 inches to the page number; 1 inch to the body

- Bottom margin: at least 1 inch—though this will vary depending on how long your dialogue runs at the bottom of the page (more on this in the dialogue formatting section).
- Dialogue margin: 3 inches, left; 2.5 inches, right . . . but these can be a bit less rigid—the important thing is that the dialogue looks relatively centered on the page.

- *Characters/Dialogue/Page Breaks*

The first time a character is introduced, his/her name should be in ALL CAPS. After that first time, no need to cap. The character's name should be in about the center of the dialogue—approximately at 4.2 inches if you follow the standard margin rules.

Dialogue is always single-spaced and, as mentioned previously, kept to four lines or less—if at all possible. Your screenplay needs to move, and in film, characters rarely make long speeches. And every character's speech needs to be on one page. So if you have a character speech that's four lines long, those four lines need to be on the same page. That means if you begin typing those four lines of dialogue at the bottom of a page and only one line fits, you can't just type the next three lines on the following page. You need to either fit them on the bottom of the page you began on, or move the entire four lines to the top of the following page. This means that your bottom margin will vary, depending on how the dialogue lays itself out. You never want to have single lines dangling at the top or bottom of pages—your page breaks need to be clean.

If you do have a character speech that's on the long side—say, 10 lines of a funeral oration—and it happens at the bottom of a page, you might want to space it out over two pages. In this case, you'd type, say, the first five lines on the bottom of a page, and on the top of the next page, you'd write the character's name and then "CONT'D" so that it looks something like this:

```
                    MARIANNE (CONT'D)
```

This will let the reader know that the dialogue has been continued from the speech Marianne began on the previous page.

Sometimes a line of dialogue can be preceded with a parenthetical. A useful parenthetical tells us something about how a character is feeling, or can indicate a small action. Here are two examples of a parenthetical used to communicate feelings/attitudes:

```
                         JOE
                    (skeptically)
              Sure I believe you.

                        MARGO
                    (seductively)
              Come here.
```

Notice Joe's line—if you were to read it without the parenthetical that tells you Joe *is* skeptical, the line could read as if he actually believes her. The parenthetical tells the reader that Joe totally *doesn't* believe her. And the same with Margo's line. Her 'come here' could be totally utilitarian, as if to tell him to just come over to where she's standing because she has to show him a blueprint or something. But when you use the parenthetical, it tells the reader that she's turning on the charm to get him to come to her . . . and it's not just to show him a blueprint.

Here are a couple of action-oriented examples:

 KATE
 (running down
 the alley)
 Stop him!

 PRESTON
 (trips on a rock)
 Damn!

 KATE
 I'll get him.
 (POINTING TOWARD
 THE BUSHES)
 But watch out!

Notice how the action parenthetical in Kate's first line wraps around to a second line—the longer parenthetical is centered under her name. And in her second line, after Preston's line, the parenthetical breaks up her dialogue and is clearly distinct from that dialogue. To make sure it's distinct, it's often capitalized, as this example shows. But this is a matter of taste—some writers cap a parenthetical that's in the middle of a character's dialogue, and some don't. But you can see how the parenthetical saves time—if you didn't interrupt her dialogue with "POINTING TOWARD THE BUSHES," you'd have to double-space and do a narrative line "Kate points toward the bushes" and then double-space again, type her character name, and continue with the line. Putting the action within her line makes the reading of the script move much faster.

- *Slug Lines*

A slug line, or scene heading, begins every scene and is always capitalized. There are three things each slug line indicates:

- *Whether the scene is an interior or exterior scene (indoors or outdoors)*
 Every slug line begins with either INT. for an indoor scene (interior) or EXT. for an outdoor scene (exterior).

- *Where the scene is located*
 After the EXT. or INT., you note the place the scene is happening. This can be a generic place like OFFICE BUILDING or a more specific place like TOM'S BEDROOM. Sometimes your slug line can combine interiors and exteriors. If you want to show that we're at UNCLE MORTY'S HOUSE and then are inside the house right afterwards, you can say EXT./INT. UNCLE MORTY'S HOUSE. This avoids having to have two scenes with two slug lines. Why have EXT. UNCLE MORTY'S HOUSE if that's just to establish that we're at his house? If nothing actually happens outside his house but the point of the scene is to get to what's going on inside the house, the EXT./INT. configuration works really well.

 Be sure to be specific with your location. Don't just say ROCKO'S APARTMENT if all the action in the scene is going to take place in his basement—say ROCKO'S BASEMENT instead.
- *What time of day the scene is taking place*
 Generally speaking, all you need to indicate for the third element of your slug line is DAY or NIGHT—and I know lots of writers who never vary from that. However, you can put other things like SUNSET or SUNRISE. You can also put LATER but try to avoid it—your scene should clearly tell us if time has passed. One of the things you don't need to put is CONTINUOUS—that will be obvious and just clutters up the page if you have CONTINUOUS after every slug line. By and large, DAY and NIGHT should serve just fine.

Here are some examples of slug lines:

INT. TOMMY'S HOUSE—NIGHT

EXT. BASEBALL FIELD—DAY

EXT./INT. METROPOLITAN MUSEUM—DAY

INT. MARK'S GARAGE—NIGHT

You'll note that the slug lines aren't numbered—they just begin at the left margin. This may differ from what you see in a shooting script—the kinds of scripts that are published or that you might find online. Shooting scripts have all the scenes numbered because the production needs to be able to refer to scenes easily. But the writer's draft *never* includes scene numbers.

Additionally, you'll note that the four slug line examples above are in bold print. Ten years ago, most slug lines weren't in bold print but that has changed. I advise putting your slug lines in bold print because it makes them stand out on the page. The script needs to be easy to read, and putting the slug lines in bold print helps the eye to slide easily down the page and makes

it super clear where the story is going. It's not required to bold your slug lines, but it's a good idea.

Slug lines can also be used to assist in writing action sequences—check out Chapter 6 for examples of how slug lines are used beyond just labeling your scenes.

It's amazing that one little typed line of print can add so much to your script, but it does. It sets your reader up for where we are at the moment and what time of day it is. It carries that reader along into your story in a seamless way—so that small slug line can mean a lot.

- *Narrative*

The narrative, or description, is what falls between lines of dialogue. That narrative tells us what's happening visually in the story. And writing narrative can present one of the biggest problems in screenwriting. Your narrative should always be as spare as possible and there are a couple of rules to abide by.

First, thoughts or feelings of characters cannot be discussed. The narrative can contain only what can be seen or heard on screen. This is quite different from writing fiction where you can go on for pages and pages into the feelings or thoughts of a character. But film is a *visual* medium, and what you put in narrative needs to be visual.

Second, the length of any narrative paragraph should not, normally, exceed four typed lines. If you have narrative that needs to go on longer than four lines, you need to break it up into two four-line sections. If you read screenplays, you've probably seen entire pages of narrative—and if you're a million-dollar-per-script screenwriter, you can have as many pages of narrative as you want. But until then, keep it lean. Script readers—people who read scripts for a living—talk about skipping long passages of narrative and just going to the dialogue. It's all about this thing called 'white space'—something loved by script readers, as mentioned previously. The more white space on a page (i.e., the less typing, the less long paragraphs of narrative), the faster the pacing is said to be in the script.

Here's an example of how to cut down on narrative description:

Version 1

```
Thomas looks at her, exasperated. They are now
the only two people not in the garden. Agnes
gestures toward the garden but Thomas pulls her
back to him and kisses her ever so lightly on the
neck. She doesn't respond. As his kisses heat up,
Agnes raises her hand to the back of his neck and
runs her fingers through his hair for a moment
before turning and exiting to the garden.
```

Version 2

```
Thomas looks at her, exasperated. Agnes gestures
toward the garden but Thomas pulls her back to
him and kisses her ever so lightly on the neck—
she doesn't respond. As his kisses heat up, Agnes
runs her fingers through his hair, turns and goes
into the garden.
```

Version 3

```
Alone on the terrace, Thomas brazenly kisses
Agnes on the neck. She freezes but he doesn't
stop. Boldly, she runs her fingers through his
hair, then races to join the party in the garden.
```

Look carefully at each of the three versions and follow the cutting process. An eight-line narrative description becomes six lines and finally four. How does this happen? It just takes lots of work, lots of refining, lots of whittling down to the important elements in this moment.

In this instance, the important points are:

1. They're alone on the terrace.
2. He kisses her.
3. She doesn't respond.
4. He doesn't stop.
5. She runs her fingers through his hair.
6. She leaves him to join the party.

In every situation like this, you have to break down into its smallest components what's absolutely necessary to tell your reader. You don't want to be flowery with your description, you don't want this moment to read like you were writing a novel, you want to focus on the *actions* that happen and make sure those are expressed visually so that the reader can *see* what's happening in this moment. Do you want to communicate their attitudes during this action? Absolutely. He's 'brazen' in his action at this moment and though at first she 'freezes', she's not going to let him be the only brazen one, so she 'boldly' responds with an action of her own.

While it's fine in your first draft to put down all of your narrative thoughts, you should only allow yourself to do that if you know you're going to go back and revise and revise and revise. After going through this process over the course of several scripts, you'll find that your narrative becomes leaner and leaner—even on the first or second pass!

- *Shots/CUT TOs/Phone Calls*

The writer's draft doesn't contain shots—no CLOSE UP, no ZOOM IN, no REVERSE ANGLE, etc. While you may see these things in scripts, they're in the shooting script—the writer's draft never includes them. If you put camera angles and shots into your script, you'll be seen as a rank amateur. In addition, the director won't like it—he or she will feel you're trying to show how you want the script directed . . . and I have yet to meet a director who likes to be directed.

CUT TO used to be a common direction put at the end of a scene—it would be in the right margin and would simply be followed by the slug line for the next scene. But after awhile, screenwriters realized that *every* scene ended with a kind of automatic CUT TO that precedes the next scene, therefore the direction of CUT TO really isn't needed and you don't see it used today by too many screenwriters.

Phone calls are one instance where you do use a screen shot. If MARK and LINDSEY are talking on the phone, you don't want to use a slug line every time you go back and forth between them during the phone conversation—it would unnecessarily clutter up your script because we all get that it's a phone call. So after the first person speaks, you say, in the right margin, INTERCUT WITH and continue to the slug line for the second person in the phone call. Here's how that might look:

```
INT. MARK'S DORM ROOM—NIGHT

Mark is on the phone with Lindsey.

                    MARK
          Are you kidding me? Him? You're
          leaving me for that jerk?!

                                       INTERCUT WITH:

EXT. LINDSEY'S DRIVEWAY—NIGHT

                    LINDSEY
          Paul. His name is Paul.

Lindsey puts her arm around PAUL, 21, as he
bounces a basketball. He stops and KISSES her.

                    MARK
          Are you . . . seriously, are you
          kissing him right now?
```

```
                    LINDSEY
          Mmmmm. He could give you lessons.
```

Note that you only need to put INTERCUT WITH in the scene one time, the first time you cut to the second person in the phone call. When the call is over, you'll then need to have a new slug line for the scene that follows the phone call.

All of these formatting dictums are exclusive to feature screenwriting. While there's some overlap, both television and playwriting have quite different formatting conventions. If your story tells you to deviate from one of these formatting rules, so be it—but make sure it's worth it!

Top 7 Things *Not* to Do in Your Screenplay

When you're learning to play the piano, you're told not to hold your fingers out straight—which seems normal to do—but instead to hold them in this weird, curved fashion ... at least, it seems weird when you first begin and then after you force yourself to do it, you realize that it gives you amazing power when hitting the keys—power you never would have had if you had listened to your personal thought process saying, "Don't hold your fingers like that, it feels weird." Sometimes learning how *not* to do something is the best way to make sure we do it right.

There are many mistakes the screenwriter can make—here are seven big ones to avoid.

1. Having Scenes That Are Too Long

If the average screenplay is 100 pages, want to guess how many scenes that screenplay has? You've watched a lot of movies, right? Think back to your favorite film and guess how many scenes. 50? 100? Would you believe the average film has closer to 200 scenes? If you look at screenplays from the 40s, for example, you'll find they had way fewer scenes. The films were just as long in the 40s, but that script had fewer scenes because they were very talky. But as time passed, the pacing in films sped up, and film scripts accomplished that by having briefer scenes. The Academy Award winner for best film in 2012, *Argo*, had—get ready—339 scenes in the 122-page script. That means an average of almost three scenes a page. Of course, every page doesn't have three scenes—there might be scenes that are a page or even two pages long—but they're balanced out by pages that have four or five scenes per page.

What does that mean to you? Your average scene should be about a half page. That's right, a half page. Many times, I'll have four or more scenes on a page. Why is that? Because screenwriting is all about creating visual moments that move the action along. Whether it's narrative or dialogue, your scenes should be as short as humanly possible.

The fact is, film strings together moments, it's a visual medium, so there's rarely a need for a long, talky scene.

In terms of narrative, that means making your descriptions as sparse as you can. There's no need to go on and on about describing a room, for example. Your job is not production designer, it's screenwriter. If you want to describe a businessman's office for a scene, think about what you really need; after all, we've all seen an office or two and they're not that different. Perhaps all you need is an adjective: "Jonathan's austere office" or "Jonathan's shabby office," for example. But the last thing you need to do is give us a paragraph about his wallpaper, his desk style, his bookshelves—we just don't need all of that. We need to get on with the story—what *happens* in that office, that's what we want you to tell us. If there's something important to his character, you might want to use that. If Jonathan is a cheapskate and that figures into his life at home in a big way, you could emphasize that element of his character by saying "Jonathan's bare bones office."

In addition to your narrative being sparse, your dialogue needs to follow suit. If you're going to have short scenes, characters can't ramble on and on. Listen to most conversations and you'll see that in everyday exchanges between people, no one's giving speeches.

Writing lean takes time, no doubt about it. It's difficult to find just the right word or two to convey what a room looks like or to find just the right response your main character is going to give to her husband when he's forgotten her birthday. But that's your job—to find the perfect word, the perfect phrase.

So as you write, keep asking yourself if every line in a scene is needed and cut accordingly!

2. Writing Overly Expository Dialogue

As the writer, you know things that happened in your main character's life that you want your reader/audience to know. So it's tempting to weave those things into the dialogue to explain the backstory for your character. Resist this temptation.

First, we don't need to know everything about this character at the beginning of the film. It's more fun if we learn her backstory as the film evolves. Let us wonder about why she left her last job or why she wants to run in the marathon. Think about it the way you'd think about meeting someone new—you're at a dinner party and introduced to a new neighbor. You don't know anything about her but in the course of the evening, you learn a crucial thing or two. Do you know her life story? Unlikely. Chances are, you form an impression or two from a conversation and the next time you meet her, you'll probably learn more. That's exactly what you want to happen in your script—you want our understanding of her to be organic, to come about in the film exactly as it would in life.

Second, trying to explain everything in dialogue will just weigh your script down. The last thing you want is for your script to seem top heavy with unnecessary explanations. Readers want to be drawn in by your story and that won't happen if they're bogged down in listening to bits and pieces about why your character is where she is in life and what happened to bring her to this moment.

3. Using Screenplay Terminology Like BEAT

Sometimes I think we just fall into using screenplay terminology because it seems cool—if we use the lingo, we must be a screenwriter, right? Well, not so much. The biggest offender in this category is the use of the term BEAT. This term is synonymous with PAUSE.

The derivation of BEAT is probably a musical one. Every line of music is composed of beats, and in many ways, good dialogue has a rhythm to it, doesn't it? And in outlining a screenplay, some people write beat sheets or beat outlines—those outlines break up the action of the screenplay into individual moments, or beats, of action. (I don't recommend using beat outlines—they're too confining.)

My concern with using BEAT is for the reader. The minute you throw the term BEAT in the middle of a line of dialogue or an action, it takes the reader right out of what's being said and reminds them they're reading a screenplay. I don't want my reader to think about the fact that they're reading a screenplay—I want them swept away by my story and what's happening in that story. So instead of BEAT, I like to think about what's actually *happening* during that pause, during that moment—and then I write that. Here are two versions of the same moment, using BEAT (or you could use PAUSE) and not using it:

VERSION 1

```
                    SIMON
         You don't understand, it was like . . .
BEAT
                    SIMON [CONT'D]
         . . . like she didn't even know me.
```

VERSION 2

```
                    SIMON
         You don't understand, it was like . . .
              (shakes his head)
         . . . like she didn't even know me.
```

Notice that the second version takes up less space on your page—four lines instead of seven. Also, look how much more specific the second version is. Whether you use BEAT or PAUSE, neither is as effective as version two, because then I *see* Simon shake his head, and that head shake tells me how dismayed he is by the fact that she didn't know him. So instead of using screenplay terminology to make a point, my character makes the point with his actions.

See how creative you can be. When you're tempted to use BEAT or PAUSE, resist, and tell us instead what's going on during that momentary pause.

4. Writing Indistinct Characters

One of the things that will draw people to your script—whether they be agents, producers or actors—is interesting, unique characters. If you populate your script with stock characters, there will be nothing different that makes your characters stand out over the characters in any other script and your reader could lose interest.

What is a stock character? Here are a few:

- the curmudgeonly grandfather
- the hooker with a heart of gold
- the wise old man
- the self-sacrificing mother
- the absent father
- the womanizing actor
- the resilient cancer patient
- the ditzy blonde
- the precocious child

In essence, a stock character is one you can describe in just three or four words. They're a 'type'—and you don't want that. You don't want *any* character to be just one thing—you want each and every character to have limitless range. So instead of a wise old man, you create a disorganized old guy who mumbles to himself a lot, but when you can sit him down, get him to look you in the eye (hard for him to do because he's actually very shy and distrustful of most people) and ask him something specific, his advice is never what you expect but always tinged with a wisdom that you don't get from anyone else. Oh, and he's also going blind. All of this your main character discovers about him, as do we the audience.

See what happened? He went from being a 'type' to a person you can actually visualize, a person who has layers that make you want to figure him out. And not only does he exist in terms of what he does for the main character, we see that he has problems of his own—in this case, the fact that he's going blind.

It's all about dimension. Each of us isn't just one thing—mother, father, sister, priest, babysitter, lawyer, mental patient, prodigy, etc. In life, most people you meet are multi-dimensional, so make your characters resemble real people and your script will be more real, more true.

5. Moving Your Story Along Too Slowly

Too often, scripts give us lots of backstory so that we'll better understand the current story, and go through so much set-up that the story of the film doesn't really begin until several pages into the script. This is a problem.

If I don't sense your story on page one, there's a good chance you're moving it along at too slow a speed. Ask yourself what your story *is*, and then be sure that every scene, every exchange between characters, every action serves to tell part of that story.

In *The Hurt Locker* [2008], I know from the top of page one that I'm smack in the middle of a bomb squad in Iraq, and often that's how a story begins—you put us in the place the story's going to unfold and that tells us a lot, it grounds us in the atmosphere that's going to give birth to your story. And in *The Hurt Locker*, it would have been easy to begin the story back at the barracks—we would get to know each of the guys on the squad in their down time, and therefore get a sense of who they are, and *then* we would see them get the call about the bomb and head out to do their job of disarming it. That might be OK, but how much better to throw us right into the middle of the world these guys are living in, right into the middle of the chaos—that way we get to know them very quickly in terms of how they respond to that world. So by going right to the kind of action they have to deal with, we get to our story faster AND we get to know our characters and how they react to these pressure-laden situations.

As you write, with every single scene, ask yourself, "How is this advancing my story?" If a scene doesn't, ask yourself what it is about that scene that you thought so important that you'd put it in even though it didn't advance the story. Really look at it and figure that out. Then *find a way to put that element in a scene that* does *advance your story*.

6. Leaving Your Main Character Off-Screen

It's not that your main character has to be in every scene, but the person whose story this is should be in almost every scene. And any scene he/she is not in should still be about them or their dilemma in one way or another.

Being able to do this has a lot to do with understanding not just what your character wants, what goal he/she is going after, but understanding what that character *needs*. They're two different things. JENNIFER, a high school sophomore with a lisp, wants to be popular at school but actually needs the love of her parents, for example. Every scene should have her struggling with either that want or need. You'll place obstacles in her path, surprises that will

make us wonder how she's going to manage, etc. But every scene will either have her on screen or have those around her talking about her—she's your star, she's the person whose story we're in that theatre to watch, so she's the person who's the center of our interest and everything that goes on should impact her in some way.

This can be an interesting process. Sometimes when you're writing, your story can be kind of hijacked—don't know any other way to put it. A minor character can come into the picture and all of a sudden, their story takes center stage. Pretty soon, you notice that your main character hasn't been in a scene for 7–8 pages—and, truthfully, you're more interested in writing about the minor character's story that seems to have just popped up out of nowhere.

Well guess what? It didn't pop out of nowhere, it popped out of your innate dissatisfaction with the story you were writing—so your subconscious storyteller took over and gave the script a shot in the arm. So either, deep down, you weren't committed to the main character or his/her story, OR your inner storyteller found a better story within the landscape you were exploring. So maybe that means you change your focus, change your story, change your main character. There's nothing wrong with this—any time a better story comes up, feel free to go with it. You can always go back to your original plan, but why not try out different offshoots of that story—what could it hurt?

When you're happy with your main character and what he/she is getting up to, it will be difficult NOT to keep them in every scene because you'll constantly want to be exploring how they're going to handle all the stuff that's coming at them—via your wonderful imagination.

7. Trying Too Hard

Remember the kid on the playground in 4th grade who wanted to be everybody's friend? He gave things to kids so they'd like him, he gladly helped with homework when asked, he went out of his way to impress the teachers—and nobody liked him. Why was that? What's wrong with wanting to be liked and, therefore, trying different strategies to make that happen?

The problem with trying to get people to like you is that nobody likes to feel pressured into feeling one way or another about something—be it a person or an idea. Most of us like to just let a relationship evolve and see if we 'fit' with the other person. If the other person is too needy or, even worse, cloying in their affection for us, it repulses us rather than attracts us.

This can happen in your script as well. You can want people to like it so much that you try and make sure, with every character and every scene, that everyone will love it. This often means that you write to impress. And just as with that kid on the playground, you won't get what you want—because rather than like your script, readers are apt to be turned off by watching you try. Because that's the crux of the problem, when you try too hard it shows—and *seeing* that trying turns off an audience, it makes them uncomfortable.

How do you avoid this? You listen to your characters and you write their story—you don't grandstand for anyone. In fact, you don't even *think* about who's going to read your screenplay or sit in a movie theatre someday and watch your movie. You think about your characters, their wants, desires, concerns, needs, and you stay true to the story about them that you're telling. You make sure, with every keystroke, that you do right by them—that you're honest and unrelenting in your efforts to do their story justice. Because *that's* who you are and that's what a screenwriter does.

Are there more things to avoid doing than just these seven? Sure. There are plenty. But if you work on avoiding these seven, you'll be doing a bang-up job.

Proofreading

When I was in college, I wrote a paper and didn't get an A on it. Being an annoying little A-student who was obsessed with her grades (waste of energy but I was too young and clueless to realize that at the time), I went to the professor to complain. He told me I'd gotten the A- instead of an A because of the proofreading errors in my paper. Here's how that scene played out:

 MS. LAKE
 Oh! Proofreading. Well, that
 explains it, I just can't
 proofread. Not in my DNA.

 PROFESSOR
 Is that right?

 MS. LAKE
 (big smile)
 Sorry!

She relaxes—confident he will forgive her disability in this area. He hands her the A- paper in question.

 PROFESSOR
 Let's try a little experiment.
 There on page three, what's the
 first word, Ms. Lake?

 MS. LAKE
 On.

 PROFESSOR
 And is it spelled correctly?

 MS. LAKE
 Yes, professor.

 PROFESSOR
 And the next word?

 MS. LAKE
 Several.

 PROFESSOR
 And is it spelled correctly?

 MS. LAKE
 Yes, professor.

 PROFESSOR
 And the next word?

 MS. LAKE
 (squirming)
 Occassions.

 PROFESSOR
 And is it spelled correctly?

 MS. LAKE
 (sighing)
 No, professor.

 PROFESSOR
 Is that right? What would be
 the correct spelling?

 MS. LAKE
 (grudgingly)
 O-c-c-a-s-i-o-n-s.

 PROFESSOR
 Well, look at that! Apparently,
 you *can* proofread, Ms. Lake.

I wanted to slap him. But he'd made his point. Proofreading wasn't some gift that comes from above—it is a boring, arduous process that anyone can do . . . even an annoying little Ms. Know-It-All like me.

On the weekends, most development execs, studio execs and agents take home their 15 scripts for the weekend read and are actively looking for reasons not to read them. It's part of their job, though, and on Monday morning when they gather with everyone else in the office, they'll be expected to discuss the scripts in question. But if they find errors in your script, guess what? They're able to say at the Monday morning meeting that they couldn't wade through that one because of the errors. And others will back them on this—they, too, were looking for reasons not to read—and your script is out.

This is not an unlikely scenario. Your script is expected to be perfect in format and grammar so that it's easy for the reader to read. That reader feels he/she is giving you his highly important time to read your script, so you'd better respect that time and make the job as easy as possible.

Even if your script isn't being read by a bunch of important executives for the weekend read, anyone who reads your script is important—because they could pass it on to someone who actually IS important. So every reader deserves your respect. But it's about more than respect.

Every time there's an error in your script, it has the potential to take the reader out of the scene, out of the conversation you've written, and they're distracted from the content of your script because they've focused on that error. Often they go into a 'trying to figure it out' mode. If you leave just one word out of a sentence, for example, the reader might stumble and not get what the deal was in that sentence—and your reader has to go back to the line from the previous speaker, re-read that line, then try to figure out what the missing word was from the next line . . . and after all of that's been done, your reader has to get back into the rhythm of the scene and continue reading. Chances are, by that point, you've lost not only your reader's good will but the reader simply isn't into the scene as much as he/she might have originally been.

Before I send a script to my agents or a producer or anyone who is waiting for it, I send it to my writer friends first. Of course, I've proofread it, but though I've evolved beyond the know-it-all student I was in college, I'm not perfect and I hope that, in addition to my friends giving me feedback on the content of my script, they'll find any errors I've missed as well. I remember the time I sent a script off to friends and one of them wrote to me in his page notes: "I had to go <u>BACK!</u>" And, yes, he'd capped and underlined 'back'. There was something missing in the offending paragraph that required him to go back to the previous page and try and figure out what I was going for. And guess what? In the real world of script-reading, whether it's a script-reader or an executive, they rarely take the time to go back and try and figure something out. If it's not clear, they just assume it's a writer's error and that's another reason for them to think less of your script.

Your goal in writing this script is for someone to want to option it or buy it—you're not writing to put your hard work in a trunk to be found sometime after your death, like Emily Dickinson did with her poetry. You want something to come of that script. So you have to present that work in the best form possible. And *that* means you go over every sentence, every bit of dialogue, every word in that script until you're certain all words are spelled correctly, all sentences are complete—with no missing words—and it all looks absolutely perfect.

I find proofreading painful—it's so tedious! It takes forever and I worry that I'm missing something the whole time I'm doing it. To minimize the tedium and to help myself find all the errors—many of which are typos that spell-check doesn't catch—I proofread daily. If I have time, I'll proofread what I've written today at the end of the day. And I'll catch an error or two, for sure. Then tomorrow, I begin my writing day by proofreading what I wrote yesterday. And guess what? I'll probably find another error. Yes, I just proofread that piece of writing yesterday but I'll still find an error or, if not an error, a better way to say something. So one way to make proofreading less painful is to do it more often but for smaller amounts of time. Then, when you're done with the script, enlist friends to read it and tell you the errors they find. And even with all of that, you might still have an error or two in the script. But with enough readers working on your behalf, you'll maximize your chances of having an error-free, easy-to-read script.

Make it your business to be sure your script is presented in its best light both in content and format. Doing that might not get your script optioned or bought—but it has a better chance of getting *read*. And *that's* the first step to a sale.

Formatting, what not to do, proofreading—they may seem like little things, but fall down on the job on any one of them and your script could meet with disastrous results. Don't let that happen. Budget the time in your writing process to do all the things necessary to make your script sparkle and shine!

Chapter 10 Exercises

1. Instead of buying expensive screenwriting software, see if you can use your word processing software—whether it's Word or WordPerfect or whatever—to formulate your own macros or style sheets to format your screenplay.
2. Watch a scene from your favorite film and write a piece of narrative from that film, seeing if you can capture the *feeling* of that narrative that you experienced while watching the film.

3. Take the piece of narrative you wrote in exercise two above and rewrite it—force yourself to cut it by at least one third.
4. Create a montage for a marriage that's falling apart, writing six or seven scenes in the montage—no dialogue, of course.
5. A 13-year-old girl doesn't realize why she's always frightened when she goes to visit her cousin on his family's ranch—until she sees a pulley in the barn. Write a flashback where she remembers when she was 6 and something horrible happened in that barn involving that pulley.

PART TWO

Slogging Away

How to Know If You're on the Right Track

In both your life and your writing, there's a certain amount of work you need to do after your script is written to make sure it touches all the bases. You have to be able to pitch your story to get someone interested in reading it, you have to be sure you've got a story that hits the right emotional points and is also full of surprises, and then you have to decide how you're going to fit all the things that you need to do as a writer into your life.

The Pitch: Every Writer's Touchstone

Pitches are important. They can sell someone on you and your story. They're always oral—you do them to interest people in your story. While they can be short or long, a pitch is usually one of two things:

1. an attempt to summarize your script in a few words so that you can pique the interest of the producer/studio exec/agent/reader you're trying to tempt into reading your script, or
2. an attempt to summarize your idea for a film in a few words so that you can convince a producer/studio exec to hire you to write it.

Understanding what's needed in a pitch is fundamental to being able to sell someone on you as a writer and on the viability of your script as a movie, so it's important to know what various pitches are and how to do them so they resonate.

- *The Short Pitch*

Famously, there's something called the elevator pitch—the pitch you'd give to Steven Spielberg if you were in an elevator that would make him want to read

your script—and this is, of course, a very short pitch because you need to be able to make it in the course of an elevator ride.

Obviously, when you see Spielberg in that elevator, you have to first resist the desire to fall all over him and tell him you're his biggest fan and make him worry that you're a psycho. You need to come across as your wonderful, unique self who just earnestly wants to do him this huge favor of letting him hear about your film. Now, on the surface, that might seem egotistical—but I assure you, it's not. You're a writer who believes in the story you've written and you just want to communicate that to him. That's all. You're not trying to be his best friend, you're not trying to get him to have a drink with you, you're not trying to impress him with the depth of your filmic knowledge—you're just trying to share with him this one idea, this one story that you were passionate enough about to have taken all this time to write into a screenplay. Think about what you'd say. How could you break the ice?

"I've had this fantasy—of meeting you and being able to tell you about this script I've written—and knowing your films, I think this is a story that might really resonate for you. It's about a young woman who . . . " and then you tell your story—BRIEFLY. Ask yourself, could you do this?

You might say, "Well, that's just not me—I'm too shy" . . . to which I'd reply, use that. Use your shyness, preface your remark with a shy smile, clear your throat AND TELL THE MAN YOUR STORY. Fact is, he'll probably say, "Thanks but no thanks" anyway, but why not give it a shot? What's the worst that could happen? He'll get off the elevator, probably not invite you to the studio to talk about your story more, but being a nice guy, he'll wish you luck. So what's wrong with that? Who knows, maybe he'll give you a bit of advice to make it stronger . . . or maybe he'll have to take a call on his cell just when you get to the good part and the doors will open and he'll nod goodbye and that will be it. OR . . . maybe he'll say, "Hmmmmm. Interesting . . . do you have a couple of minutes?" And you'll join him for a cup of coffee and talk about your idea.

Most of our fantasies don't come true. Sure. We know that. We're not idiots. But still, is there something wrong with *trying* to get that fantasy to become reality? With *hoping* for the best? What does it cost you to try? To hope? To a large extent, that's what anyone in a creative field has to keep repeating as a mantra over and over and over again—you need to remind yourself that you want this bad enough to make a fool of yourself trying to get it. You want this bad enough to take a risk—even when this risk makes you uncomfortable. You need to get to the point that you realize your IDEA—your SCRIPT—is what's important, and you being embarrassed doesn't even come close to the level of importance of your work. It's about your work—it's not about you. And the work comes first. So the pitch to Spielberg? Hey, you wanted into the screenwriting game, so how can you not play?

So yes, you need to have the guts to DO the pitch. But just as important, you need to know what to SAY in that pitch. Guts aren't everything. So once you've finished your script, ask yourself how you'd do that. How would you summarize it so that you can tell it to Spielberg in a super short amount of time?

The first step you can take is to try and summarize your script in 25 (or so) words. How would you do that to show your screenplay off to its best advantage? Some examples of famous films:

- *Casablanca* [1942]: During the early days of World War II, a wry American expatriate meets a former lover in Casablanca—can they rekindle their romance or will the exigencies of war stand in their way?
- *Gone with the Wind* [1939]: A manipulative Southern belle carries on a turbulent affair with a dashing blockade runner during the American Civil War.
- *Gone Girl* [2014]: When Nick's wife, Amy, disappears on their fifth wedding anniversary, the supposedly distraught Nick comes under suspicion when their happy marriage comes under scrutiny by the press.
- *Django Unchained* [2012]: A German bounty hunter helps a freed slave rescue his wife from a vicious Mississippi plantation owner.

As you can see, whether the film is contemporary or 75 years old, you can summarize the plot in a sentence. And note that this sentence doesn't tell the whole story, does it? It doesn't tell the end ever! It's meant to tempt. It can end in a question or not, but it needs to draw us into the story. And it's not your whole pitch, it's just a summary of your story—so that sentence isn't really your pitch at all, but it gets you on the road to thinking about your pitch and trying to flesh out the story. For that Spielberg pitch, think of something that's about a paragraph long and really draws us into the story. So work on fleshing out that story and that will become your pitch. Let's go back to *Casablanca* and see how that might be fleshed out:

> *RICK is an American ex-pat who runs a bar in seedy Casablanca in early WWII. The bar is populated by scary characters, and it's clear Rick's haunted by something. On the surface, he seems jaded and like he's got everybody's number—vulnerability is a word that wouldn't be in his vocabulary. But when ILSA walks in the door, he turns to jelly. This magnetic, beautiful woman left him awhile back in Paris and it's that event that's made him the hard guy that he's become . . . and when she asks him for a favor, well, she's with another guy now, someone important in the war effort against Hitler. Will he help her? Will he win her back or will he let her go? It's a chilling time and his decision could either make or break his life. But it's bigger than that—not only his fate, but the fate of the world might rest on his decision*

And that's one way you might tell your story to Spielberg. It's not the only way, but it's a possibility. With appropriate pauses and emphasizing certain points, it's about 55 seconds. Say it aloud. Try to make it yours. Make it conversational—imagine him standing with you in that elevator. Imagine looking into his eyes and trying to convey the passion you feel for Rick's story. Pause in all the right places to give it the most compelling meaning possible.

Figure 11.1 Nick Dunne—did he or didn't he—in *Gone Girl* [2014]

Let's try this with another story—let's try to flesh out *Gone Girl*.

Nick and Amy seem to have the perfect marriage. But on their fifth wedding anniversary, Amy vanishes. Has she been kidnapped? Murdered? Nick seems distraught—but is that a cover for the fact that he's killed her? The press—on his side at the start—find out he's lied about a few things and public sentiment turns against him. We're beginning to think this guy has done something horrible to her. And then, about midway through the film, we discover Amy left on purpose, implicating him! She hates him for cheating on her and wants to frame him. But on the road, she has problems that lead her to an old lover . . . whom she kills. She then returns to Nick covered in her old lover's blood and claims the lover kidnapped and tried to rape her so she had to defend herself. Nick knows she's lying—and he'd leave her in a heartbeat but she tells him she's pregnant. Since he hasn't slept with her in months, he knows the kid can't be his. But guess what? It is. They'd been trying fertility treatments and she'd retrieved his semen and used it to impregnate herself. If he leaves,

what will happen to his child, being raised by a seriously twisted Amy? He's stuck—and he knows it.

Again, this is just one way to tell the story. And this one's a little longer—about a minute and 10 seconds.

Notice that with the *Casablanca* pitch, you didn't reveal the ending—you just titillated your listener enough to make him/her really want to know if Nick was going to help Ilsa or not, and going to win her back or not. But in the *Gone Girl* pitch, you did reveal the ending. Why? Because it's a great twist. And with *Gone Girl*, that's part of the fun—that's part of what would win someone over to wanting to read this script . . . to see how this manipulative woman could pull this off. And it also shows that you're a writer *capable* of such a cool twist—and as it comes at the very end, it's that thing that could simply make your listener go "sweet" at the end of the pitch and smile a big smile at you to compliment you on your ingenuity.

Whether or not you ever run into ANYONE in an elevator to pitch your story to, it's a good idea to write down a pitch and refine it and refine it and refine it. You want to practice it over and over so that you really know it. You want to be so comfortable with it that you could recite it in your sleep. Then when you're at a wedding in Pasadena or something and someone introduces you to their friend, the agent, you know that pitch *so well* that you can throw yourself into it and impress the agent enough that he'll agree to read your script. Done deal.

- *The Long-ish Pitch*

In our Spielberg fantasy, let's say your elevator pitch interested him enough that he wanted you to come in and pitch it in the office. Now, chances are, you won't be pitching it to him, but you'll be pitching it to one of his development people. But no matter—you want to absolutely *kill* with this pitch. He liked the overall idea, clearly, or you wouldn't have been invited in to pitch. But you need the whole film to seem just as compelling as the 1-minute pitch did. Here are a few questions to ask yourself as you prepare this pitch:

1. How Long Should It Be?

I remember a great dinner with a bunch of writer friends in L.A. a few years back. For whatever reason, the topic of contention that night was how long a pitch should be. What was the perfect length for a pitch? Arguments were made for 5 minutes and for 15 minutes and everything in-between. After a great deal of heated discussion, the perfect pitch length was determined to be 12 minutes. Why not 11? Why not 13? I have no clue. But 12 seemed to us, on that balmy evening, to be just right.

While there's no 'just right' length to a pitch, generally speaking, less is more. You don't want a 30-minute pitch. No way. The executive you're

pitching to will fall asleep or have to leave and deal with an emergency or something to avoid listening to such a long pitch. Plus, they won't be able to retain that. You want to give them something they can retain because if they like it, they'll have to pitch it to *their* boss and you want them to be able to do that effectively.

So knowing that you're going to aim for a pitch that's around 12 minutes, map it out. Plan to take 3 minutes to pitch act one, 6 minutes to pitch act two, and 3 minutes to pitch act three. OR take a minute off each of those times and save those 3 minutes for an intro where you talk about casting and the genre you're aiming for, and at the end talk about budget and the marketplace today and why this film will succeed with moviegoers. It never hurts to remember that while they're buying your creative genius, they also have to be able to market your work in the real world, so showing that you're in touch with that world isn't a bad idea.

2. In What Kind of Conditions Will I Be Giving the Pitch?

Pitches are nearly always given sitting down. Generally, the executive will come out from behind the desk and sit across from you in a more casual setting. More often than not, you'll be sitting on a sofa, there will be a coffee table in front of you and the exec will sit in a chair across from you. I've always found it interesting that the chair the exec sits on is invariably higher than the sofa you're sitting on—it's clear where the power is and it's rarely with the writer!

While I've heard horror stories from friends—like one about an exec who sat in his desk chair, turned around and looked out the window for the entire pitch—I've never experienced anything quite that rude. The worst pitch I had was where an exec stopped me 2 minutes into a pitch. A producer was with me and he had actually worked with this exec on another film, so she should have been predisposed to like something coming from him, but she stopped us and said she just knew she wasn't going to like the idea. And I was like, "Really? You're not even going to give us 10 minutes?" But she wasn't. Rude? Yeah. But not everyone in this business is polite. The producer, who was very high on the pitch, proceeded to argue with her for the next 10 minutes as to why she should listen to the pitch—so, of course, she spent more time arguing with him than she would have had she just listened to the pitch!

3. Who Is the Executive I'm Pitching To?

It's a really good idea to figure this out. Do research, ask questions. Google this person, look them up on IMDB and LinkedIn and Facebook and the whole gamut of social media. And don't just find out about their career—find out about their personal life if you can. Ask other writer friends if they've met the person or pitched to her and really pump them for anything that you think could help with your pitch. If you have an agent, manager or attorney,

be sure and ask them questions about the exec you're meeting with—anything personal you can find out would be great. Married? Kids? Hobbies? Pet peeves?

I recall a pitch I had with the head of a studio—a woman, as it happens (still a bit unusual). My agent told me to tell her how great she looked because she had just had a baby and was paranoid about looking fat. When I met her, I dutifully said, "OMG, didn't you just have a baby? But you look so great!!!!" And I tried to say it as sincerely as I could. I think it's a little sad that someone who just had a child would worry for one second about how she looked—I mean, everyone knows she just had the baby, what halfway decent person would criticize her for how her body changed? So I tried to put myself in her shoes and think about how she must feel having to live up to some incredibly unfair standard we set for women when it comes to appearance—especially in a town like L.A. So when I told her she looked great, I meant it and I was as sincere as I knew how to be. The fact that I said that helped me to relate to her on a personal level and I hope it broke the ice a bit as I'd never met her before. Did I sell the pitch? Nope. But I'll bet she thinks I'm an OK person and wouldn't cross the street if she saw me coming.

Also, while you're generally pitching to one executive, there are often more people in the room. Sometimes the boss will bring in an underling as well as an assistant, the latter of whom will take notes on the pitch. Be sure to look at all of the people you're pitching to—not just the boss. Remember that today's underling is tomorrow's boss and you want them to remember that you treated them with as much respect as you did their boss.

4. What Kind of Movies Has This Studio/Company Put into Development Lately?

Take a look at the slate of films this company has produced—easy to look up on the Internet. If you liked a particular film of theirs, say so when you meet them. People always like to hear that you responded to something of theirs. But look, also, on specialty sites to see if you can discover projects that have been put into development. While websites can often change, a couple that are helpful in the current climate are www.deadline.com and www.movieinsider.com/production-status/development/. Both of these sites will show the kinds of projects being bought these days. If you're lucky enough to have an agent/manager, they should be able to give you even more information.

5. Should I Leave Them a Printed Copy of My Pitch? Or Offer to Email It to Them?

The short answer is NO. But I used to wonder about this.

When I first started pitching, I always left a summary of my pitch with the executive I was pitching to. It seemed logical to me because most of the time, there was an assistant in the room taking down my pitch—so why not give

them an accurate, well-written summary of the pitch? Surely, I could summarize it better than an assistant just hearing it for the first time. So I would leave them with a one-page summary of my pitch, a document that hit all the important points and was geared to make them want to BUY IT.

Somehow my agents got wind of the fact that I was leaving this summary with people after I pitched. I was told in no uncertain terms that I had to stop doing this—"You don't write for free," said my agent. So I stopped leaving my one-page summary.

But I still wondered about that. After all, what IS the advantage of having an assistant in the room rapidly take notes to summarize it? If they're really going to think about buying my pitch, I'd like their discussions in that direction to be based on accurate info. But the reality is, what sells your pitch isn't just words on paper—it's your passion. And no matter how good a writer you are, those words on the page can't convey your passion to write the story. If the executive has your summary, they'll pass it on to their boss rather than try and pitch it—no passion there! So if the executive has to pitch it orally herself, she'll be trying hard to *convey* that passion. Her boss will see her excitement and you have a better chance of making a sale.

What do you do if the exec asks you to email you a summary of the pitch "for her boss" or something similar? Just say your agent would kill you but you're happy to come and pitch it to her boss—you'll come as many times as necessary.

And the WGA, too, absolutely forbids you leaving anything after a pitch and the company knows this. They know that asking for a copy of your pitch is against the rules! So right is on your side—don't give into the temptation to write for free. You might think you're helping sell your pitch, but you're not.

Going through the process of coming up with a pitch for your script (or script idea) is a great exercise to help you see if you're doing the film you meant to do. It can be a way to show yourself what's missing in your story or what you could add to bring it to the next level. Two things that are often missing in a script are a sense of the emotional story of your main character and the lack of surprise in the story—two elements that need to be there to sell that screenplay.

The Emotional Story: Make Sure You're On It

How do you engage your reader's emotions? Because if you want to sell a script, that's what you need to do. I wish there was an easy answer, but this is one of those elusive questions where there isn't one. It's a process, and as such, is very hard work.

If plot is what happens in your story and characters are the people it happens to, then the emotional story is the change the people go through in the course of the story. If a character remains static in a story—doesn't grow or

change at all—then your script will be static and less interesting to read. You need your characters—all of them, not just the main character—to be alive on an emotional level and to experience the events in your script in a way that impacts them deep inside.

For every major character in your script, map out not just what happens to them along the way but how their inner self changes and grows. Let's take a look at a few films to see how this often works:

- In *Big* [1988], the main character, Josh, is a young boy who's bummed he's not big enough to go on a roller coaster ride—all he wants is to be bigger, like the guys he envies. He has a best friend, Billy, who doesn't care that he's short, but Josh seems to forget that in his mad desire to be grown up. He magically gets his wish and wakes up one morning as a 20-something man. His mom doesn't recognize him and he ends up in a fleabag hotel in New York City—Billy his only friend. We see him scared and vulnerable and SO wishing he could go back to being 12 again. During the course of the film, he gets to experience everything he longed to do when he was young and the life he gets to lead at 20 starts to seduce him. Over the course of the film, Josh gets so involved with being a grown-up that he pretty much forgets about Billy and forgets about wanting to get back to his family. And in fact, being a grown-up is only interesting to him *because* he's able to maintain his exuberant childlike view of the world. But pretty soon, all he thought he wanted as an adult loses its allure and he desperately wants to get back to his family. He finds himself calling his mom up just to hear her voice. Finally, again through magic, he turns back into a young boy—and being a kid never felt so great. So in the course of the story, Josh goes from wanting something he doesn't have to realizing that what he has is all he really wants. In the course of that journey, he experiences wonder, love, excitement ... he goes on an emotional roller coaster. And in the end, when he gets back to being 12, we're happy to see how satisfied he is with himself.
- In the film *The Big Chill* [1983], a group of old college friends gets together after the funeral of a mutual friend. The married couple among the group, Harold and Sarah, invite them to spend time at their country house for the weekend. Meg is a high-priced attorney, Michael is a *People* magazine reporter, Nick is a Vietnam vet with a drug problem, Sam has become a famous TV actor, and Karen, now unhappily married, is the girl both Nick and Sam were after in college. During the course of the film, each of the characters deals with a range of emotional issues. Meg, who has been career-obsessed, begins to doubt that commitment and wish she had had a child. By the end of the film, Harold, with Sarah's permission, agrees to act as her sperm donor. Michael changes from being a crass womanizing guy to someone who values the woman he lives with

back in New York. Nick decides to take a break, get himself together and get off drugs, Sam and Karen rekindle their college romance only to discover that they both don't want to go back to the past—something they'd thought they *did* want, and Sarah puts her affair with the dead Alex firmly in the past and reaffirms her love for Harold. Each character in the film goes on an emotional journey and that journey is varied for each person.

- In *The Intern* [2015], 70-year-old Ben is unhappy in retirement so he applies to a senior citizen intern program. He ends up as an intern in an Internet fashion start-up run by 20-something Jules. She thinks he's all wrong for the job and is too busy to talk to him or, frankly, most of the people who work for her ... and her husband and kid don't see enough of her either. By the end of the film, Ben has come to be happier that he's no longer just lounging around in his retirement but actually helping someone, and Jules learns to feel more connected to the people around her and not just focused on the business alone. By letting herself be vulnerable to Ben, she grows emotionally. And that's what you want in a script—to see how the feelings of each character change and grow because of what they've been through.

In Chapter 6, I presented the 7 steps as a way to structure your film. You could use the same system to do a kind of *emotional timeline* for your main character. How is she emotionally at the beginning? How does she change throughout the script? Does she backslide at any point when it comes to her feelings? Does she explode at some point because she's been bottling things up? Does she deny that she has any emotional issues to work out? Think about doing a kind of structural emotional timeline for your main character and see if that doesn't give you a better window into her soul and thus help you see how she can change/grow as your story progresses.

The Element of Surprise—And Why It Makes All the Difference

One of the ways you can be sure I won't commit emotionally to your script is if it's trite. If I know what's going to happen next, well then, why would I care to keep reading? If I, as a development exec or producer or agent, can predict every move of the action, then it holds no surprises and I will throw your script across the room and pick up the next one from the limitless pile on my overflowing bookcases. To capture my attention as a reader, you need to surprise me on every page.

This is a hard rule to live by as a screenwriter, but it's true: every single scene should surprise your reader in some way. Every scene should leave me, as a reader, going "Cool!" at some point or "Wow!" or "Oh no!" And when I start

the next scene, I should eagerly look forward to figuring out what's going to happen next. Think about telling a story to a child. The child sits on your lap and as you tell the story, he/she eagerly asks when you pause, "Then what happens?" And they really don't know. And there's excitement in their little face at the anticipation of what's going to happen next. They want to be surprised, excited, scared, etc. They're eager for it. They can't wait. Now think of your script reader as a child—appeal to that child in every jaded exec, agent and producer, and make them want to keep turning those pages to see what you've come up with. Can I tell you how to surprise us with your writing? Not really. But look at your story—where is it now and where do you want it to go? And what's an interesting, different, unexpected way for it to get there? If you're deeply into your story, if you're driven to tell it, ways of telling it that will surprise us will come to you. In fact, if you're truly into your characters and your story, guess what will happen? Your characters will start telling you what to do.

So you're aiming for surprises, twists, unexpected turns—and not just in plot but in character as well. Start thinking about surprise, suspense, and the unexpected and see where that leads you. Remember that what may surprise one person might not surprise another. In *The Sixth Sense* [1999], I was bored to death—figured it out after 20 minutes. But a lot of people were fooled. Go figure. You do better. Fool ALL of us . . . or at least try to.

Interestingly, Hitchcock said he preferred suspense to surprise because when you blow up a bus, it shocks people for a second or two, but when you show the ticking bomb that's *going* to blow up the bus in 5 minutes, you have the people on the edge of their seats for those whole 5 minutes. For our purposes, suspense is in the 'surprise' family, so aim for that as well and you'll keep me turning those pages.

It's important to realize that it's not just in horror/suspense films that we want to see surprises and twists. It's easy to come up with examples of suspense/surprise in classic suspense films like *Alien* [1979], *The Shining* [1980], *Scanners* [1981] and *Psycho* [1960] . . . but ALL films that are special have their moments of surprise. Look at *Raiders of the Lost Ark* [1981]. Remember the swordsman fight scene? Where Indiana Jones is challenged by the master sword fighter and we wonder if our hero can possibly compete with this master swordsman? What happens? Indiana throws down the sword and just shoots the guy. It's not only surprising, it's hilarious.

Other famous surprises or twists—Rick giving up Ilsa at the end of *Casablanca* [1942]. I mean, how often does that happen? The hero not getting the girl—and willingly letting her go! Then in *Tootsie* [1982], there's the moment at the end when Dustin Hoffman's Dorothy Michaels reveals himself to be Michael Dorsey on a live taping of the soap opera, to the surprise of friends and viewers alike!

Language itself can also be a way to surprise people. When *Gone with the Wind* [1939] was made, Rhett Butler's final line, "Frankly, my dear, I don't

give a damn" was a shocker—both for the use of the word 'damn' and the fact that he LEFT her! What hero leaves the heroine at the end of the movie?

And in *Speed* [1994], at the beginning of act two, Jack is led on a wild chase to stop the bus, then boards it when he realizes the bomb is armed . . . but when Jack says he's LAPD, a passenger pulls out a gun, assuming Jack's come for him, but the passenger shoots the driver by mistake . . . so plucky Annie has to drive the bus. This is a surprise not only because a passenger is carrying a gun on the bus but also that he shoots at our hero. And, of course, this young woman having to drive the bus in this scary situation is also a surprise twist.

You can certainly use dialogue to indicate surprise. A good example is in *Legal Eagles* [1986], where lawyer Robert Redford surprises the jury—and the audience—by pointing to his client and saying, "Even I think she's guilty." It's not something a lawyer would say and with his delivery, we even laugh at the line.

Sometimes you can surprise an audience by making them think a character is one thing and then revealing that he/she is something quite different. In the classic *North by Northwest* [1959], this is done three times with the character of Eve. First, she's helping our hero escape the bad guys, then we find out she's *with* the bad guys and she sets him up to be killed, and the third twist is when we find out she's a government agent working undercover with the bad guys.

Figure 11.2 A chase in a cornfield in *North by Northwest* [1959]

You can even surprise an audience with a location. Again in *North by Northwest*, instead of sending Thornhill to a dark warehouse for the attempt on his life, the bad guys send him to a cornfield at noon! An improbable

place for an attack but one of the most memorable in cinema history, and that's *because* it was so different, so unexpected.

In *Jaws* [1975], the constant suspense is where the shark is going to strike next. Right from the beginning, we're on edge, wondering, and then we see the girl swimming, and CHOMP. Then later in the film, when we think it's going to get the sheriff's son and the sheriff and his wife run to get their boy out of the water, it ends up being another boy who the shark kills. Misdirection—often the mother of surprise.

In *Rear Window* [1954], our hero, Jeff, is wheelchair-bound, so when the villain, Lars Thorwald, comes to his apartment to confront him, Jeff can't run away. So he picks up a camera—the kind they had in the 50s with actual flashbulbs—and uses that FLASH to try and blind his attacker. A less imaginative writer would have had him have a gun in the apartment so he could just shoot the attacker. But this scene is much more suspenseful because one flash only stops Thorwald for a few seconds, and Jeff has to pop out that flashbulb, insert a new one, and flash it again to try and keep Thorwald at bay before help comes. Can he do it, we wonder? It's super exciting.

Endings are great places for surprises—and it's a great time to surprise the audience, to give them a final twist, because this is what the audience leaves the theatre remembering—and we all love good surprises. At the end of *The Sting* [1973], we find out Gondorff ISN'T dead but his death was faked and Hooker DIDN'T kill him and is the good guy we always hoped he was after all! Well, it's a celebration of an ending. And, of course, there's the iconic *Citizen Kane* [1941], when we wonder what that final word of Kane's, "Rosebud," meant—and we discover it's merely the sled he had as a kid. SUCH a surprise for a billionaire who's had it all to have that be his last word. (I would have said 'spoiler alert' but I can't imagine anyone reading this book who hasn't seen this classic film.)

The best place to establish that your film is going to be full of suspense and twists is right at the beginning. And it's important to remember that surprises don't always have to be huge things—they can be small, innocuous moments—they just need to surprise us. A good example of this is the opening of *Charade* [1963]. There are at least 10 surprises in the first 10 minutes of the film:

1. In the opening scene, we see a bucolic European valley in the early morning. A train goes through this idyllic location and BAM—a body is thrown off a train.
2. In the second scene, we're at the top of a Swiss mountain at a fancy ski lodge and our main character, Regina, eats and eats as she talks to her friend about getting a divorce because she doesn't really love Charles, and in the distance, a GUN points directly at her head. Then she's SHOT . . . by a water pistol!

3. Regina exchanges banter with Peter Joshua who asks if he can call her—but she gives him a bit of a hard time and makes it difficult for him to even talk to her.
4. Regina returns from her ski trip to find an empty apartment—all the furniture, all her clothes, everything is gone.
5. Running through the apartment in astonishment at what she's found, she SLAMS into a policeman.
6. At the police station, she can't answer questions about her husband—doesn't know his family, how he makes a living, where he keeps his money, etc. Both the policeman and we think this is absurd that she doesn't know her own husband very well—and she agrees.
7. When the policeman asks Regina if she minds him smoking, she says she does—very unusual for a woman to say in the 1960s.
8. Regina learns her husband has multiple identities when the policeman shows her his five passports, and when he tells her that $250,000 is missing from the auction where he sold the contents of their apartment, she is astounded.
9. Alone in her empty apartment, we see Regina smoke—a surprise after we remember she wouldn't let the policeman smoke.
10. A door creaks... we wonder what's going to befall her now? And it's Peter Joshua, from the ski lodge, there to console her—a big relief.

And *Charade* is a film where the suspense and surprises don't stop—they continue throughout the film and are a big part of what makes it such a delight to watch.

Another great way to show surprise is when the audience knows the bad guy but the hero doesn't—and we are on the edge of our seats wondering if the bad guy will take our hero in or if our hero will figure it out before the bad guy can hurt him. A terrific example of this comes from *Die Hard* [1988]. There's a point in the film where our hero, John McClane, goes down to the bowels of the building in search of a way out or a way to communicate with the outside world about the villains who have taken over the building on Christmas Eve. We see the bad guy, Hans Gruber, down there. And so the surprises begin:

1. Gruber puts down his gun—not something a villain normally does.
2. When Gruber jumps down, McClane is there pointing a gun at him.
3. Gruber pretends to be one of the hostages by faking an American accent.
4. Gruber tries to get his gun back, but without success.
5. Suspicious at first, finding this guy in the basement, McClane buys Gruber's story that he's been hiding down here to avoid being taken hostage like everyone else.

6. McClane gives Gruber a gun—and, of course, we're wincing in the audience because we know Gruber will kill him given the chance.
7. Gruber says something clever as he fires the gun, but surprise! McClane had taken out the bullets.
8. McClane's superiority lasts about 2 seconds, though, when Gruber's guys appear.

At every moment in this scene, something unexpected happens that throws us a bit off-kilter. Will McClane be taken in by Gruber? Will Gruber torture him or something? It's all very exciting.

All the work you do writing! And then pitching, going over your story to make sure you've hit all the emotional points and told the story in a surprising way . . . this is a lot of work. And unless you have the luxury of a rich uncle to support you while you do this, you're probably under a bit of time pressure. So that's another part of slogging away—finding the time and routine to let you DO all of this.

The Writer's Life—And How to Live It

Even if you haven't been paid yet to be a writer, it's a good idea to start apportioning your time as if you WERE paid. In many ways, you want to truly think of writing as your job—your real job. Sure, you may work downtown at a job that pays the rent, but your real work happens in front of your computer. I'm not naïve enough to say that if you think you're a writer, you'll be one—because you have to do the work. But you're a writer if you write—remember that. Whether you're paid or not is an entirely different subject.

Decide on a Routine That Works

First, ask yourself how you want to write—on an old, beloved typewriter your grandfather owned, by hand on yellow legal pads, or on a laptop? Pick what's best for you but realize that you don't *have* to have certain equipment to write. Writers deprived of pencils/pens while incarcerated have actually used their own blood as ink to write on the walls (I'm not recommending this). Point is, a writer writes with what's available. If you have the luxury of a laptop, you can take it anywhere—but a legal pad or notebook can go anywhere too, so whatever you have, you can always write.

Second, ask yourself where you want to write. If you have a home office where you can go in and shut the door, fantastic. If not, setting up a desk in the corner of your bedroom might work—or simply sitting up in bed, your laptop or notebook propped up on a pillow in front of you, can be a comfortable location in which to write. Whatever location you pick, it would be

nice if you had privacy. But if privacy isn't possible, while the family watches TV, put in your earphones and listen to soothing music while you write. The point is, whatever logistical restrictions you're living with, you can carve out a place and space for your writing.

Most importantly, think about when you feel most creative. You may feel more creative at night, but you're too tired to write at night so you have to do it in the morning or on your lunch hour or on the weekends. Sometimes when we FEEL more creative isn't the time when life gives us the freedom to BE more creative. So you have to balance when you like to write with when you can work the writing into your life.

Different writers write at different times of the day. I know a writer who writes every morning until noon and then stops. If the clock strikes noon and he's in the middle of a sentence, he stops. I know another writer who only writes after his family is asleep at night. And I know another writer who gets up *at four in the morning* and leaves her comfortable house to go to a local diner and write until 7:00 am, when she has to go to her job. (Since the diner was relatively deserted at 4:00 am, the wait staff got to know her and soon were sitting down to chat. Over time, they all got so friendly that much of her writing time was taken up talking with them—she had to switch diners to get her writing time back to herself!) Sylvia Plath famously got up every morning 2 hours before her kids woke up. When I was a struggling writer in L.A., I worked in an office and always wrote during my lunch hour. Then, at 6:00 pm, when everyone left for the day, I'd stay at my desk and write for a couple of hours. It was a quiet place and most people were gone—plus I avoided the worst of the commute, never a small thing in L.A. My point is, look at your life, your obligations and your preferred time to write and see if you can figure out a routine that works for you that won't add to the stresses of life but enhance your quality of life because you're doing something you want to do.

One question to ask yourself: "Am I a morning person or a night person?" I'm lucky, I can write anywhere, anytime. Generally, though, I'd say I'm more creative at night. For me, there's something about writing at night when everyone else is asleep that makes me feel like I'm using the time that other people don't see or don't notice. I find myself less alert in the morning when I have the cares of the upcoming day to think about—if I write later in the day, I've done what I need to do. But I have friends who find if they write first thing, it makes them feel great the rest of their day. You have to discover what routine works for *you*.

Once you do discover a routine, stick to it. You need to think of writing as something you have to do every day (if possible). You wouldn't forget to brush your teeth every day, would you? Writing has to be that much a part of your routine. You brush your teeth so they won't fall out when you're old and leave you to become gummy-smile-man. It's healthy to brush your teeth. And it's healthy for your inner creative spirit to write. Give yourself a day

off when you need to. If you go away for a romantic weekend, that might be the time to not take the computer with you. But beyond the really important exceptions, try to write something every day.

It's up to you whether you give yourself a time period or a word count to achieve every day. All writers are different. You can choose to write 2 hours a day or 6, or you can choose to write 500 or 2,000 words a day. No one's standing over you forcing you to do anything—this is your choice. But once you've given yourself a realistic goal, try and stick with it. You can always revise that goal if you've given yourself too much to write or too long a period to write per day. I'm good for about 4 hours in a row and then I really have to take a long break. But it depends. If I'm toward the end of a script, I sometimes can't wait to 'see' the ending and how it plays out, so it's just like reading a book where you can't wait to see how it ends—I can't wait to finish a script so I can see if it turns out the way I thought it would or if the characters take me in a different direction. I once wrote 27 pages in one day because I was so anxious to get to the end of that script. But believe me, that's definitely the exception!

If you live with a significant other, or with kids, tell them how important your writing is to you. Let them share in helping you find the best time for you to tackle this thing called screenwriting. Reward them with quality time in exchange for that support.

Bottom line is, you don't want to write to the exclusion of living! You're presumably writing to enhance your life, not to replace those who are in your life with this solitary activity. And believe me, it's a solitary life. You should be quite happy to emerge from your writing time each day into the bosom of your world and the family and friends in it.

Everything Is Material

How do writers see the world? Do we look at things differently than other people? How do we choose what to write about? What makes a writer's view of people and the world more valuable than any other person's view? Why does the public pay money to go see movies written about what that person called a 'screenwriter' chooses to write about?

As a writer, you choose what you wish to write. I know writers who claim to use none of their own life in their writing—though I doubt the veracity of that claim. Even if you're writing about creatures on another planet, those creatures are a part of you and your life experience, so there will always be *something* of you in those creatures. What if they're monsters? Does that mean you have a monster side to you? Well, yeah, somewhere, on some deep level, maybe. But it also might mean that you have a curiosity about what drives people—or monsters—to be the way they are, and in trying to figure that out, you get into what you feel *would* be the mindset of such a person or creature. But it's always you getting to the bottom of that character.

But what if you happen to live in some remote location and really don't have the life experience of, say, a Hemingway—is this going to hamper your ability to write? I was speaking on screenwriting at a writer's conference in Hawaii and at that conference I heard Luanne Rice, the best-selling novelist, speak on writing fiction. She talked about acquiring life experience. Worried, at 19, that staying in college in Connecticut wouldn't provide her with the life experience she needed to be a writer, she quit college and worked at a series of jobs in different places geared to provide her with that life experience. She worked on a scallop fishing boat in New England for a year, she was an au pair in Paris for a year, she was a maid in a Newport mansion for a year, etc. And what does she write about in her novels? Families and relationships—she writes about what it means to be human and how we relate to one another. Did she need to work on a scallop boat to do that? I remember her smiling and saying, "Probably not." And chances are, you don't either. However, life experience, in whatever varieties you can manage, will always enhance your writing.

Wherever you are, you just need to keep your eyes and ears open to the life that goes on around you. If you're in the grocery store and you witness a husband and wife fighting over the fat content in the cottage cheese they're going to buy, take it in. Ask yourself, are they *really* fighting about that cottage cheese or is this argument a cover for something else they want to fight about but are afraid to? Is there something wrong in their relationship that's causing them to fight about every little thing—cottage cheese included? Or is it just that the wife wants the husband to lose weight and is trying to change his habits and he's resistant? Whatever it is, it's material.

If you have a fight with your girlfriend, alas for her, it's material. Believe me, you'll find yourself using that fight—how you felt, what your motivations were, how you imagine she felt, what her motivations were—some point down the road when you write a scene about two people arguing. If you're not in a committed relationship and are dating, I would encourage you to warn your dates/potential partners to be aware of what they're in for because a writer's life experience fuels his/her writing. What's said in casual conversation, a small aside even, can appear in your next screenplay. Sometimes I've written something and worried that the person I based that scene on would recognize him or herself in it—but guess what, often they don't! I think this is because you bring your own, unique interpretation of that moment to it when you're writing something at a later date. And the change of character as well as context doesn't make the person who inspired you to write about that moment any the wiser. It's famously said that people don't recognize themselves when you write about them, and I expect this is often true—because the writer is always writing a personal *interpretation* of how that person behaved, and that interpretation changes the original conversation just enough so that the person it was based on doesn't see it as him/her at all.

Sometimes this idea that everything you experience as a writer will later become material for you to write about can be a very good thing. If you experience a death that shakes you to your soul, it's a horrible thing. The *only* upside I can think of for a writer is that it gives you the opportunity to later try and communicate what real loss feels like. It's one thing to write about a character who has lost her husband in a war—and if you're a good writer, you can hopefully do that well—but if you've personally lost a spouse, you know what loss *feels* like, and that knowledge of the absolute emptiness at the core of your being will more vividly come to life for the character you're writing because you've felt what she's felt in losing her spouse.

Actors study something called 'sense memory' to help them play a scene. If they're in a scene where they're trapped in a locked room, they try to remember a time in their own life where they were trapped in an enclosed space, and remember what that *felt like*, and use that real memory to portray how their character feels in the locked room. You can use this same technique in writing—think back to when you had an experience similar in some way to the experience your character is having in a scene. Your goal is to try and use how you felt then to portray how your character feels. The more genuine you can make your character's response on an emotional level, the more realistic your scene will be.

A couple of years ago, I was at a Bastille Day party at a lovely house in the French countryside. The party was taking place outside the house on the grounds but food was occasionally brought out from the kitchen and, of course, the bathroom was in the house. I walked inside, used the bathroom—and couldn't get out. Seriously, something had happened to the lock and I couldn't unlock it. This was the smallest bathroom I had ever been in—toilet, bijou sink in front of the toilet, door . . . that was it. At first I couldn't believe it—how could the door be unable to be unlocked? That made no sense. So I kept fiddling with the lock, figuring I was just doing something wrong. But it became clear that the mechanism was simply stuck. So I pounded on the door—nothing. Surely, I thought, someone else at the party would soon have to use the bathroom and I'll be rescued. But several minutes went by—nothing. There was the tiniest window on the planet beside the toilet so I opened it and yelled—nothing. The party was on the other side of this very large house so no one was back on this side to hear me. Did that stop me from yelling? Of course not. I was convinced I could attract someone's attention. Surely, my voice would carry. But no one came running. I then went back to pounding on the door—nothing. Everyone was outside having a grand time eating all that great food, and here I was, trapped in this closet of a bathroom. In a short amount of time, I went through a myriad of emotions—denial, incredulity, anger, hope, anxiousness, self-pity, and a few others. Didn't my husband notice that I'd now been gone for 20 minutes? Didn't he wonder where I was? I pounded some more. Then I finally gave up yelling and door

pounding. I sat back down on the toilet seat, picked up a magazine from the reading material supplied for the room, and read. I made peace with the fact that, eventually, someone else would have to use the facilities and then I'd get out of here. And I finally laughed. What a ludicrous situation this was! Just imagine how everyone would ridicule me for years to come. "Remember that Bastille Day when you were locked in the loo?" I rolled my eyes as I turned the pages of the magazine. Then I heard footsteps. I jumped up and pounded on the door. "Au secours!" I yelled—that's "Help!" in French. And I was found. And the owner was called—he retrieved a key and unlocked the door. "You locked the door?" he said to me in French. "No one ever locks that door." And that spurred my final emotional response—murderous intent. How in the world was I supposed to know not to lock the door?!

That's a half-hour span of my life and it's overflowing with feelings. And it WAS such a ludicrous situation that it's remained vivid in my mind. When I want to write a scene about a woman's anger toward her husband, I can tap into those moments when I was mad at him for not realizing I was gone. When I want to write a scene about someone who's trying to change the world but no one seems to care, I can tap into how I felt yelling out that window into a world where no one responded. If I want to write about a child locked in a closet by an abusive parent, I can remember that initial feeling of being trapped and not having the control to open the door and just leave. There are SO many scenes I might write in the future that will seem more real—more true—because I'll be able to remember the feelings I felt on that Bastille Day when I had the bad fortune to get locked into a bathroom.

So *anything* in your life that happens can be material for your work—sometimes remembering that makes it easier to get through life's difficult times.

Form a Writers Group and Stay With It

You can certainly take a class in screenwriting—many schools offer such courses at night and more and more world-class institutions offer classes online as well. Taking a class will force you to write some pages each week and give you the opportunity to get feedback on your work from a professor as well as other students. If you do take such a class, look carefully at the credentials of the person teaching the class. Ideally, you want a professor who doesn't just have a degree allowing them to teach writing, you want someone who's been paid to write screenplays by studios or independent producers. A professional screenwriter will invariably be a member of the Writers Guild of America (WGA) and that's proof they're a professional in the field. But taking such a class will cost money and might be out of reach for some. A great alternative is to form a writers group.

When I went to L.A. in 1990, I had no clue what I was doing and knew no one. I went to hear screenwriters speak whenever I could and I started

reading screenplays—I advocate both as a means to get to know the business. Listening to what others have to say about writing can help you form your own writing ideas. And reading screenplays is hugely important. If you're like me, you want to write films because you love movies. But if you're like me before I went to L.A. in 1990, you've only watched films—you've never *read* them. There's a huge difference.

Seeing a script in print is hugely important. I remember before moving to L.A., I went to an event where a writer of children's books was speaking—I'm sorry to say I don't even remember her name. And I wasn't even interested in writing children's books but I was interested in writers—I'd never met one and to me they were almost a different species. As this writer spoke, she passed around the room the typed manuscript for one of her books. I was listening to her and trying to take in all her wisdom about writing when the book was passed to me . . . and I stopped listening. I was holding an actual manuscript of something that was *published*. Wow. I just stared at it. I ran my hand over the first page, then I flipped to the next and the next. This was a *real* book, just as it was when it came out of her typewriter. There's no doubt that in my mind, this was something holy. But this was the point that I also realized what this novel was—words on paper.

Words on paper. That's what a screenplay is too. Just words on paper. It's not magic, it's not something only the chosen can do—if you can type, you too can put words on paper. Doesn't mean they'll be great words, but you can do it. But as such, those words can always be changed. So it's not like being a surgeon where a mistake can mean death to a human being. You make a mistake in a scene you've just written and you just redo it. But you need to get that point of knowing when/how to redo it and that's where a writers group helps.

You can form a writers group by asking friends you know who are trying to write to get together with you once a week and read their work aloud. You can even mix novelists with screenwriters—believe me, you'll both learn about writing and perhaps more than if you were just all screenwriters. If you don't have friends who are trying to write, try putting a notice up on Craigslist or some similar site about the group you want to form. Or go to a library and ask if you could put a blurb on the library's website or on their bulletin board about the group you're forming. Then talk to the people who respond and make sure they're not psychos or overly belligerent or haughty or whatever else you think wouldn't enhance your group. But don't try to just get people like you—go for variety in age, personality, temperament, etc. Really try and get a mix of people because when you read your work, you want a variety of viewpoints—that's how you'll get better.

Decide on how to run your group. Will you be the leader or will you have a different person lead the group each week? Will you meet at one another's houses on a rotating basis or will you reserve a room in the public library

to meet? Will you meet on the weekend or on a weeknight? How will you decide whose work to read each week? Will you bring copies of the work to the meeting for everyone to read or will the author read the work aloud? Will people bring their dinner to the meeting so you can work while you eat or will you order pizza each week?

While there are lots of logistical questions to answer, those aren't actually the important ones. It's crucial that you establish how feedback will be given. This is why you're forming the group—to get responses to your work. So you need the group to agree on how that will be done.

After years of being in writing groups, there are some things I've discovered that can help you maximize your feedback sessions.

1. If at all possible, *have copies of the script available for each person* so that you can assign parts and the script can be read aloud. You can email each person a script and they can read it off their iPhones, or you can print out copies.
2. While your script is being read, *do not read along*. This is the point where you sit back, with pen and paper in front of you for taking notes, and *listen to how the script sounds*. If you read along, you won't really *hear* the script and how it's coming across to the readers. So this is the time where you just listen—does the person reading your narrative stumble over some lines? Note that—maybe the studio exec reading your script would be stumbling internally at that point as well because something is clunky in how you wrote it. Does a character seem to go on and on and not get to the point? Note that and see if you can't go back and streamline that dialogue. Are the voices of the three characters in the scene all sounding sort of alike—so it's hard to distinguish who's speaking? Note that and rewrite that dialogue so that each of those three people speaks in a distinctive manner. Does a scene seem to drag? Note that and work to streamline that scene. This is the time where you can stand back and see how what you've written really sounds—and if you do that, there's a chance you can fix it and make it sound better.
3. After your script has been read, *do not speak*. This is HUGELY important. Here's the thing—most of us writers just want to be told we're brilliant, that what we've written is Academy Award-worthy. But we have to get past that because if we want to write something good, we have to be willing to see it as others see it and fix what needs fixing. The natural instinct when we hear what we perceive as criticism is to defend ourselves. So when someone says they didn't understand why Sally slapped Tim in your scene, your instinct will be to jump in and explain why. AVOID GIVING IN TO THAT INSTINCT. Instead, the group should chime in and all give their opinion on that point. At the end of the discussion, the

outcome could be that no one understood why she slapped him OR that everyone except the first person who spoke understood why she slapped him. But if you chimed in to EXPLAIN what you were going for, you'd never know what people's *real* reactions were! One of the best ways for you as a writer to benefit from the feedback session is if the group simply pretends you're not there. You're a fly on the wall. In many ways, this is the truest feedback you'll ever get. Imagine your script being read by a group at the studio over the weekend and they come together to talk about it on Monday. Do they sit around and worry about saying what they really thought about the script because they're afraid of hurting your feelings? Are you kidding me? You and your feelings don't even enter the picture. The focus is on the script and how to make it the best it can be—and that needs to be the focus of your group, but this can only work if you as a writer KEEP YOUR MOUTH SHUT and don't try to explain why you wrote it the way you did. The point is, you *know* why you wrote it the way you did. The question is, did they get that? If they didn't, you want to listen for why so that you can fix it. Period.

4. So this is where each of you in the group agrees to *make a pact to say EXACTLY what you think*. No "wow, that was really good" or "I really liked it"—because those sorts of comments do nothing for the writer. The overriding goal in feedback should be to talk about what worked and what didn't work. And the majority of time should be spent on what didn't work and needs to be better. In a real notes meeting at a studio, after you've turned in a script and they read it, the focus of that meeting will be to tell you what they want changed—i.e., everything they felt didn't work that they want you to rewrite. And that should be the focus of your group. Sure, tell someone if you liked a particular scene—but you know what the writer's instinct will be . . . to smile and say "thanks." I'd like to get writers to the point where, when someone in the group rips apart a scene, the writer would smile and say "thanks." Because that's what you want—you want someone to be honest with you about what didn't work so that you can fix it before someone important sees it! A real friend will make that pact—will tell you exactly what they think—and you'll do the same for them. This is a real gift that you can give to one another and a gift you should be thankful for with every comment you receive.

5. Be sure to *write everything down* during your feedback session. One of the easiest ways *not* to start explaining and being defensive during a feedback session—even though you won't be explaining out loud because, as you recall, you're not saying anything during your feedback session—is to just write everything down that's said during your feedback session. Don't give yourself time to even think about responding or think about

what you'd say if you *were* allowed to talk—just write it all down. Pretend you're a court reporter and your job is to get it all down on paper. This will leave you with accurate notes of the feedback session that you can review at your leisure. If you *don't* write notes, you'll be internally arguing with people as they talk about things that didn't work for them and you won't really remember the full conversation, so that's no help when you go to rewrite.

6. Try and *forget your ego* because the focus needs to be on making your work better, not making you feel better. Try and divorce your 'self' from the work. Your script is its own entity—it's not you. No one is criticizing you, they're criticizing what the characters in the script did or said—that's all. Your ego should not be on the line here. This is a tough one because, of course, this is your baby. But get yourself to the point where you can do this.

7. It's important, also, to *be respectful* with all your comments. You can rip a scene apart but there are different ways to do that. No need to say, "Tom's dialogue is so lame—he'd never talk like that" because that's a broad criticism that the writer could take personally. You can say the same thing by focusing more specifically on why you felt that way: "Tom saying 'why should I care what you think' didn't work for me. It made him come across as too hard, too dismissive." Now, when you hear that as the writer and later you review it, you can ask yourself—did you want Tom to come off as hard and dismissive there? If so, then there's nothing to change. But if you didn't, then you need to think about how you could soften the line so that people don't misinterpret his character. The point when giving feedback is to say *exactly how you perceived* the character, the scene, etc.

8. And finally, remember that during a feedback session, *there is no right or wrong answer*—everything that's said is the opinion of the person speaking. You're entitled to your perception of a scene and another person in your group is entitled to have just the opposite opinion. You can think that violence in a scene is gratuitous and everyone else in the group can see it as perfect for the moment. It doesn't mean that they're right and you're wrong—*you're entitled to your perception*—and it's only when EVERY PERSON shares their true perception that the feedback session has a chance of working and the writer has a chance of hearing all opinions. And hearing all the honest opinions is the only thing that will help each writer in the group make their script as good as it can be.

A good writers group is to be tended and nurtured like the vines growing the grapes that will produce a fine wine. This means you don't meet once a month—you meet once a week if at all possible. Have a group that's big

enough, though no more than 10 or so, so that when a few people can't make it on a given week, you still have enough people to have good feedback sessions. Agree this week who will bring pages to read next week—that way you'll know people are counting on you to bring pages and you'll be more inclined to work on them and have them ready. Whatever the format you decide, however you decide to handle logistics, form that writers group and stick to it—it's the one thing that can improve your writing faster than anything else I know. While it's true that your writing will probably improve with every script you write, it will improve on a weekly basis as you take in feedback and use that to make the script the best it can be.

Travel. Seriously. Everywhere.

Travel, you're asking yourself? What in the world does that have to do with writing? A good question and I hope the answer surprises you because I think it has everything to do with it.

One time when I was invited to speak on screenwriting at a college in the Midwest, a professor at the college picked me up at the hotel and drove me to the campus for my speech. We drove through town on a beautiful fall day and the leaves were crisp and colorful. As the road curved, straight ahead was a canopy of trees—you know what I mean, where the trees seem to have grown from each side of the road so high that the branches touched each other overhead. The light coming through the leaves absolutely sparkled—it was breathtaking. "Wow," I said to the professor as he drove the car, "that is so beautiful." He looked around and said, "What?" "The trees," I said, "the way they form this tunnel of light." I remember him looking up, and then a smile broke over his face. "Yeah," he said, "isn't that something. I drive down this street every day and I never noticed that." We both marveled at the majesty of those trees.

Why had he never seen that? After all, as he said, he drove down that street every day. He never noticed it because it was just there—he took his drive for granted, as we all do on our way to work, and he didn't see what was special about it. After all, it was an ordinary street in an ordinary town and it looked like a lot of the other streets in his town and he was used to that look. It took someone to whom it *wasn't* ordinary for him to see its majesty. Had this professor come to my home town and I'd been the one to drive him down a street familiar to me, he could have easily pointed out something that I saw every day and didn't appreciate.

The point is, we all have our routines, the places we live and play in, and we're there so much and repeat what we see so much that there's little chance we'll see anything different. We expect to see certain things and we do. The minute we go someplace new, our brain gets hit by *unfamiliar* stimuli and we see more. That's right, we actually see *more* because we're not taking anything

for granted. I swear, I can walk down the streets of Manhattan and get three story ideas on three successive blocks—because I'm bombarded with all kinds of people and smells and store windows that make me think about different things in different ways, and BAM . . . a story idea is born.

If you want to stimulate your imagination, travel somewhere you've never been before. Not only will you enjoy seeing a new place, but you'll also help your writing. And if you can't afford to go to Europe or another state, drive 20 miles to the next town. Or get on a bus and travel an hour or two, stroll around a different city, have lunch in a different place, and take the bus back. Can't even afford that? Take a different route to work every morning. If you live in a city, don't take your normal subway or bus—take a different route. Get off a stop before you normally do and walk the rest of the way. If you travel to work by car, take the long route—a way you wouldn't normally go. *Anytime* you vary your routine, you have a chance to see different things and that's going to help your brain think a little differently—and that can help your writing.

If you're doing research on a particular location in which to set your script, it's very important that you go there. Things will come to you, ideas for scenes and characters that you'd never get if you just sat at home in front of your computer. And if you're writing a script about someone who really lived, it's imperative that you go to where they lived or traveled so that you can see what they saw and imagine what they felt based on the stimuli around them in their home or their travels.

Even during the writing process, I'm a big believer in looking out at a changing scene while I write. When I get a writing assignment, I don't always hunker down and write in my house for 3 months—I travel someplace and write there. But whether I'm writing at home or in a different location, I like looking out at an expansive view. Maybe it's the ocean or maybe it's an expanse of rolling hills, but having that long view gives me the feeling of limitless possibilities and I swear it lets my imagination fly. But we're all different. You need to write in a place that you find stimulating. And if you live in an apartment that has the view of an airshaft, well, think about different posters you could put up over that airshaft that would stimulate your imagination and change the posters out every few weeks to keep things lively.

Even if you're a homebody, I'd encourage you to force yourself out of your easy chair and travel if you want to expand your horizons and thereby improve your writing. The more places you go, the more cultures you see, the more a citizen of the world you become, and the more diverse characters and story ideas your scripts will contain.

PART THREE

You're Done!—So What's Next?

When you get to the end of a script, it's very exciting. You can just feel the exhilaration, knowing that you've done something that so many people say they want to do—write a screenplay. But most importantly, you've done something that *you* wanted to do—you've written a story you were burning to tell, and it's hilarious or meaningful or scary or dramatic or thought-provoking or bizarre, but it's yours. So pat yourself on the back . . . but not for too long.

It's important to understand that when you're finished writing, there's still a lot to do.

Rewriting: Hemingway Was Right

Let's assume you've taken the script to friends to read—or hopefully your writers group—and you've decided which of the comments people gave you are things you need to address in the script. This is when the rewriting begins. And it's not an easy process.

I've had notes meetings with a studio where they said, "There are hardly any changes—we *love* it. Just four or five things." And one of those four or five things is to get rid of the mother and have the main character be raised by her father. Well guess what? That one note means I'll need to change the ENTIRE SCRIPT AROUND. In a notes session, ideas for how to change the script will be thrown at you and you'll be expected to figure out how to do them. The people giving you the notes aren't actually writers (in most cases), so they really don't know the amount of work involved to change "just four or five things." If a note asks you to change the attitude of a character, that means you need to go back and rewrite all the scenes with that character in them so that the attitude adjustment is consistent throughout the script.

Rewriting is what screenwriting is all about.

Hemingway famously said that good writing was like an iceberg. Huh? Was he saying that it's a cold, lonely business? Well, that it may be, but no. He was alluding to the fact that when you see an iceberg, as towering and majestic as it may be, you're only seeing what's above the water, and guess what? You're only seeing 1/10th of that iceberg! That's right, the other 9/10ths are below the surface of the water—there's a lot to that iceberg that you'll never see—to you, that iceberg *is* the 1/10th that's showing above the water. This is a perfect analogy for what screenwriting is like—the script that everyone sees is 1/10th of what you wrote—that's how often and how extensively you need to rewrite.

When you finish your screenplay, you deserve to be excited. Absolutely. Have an ice cream cone. But save the champagne for when you *really* finish, and that won't be until you've done the necessary rewrites. And don't give yourself a time limit here. Don't say, "I'm finishing these *#%+< rewrites in three weeks and that's it!" This is the place where you need to spend your time. If this is the screenplay you want to launch your career, it has to be perfect—and you're new, no one is waiting for your script—so take the time to make it as near to perfection as you possibly can. Give yourself the best chance possible.

Remember, it's just words on paper. If a scene doesn't work—if half the people who read the script thought the same scene was weak—rewrite it. Rewrite it two or three different ways and see which one is best. Then take that new scene to your writers group and get their feedback. See why this can take awhile? But as the old adage goes, do you want it fast or do you want it right?

Proofreading—*Again*

I know, you proofread the script until it was perfect before you gave it to your readers to read—so why am I making you do it again?

Because you rewrote—you rewrote and changed all kinds of stuff, didn't you?—so the script needs an entirely new proofreading job. And this time, you have more to worry about than when you proofread the script after you first finished it. You've changed the structure, no doubt, and things that might have matched perfectly in the last version might not work anymore—so you need to make sure everything goes together in the new version and there are no holes, no places where your main character is called "Jenny" by anyone after you changed her name to "Marla."

You have a lot to do. It might be a good idea to make a couple of passes through the script. Read it once for spelling, grammar, etc.—the easy errors to catch. And read it again for more intricate plot and character things you changed. Make sure it all works.

Polishing It Until It Shines

Remember, this is your last chance to make the script what you want it to be before it goes to the agent/manager/producer/studio. There's a term in nearly every screenwriting contract called 'the polish'—and it's always the last writing step. The polish is a rewrite that you do on the script that just involves dialogue. When you're doing a 'polish' rather than a 'rewrite', you don't change the structure or the narrative to any large extent, but just 'polish up' the dialogue, if you will.

After you've proofread your script, pretend that the studio is paying you to do a polish. So you sit down and read all the dialogue—out loud, in the room all by yourself—and you work on each and every phrase until it's exactly how that character would say it.

This is your last chance to make every line perfect—take the time to polish it until you need your shades on when you read it because it glistens!

Launching It into the World

Yes, my child, there comes a time when you have to let it go.

You might think this would be easy. After all, you've been working on this puppy for a long time to get it to the perfection that it now is—you should be chomping at the bit to get it out there. Be careful here—because letting go can be tougher than you think.

I know writers who are afraid to let their script be seen because someone might steal their idea. And they're right—ideas can't be copyrighted, so if someone loved your idea but not your writing, they could tell the idea to a friend and the friend could write it and there's nothing you could do about it unless they used the actual words that you wrote. But do you see how unrealistic this fear is? Because if you never let your script be read, you can never be 'discovered'! You have to throw it out there and hope for the best. You can copyright your material online through the U.S. government copyright site or you can register it online through the WGA's website. Both involve fees but it's probably worth it to give you peace of mind. So protect it and get it out there.

There's another reason people don't get their work out there—because if they do and they're rejected, then their dream is dead ... their dream that this script will be bought and made and change their life. But once the script isn't bought, well, the dream isn't real anymore. As long as you don't send it out, you can keep that dream alive. Is this foolish? I suppose so—but it shows how deeply writers *feel*. And I can understand someone wanting to believe in their dream. But at some point, dreams have to make way for reality. And the reality is that, yes, your script probably won't be bought. But it might get you noticed. And getting noticed can lead to jobs. I know two young writers who'd written a kids' camp movie. A company

who had a book about kids in another venue—not at a camp—liked the kids' camp movie so much they brought the writing team in to talk to them about adapting the book the company had bought. The writing team read the book, went back and pitched the movie they'd write if they were given the assignment, and they got the job. They've had one writing assignment after another now for the past 8 years—they haven't had a film made yet but they're working steadily, making lots of money, and making lots of fans at the studios who like their work. And if they hadn't had the courage to send out their little kids-at-camp spec script, none of this might ever have happened for them.

So do it. Take a deep breath and start planning how to get your script into the world.

Partying—Yes, This Is the First Step

While you should certainly have a party to celebrate finishing the script, that's not the kind of party I'm talking about. To illustrate what I mean, let me tell you a story.

A friend of mine began her career as a playwright in New York. She wasn't making a living as a playwright—she was just trying to write plays. One night, she and her husband had friends over for dinner and afterwards, the husband went to the desk and took out a pile of scripts and said, "Here's tonight's entertainment. We're going to have a play reading." The play in question was his wife's—and she was *mortified*. I mean really, how dare he do this to her without asking?! But she couldn't very well pout and be all petulant so she just had to endure it. Everyone in the party took a part and they read the play aloud. Well, someone at that party who knew a theatre producer liked the play so much he showed it to him and pretty soon, my friend had herself an off-Broadway play . . . which led to Hollywood calling, and her career in writing for TV and film began.

There are a couple of things I love about this story—first, she did what she loved and that led to a career and life that was her dream. And second, I always wonder what would have happened had her husband not gone against her wishes and shown everyone her play? Would the play ever have been produced or would it still be sitting in a drawer while she went on to have a career in retail or something she wasn't as interested in?

The moral of this story is—don't wait to have a loved one or friend plan a reading of your screenplay: do it yourself. Have a party, give people some wine and munchies and a nice lasagna or something and then pull out the copies of your screenplay, assign the parts, and have a reading. Hollywood isn't going to be talking about your script unless it gets out there, and *you never know* who at your party might know an agent or producer or someone who could read your script and be impressed enough by it to want to talk to you. And you know what? I wouldn't just do this once—I'd do it a

few times. Have the same party to read the same script with three different sets of friends. One party could be for your fellow struggling writer friends, a second could be for your friends from your day job, and the third could be for family friends. Don't worry that people don't know how to read a screenplay—believe me, they'll be delighted to be in on this and have fun doing it. And at the very least, you get to hear it read aloud three times and can no doubt find ways to improve it further.

A script-reading party—your first marketing step that will also be a lot of fun!

Getting Your Script Read

As I said, there's no way to break into this business without getting your script out there in the world to be read by someone who could do something with it—or could *give it* to someone who could do something with it. And despite worries that someone might steal your idea, you have to get it out there. When I first came to L.A. and had written a few scripts, I used to carry them around in the trunk of my car—because if I ran into a supermarket check-out girl at Ralph's who had a friend who had a friend who would read my script, I'd give her a copy.

One of my first big breaks came not because I did anything but because friends in my writers group did something. My friends, a romantic comedy writing team, and I had agents but we hadn't made a sale. They were at a meeting with a young producer and it was clear she was a producer of dramas, not the kind of stuff my friends wrote, so they were probably never going to get a job with her. But as they were chatting, one of my friends noticed that she had a poster of an Impressionist art exhibit on her wall. He casually said, "Oh, a friend in our writers group has a script set in that era." She replied, "Wow. Do you think she'd let me read it?"

Well, as you remember, I'd let *anyone* take a script from my trunk and read it!

That producer was represented by CAA—she hadn't gotten anything made as a producer so she had no track record, but the agent at CAA was representing her because they'd gone to boarding school together. Nice to have connections, huh? But connections don't get you anything unless you have something to back them up. CAA did coverage on my script—i.e., had a reader summarize the script for the agency and make recommendations on whether they should bother with it—and the coverage was super-positive. Within a couple of weeks, I had that CAA producer and a CAA director attached to the script. And it almost got made—it got cancelled a few days before shooting was due to begin when the lead actress dropped out to take a more lucrative role and we couldn't replace her. So though the script was put in turnaround (i.e., on a shelf) at the studio, it got me a lot of attention and additional work and launched my career.

The irony here is that although you can work your butt off trying to make something happen, it's sometimes the serendipity of a situation—and having thoughtful friends—that can make the difference. But whatever, you need to work to find ways to get your script read—and all the time you're doing that, you should be writing your NEXT script. Because when someone reads a script of yours that they like, their first question will be, "What else do you have?" So this isn't just a one-script business—all the time you're searching for readers for a finished script, you're working on the next one.

Just as important as getting a script read, it's important to know when *not* to let people read a script. If, after readings and comments from your writers group, you're not confident that your script is better than anything out there, put it on a shelf and use your energy to get your next script read. As the producer David Heyman once said to me, "Not everything you write will be brilliant." So you have to accept that, and if a script isn't right, don't pull out the stops to get it read—do that with your next script. And this can be true even *after* you've made it big.

I was on a panel at a writers conference talking about screenwriting with Michael Arndt (*Little Miss Sunshine, Toy Story 3, Star Wars: Episode VII—The Force Awakens*) and he talked about how he'd written several scripts over the 9 years he'd been trying to break in before he got noticed with *Little Miss Sunshine*. After that big success—winning the Academy Award and all—his agents said, "Great! Give them to us and we'll sell 'em all." And to Arndt's credit, he turned that down flat and wouldn't even show them the scripts. Why? "They weren't good enough," he said. And I expect he was right. Each of us gets better with every script we write (though there's always the possibility of a clunker) and Arndt wanted people to see the work he could do *now*, now that he'd honed his craft and was simply a better writer. That, my friends, is wisdom.

Finding an Agent, Manager or Attorney

Finding these people who can help your career is tough, no doubt about it. And it's almost impossible to do if you don't live in L.A.—even living in New York makes it tougher, I'm sorry to say.

So what do you do if you don't live in, or close to, L.A. and your situation won't allow you to move? See the section later in this chapter on entering contests—that can be of help. But if there's any way you can get to L.A., do it. Use your vacation to take a writing seminar at UCLA or AFI or USC and network like crazy while you're there. And if you're super committed to writing, see if you can't move your day job near L.A. It's a big thing to do, but that's where the business is, that's where you'll stumble onto the contacts who can help you, and that's where you need to be.

Be aware that thousands come to L.A. pursing dreams like writing and acting—and only a small fraction of them get to realize that dream. But hey,

even if you don't become a screenwriter, maybe you can get a job at a studio and work in the movie business while you work on your screenplays. It's not out of the realm of possibility. One of my best friends is an archivist at Warner Brothers and he gets to help preserve the movies and the things we love from them for the future. He does important work that's going to be appreciated by generations to come, and in his spare time, he works on his screenwriting career. He's had some success, too. Who knows what the future holds for him?

I went to L.A. in 1990 and stayed 16 years—and I never really loved it. When I left to come back East, I missed friends and the Hollywood Bowl and the great weather... that's about it. But you might love it. I toughed it out until my career was established—once that happens, you can live pretty much anywhere if you write film. But when you're starting out, you need to be able to go into a meeting in person and convince them to hire you. After your work gets known, they hopefully just offer you the job or are happy to do a phone pitch. But though I don't live in L.A., I still need to go back a few times a year for meetings. If you're a TV writer, well, you pretty much need to live there because that's where nearly everything is produced. Even once you make it, you still have to be at the studio on a daily basis.

It's tough thinking about uprooting your life and going to a new city—really tough. But you know what? Your hometown isn't going anywhere. Maybe you can take the risk, give yourself 2 or 3 years to see if you can make some headway in this business, and take any job in L.A. just to give it a try. I know for me, I didn't want to be on the porch of the old folks' home at 90 wondering if I could have done it. But if it hadn't worked out for me, I would have happily come back to a part of the country I love better than L.A. and, hopefully, wrote plays for my community theatre or something!

So while it will be easier to try and get representation if you're in L.A., believe me, it still seems like one of those impossible dreams. One thing to remember as you navigate the representation waters: no legitimate agent or manager will EVER ask for money to read your script. If they do, they're not legit, and run, do not walk, to get yourself and your script away from such a person!

- *Agents*

Obviously, one of the best ways to get your script read is to have your agent send it out for you. Except there's that little stickler that when you're new, you don't have an agent.

The most common question I get when I speak at screenwriting conferences is, "How do I get an agent?"

Boy, how I wish there was an easy answer to that. Ask 10 writers how they got their agent and, believe me, you'll get 10 different answers.

When I moved to L.A., I assumed I'd break into screenwriting by following the necessary steps. I was smart—give me what's required to break in

and I'd follow every step meticulously until it happened. I knew nothing about how the business worked, but I'd dissect it and get on with breaking in. Agents? Surely, I could figure that out too.

Ha! The hubris of naiveté!

Well, after I wrote a script that I thought was good enough, I did everything I could think of to find an agent. The WGA maintains a list of 'real' agents—who agree to represent writers fairly and aren't scammers—and you could send query letters to people on the list to see if they'd read your work. I did that. (You can still do that today.) This was in the early 90s—pre-email—so you had to actually snail mail people. It took forever but I wrote a great query letter briefly summarizing who I was, what the plot of my script was, and why they should read it. And how many people said, "Hey, sure, send it to us!" Try zero. Wait a minute, make that one. One agent did say yes, so I gleefully sent it, and they immediately sent it back—they'd thought I was a client they already had with the last name of "Lake" and had mistakenly said to send it. They sent it back assuring me that they never read it.

After 9 months of this frustration, I did something I'd been meaning to do since I moved to L.A.—I visited a friend of a family member. I'm from Iowa—we have no connections in the business. Want a tractor? I can probably hook you up. But no one I knew had a connection to anyone in the movie business. But my dad had a cousin named Bonnie who lived in New York—I'd met her twice in my life—and when she heard I was moving to L.A., she said I had to go have tea with her old friend Francine from school who lived in the valley. I'd been given Francine's phone number and had been meaning to call it but when you're young and self-obsessed, it's kind of a chore to think about having to drive an hour out into the valley to have tea with an old lady you've never met. But I finally made the call.

I can still remember driving up to her home in Woodland Hills. Fancy. Like out of a magazine. And the pool in back had Greek columns—not that far off from Katharine Hepburn's pool in *The Philadelphia Story* [1940]. She was a very nice woman and we did indeed have tea—served by a maid. "So," she said, "I hear you're a writer." I told her I was trying. She asked what I was writing and I told her about some of the scripts I'd written. She told me that before she got married, she'd written for TV—after writing for the pulp magazine *The Black Mask*. Cool, I remember thinking. And she asked if she could read a script of mine. I said sure, and went—you know where—to the trunk of my car and got a script for her to read. The next day, she called—said she thought the script was "wonderful" and would I mind if she showed it to her son-in-law. "He has a little agency in the valley," she said.

I still clench when I remember that moment. "A little agency in the valley." Well, he read it and invited me in to meet. He would be too important to represent me but they'd just taken on a new agent, a young woman, and she was actively looking for clients to represent.

And that's how I got my first agent.

So what do you take from that? There's no way to duplicate the serendipity of that way of finding an agent—except by being in L.A. and meeting people and jumping on your own moment of serendipity. And any writer you talk with will probably have a similar circuitous route that he or she took to finding their first agent.

Remember, too, that there are all kinds of agents. There are big agencies and mid-size agencies and smaller boutique agencies. Some represent actors/writers/directors and more, and others represent only writers or only actors. There's no one 'right' agent—you just have to find the one that's right for you and, hey, maybe they'll find you by reading your work!

- *Managers*

What about a manager, you might ask. How do I find a manager? And what's the difference between a manager and an agent?

A manager can't talk money—only an agent or an attorney is supposed to do that in negotiating your deal for a writing job. The manager can find you the job, but your agent or attorney will have to negotiate the terms of the deal. A manager's job is to guide your career. An agent might have 100+ clients, where a manager might only have 25–30 . . . the idea being a manager is all about guiding your career and can give you more personal attention. Oftentimes these days, the larger management companies are also producers and will put their name on your script as a producer and try and package it for you. Many agencies are packagers as well. When your agency packages your film, they will often forego taking their 10% from you because they'll be making their money back in packaging.

If a manager offers to represent you, ask if you can talk to other clients of theirs if you don't know the manager's reputation. You don't have to be all haughty about it, just tell them with a smile that you're new to this and want to make a good decision.

Oftentimes, writers have both an agent and a manager. Just remember that each of them takes 10% of your income from every deal. That shouldn't stop you from having both, though—after all, if they find you work, they're worth it!

- *Attorneys*

You need an attorney to help your agent negotiate your deals and to write up your contract. Their standard fee is 5% of the deal they're negotiating for you up to a ceiling something in six figures that you can negotiate with them as your price goes up (hey, nice to dream big).

An entertainment attorney is essential in the deal phase because they know the kind of deals being done and they know the WGA provisions that a contract needs to cover.

Once your agent and attorney complete the provisions of your deal—how much you'll make in the initial writing phase, what percentage you'll get of profits, and tons of other provisions—the attorneys prepare the contract. Then the contract goes back and forth between the producer/studio's attorney and your attorney. Since a contract can be 30 pages long, full of WGA rules and what-ifs to cover a myriad of situations if the movie's produced, it can take a couple of months of going back and forth between the two attorneys before it's completed. They're supposed to redline each version they send off—this is something you can do on a computer program that highlights the changes made since the last draft. This means the attorney doesn't have to read the entire 30-page document to see what the other attorney is requesting be changed. One of the ways the attorney earns his/her 5%, though, is to find instances when the other attorney tries to pull a fast one.

In one of my first contracts, the studio attorney tried to fudge something by not including it in the redlined changes. There was a clause in the contract that said if I was on set for more than two weeks, a business class airline ticket would be provided to 'a companion' to fly over and join me on location. This is a standard clause, nothing special at all. But in one iteration of the contract, the studio attorney inserted the word 'live-in' between 'a' and 'companion' so the line now read 'a live-in companion'. But the studio attorney didn't redline that change—so if my attorney just read the redlined changes, he wouldn't have caught it. And as I wasn't married then, so didn't have a husband, and as I lived alone, I wouldn't be able to bring anyone over—unless my boyfriend lived with me, they wouldn't have to supply that ticket. Luckily, my attorney caught that attempt at inserting something that was completely unfair because he read the whole contract—he didn't trust the redlining. This is why the attorney takes 5% of your salary! They can find even more crucial dodges than this one and save you both money and agony.

In addition, one way to get your script sent out if you *don't* have an agent is to hire an entertainment attorney to do this for you. Be aware, this is an expensive proposition—good entertainment attorneys charge hundreds of dollars per hour. And unless your script is tremendous, that attorney won't be able to do anything for you. But as a last resort, if you're super frustrated finding an agent and have the money, you can go the entertainment attorney route. Not all entertainment attorneys will do this, so it's still a difficult way to get your work seen.

Agents, managers, attorneys—they're professionals that can help you with your career. Yes, they take a chunk of what you make—a total of 25% if you have all three—but the good ones really earn their money. Just remember that it's difficult to find these wonderful pros, so don't worry if it takes awhile—years even. Your job during that time is to keep working on your craft, keep honing those screenplays so that your writing gets better and better.

Entering Contests

So let's say you don't live anywhere near L.A., and for you to make the move, there has to be a reason or some real hope that it's going to be worth it. One of the ways to get noticed is to do well in a screenwriting contest. But beware! There are tons of contests out there that mean absolutely nothing.

Think about it—if you wanted to host a screenwriting competition online, what would you need? You'd need a website with a contest-appropriate name—you could design that yourself using lots of free software from various sites. You can promote it on the Internet in lots of cheap and even free ways. You'd need a prize big enough to attract entrants. You'd need to promise people their work would be read and the finalists judged by someone important—so all you need, ideally, is a writer with a credit, but if not, then a screenwriting professor or someone who worked at a studio once... this doesn't have to be a big name. And then you need an entry fee that each person has to pay—you can use PayPal and not even have to deal with credit cards or checks. Your entry fee has to be attractive enough given the money you're promising to pay the winner to make people want to enter. So let's say you offer a $10,000 prize. And let's say you have a $35 entry fee. Get more than 285 people to enter and you're into profit. Pick five of the scripts at random, have your 'expert' read them and pick one to award the $10,000. OR, if you're a total sleazebag, just have a friend win the $10,000 with the understanding that he/she gets to keep $5,000 for doing nothing but keeping the secret. And then send emails to everyone else telling them they were semi-finalists and came *so close*, and encourage them to enter your next contest, which starts in a couple of weeks. Do this 3-4 times a year and you'll make some nice pocket change.

Do you SEE how easy it would be to run such a screenplay contest? And many of them have fees much higher than $35!

The world is full of screenwriters who are desperate to get noticed and will do anything for the chance. Realize that there are unscrupulous people out there ready to take advantage of your hopes and dreams. So while screenplay contests can be terrific, be very careful of which ones you enter. There are two that stand out—the Nicholl and Sundance—and then another category of 'possibles'.

- *The Nicholl Fellowship* is sponsored by the Academy of Motion Picture Arts and Sciences (AMPAS) and it attracts thousands of entrants. Entry fees are, at this writing, $45–$85, depending on when you submit, and they award five $35,000 fellowships to allow you a year to write another screenplay. They also host seminars for you about screenwriting, etc. This is one of the most prestigious of contests. If you even get in the top 10%, you could use that to help attract an agent to read your work. Their website is www.oscars.org/nicholl/about.

- *The Sundance Institute* supports a number of programs of interest to screenwriters—the most relevant to most screenwriters would probably be their January Screenwriters Lab. They choose 12 writers to mentor and they fly them to the Institute and provide lodging and meals. This is a contest but it's really more—it's a chance to interact with other writers and work toward getting your screenplay to a point where it can get made. They charge an application fee of $40. Their website is www.sundance.org/programs/feature-film.
- There's *another tier of competitions* that seem pretty prominent in terms of writers getting noticed after submitting to them—one of them as I write this is called Scriptapalooza. They charge fees from $45 to $65, depending on when you apply, and you can order a critique of your script for an additional $100. Their top prize is $10,000. A former manager of mine told me that agents and managers troll the semi-finalists on Scriptapalooza to find scripts they want to read that they think they can sell—and Scriptapalooza says they'll promote the semi-finalists' scripts for a year. Their website is www.scriptapalooza.com/home.php.

While I'm sure there are many legitimate screenwriting competitions out there, be sure to do your due diligence—read up on them on the Internet, ask friends, and just be sure that if you're paying to have someone read your script, it's really worth the money.

Websites That Can Really Help

One of the truest things ever said about Hollywood and its relationship to screenwriting was said by the brilliant William Goldman (*Butch Cassidy & the Sundance Kid, All the President's Men, The Princess Bride* and so many more) in his book *Adventures in the Screen Trade,* and it's just a three-word sentence: "Nobody knows anything."

That was true when he wrote *Adventures* in 1983 and it's just as true today. No one *knows* when a film is going to succeed or, often, why it succeeds. No one *knows* if your screenplay is good—believe me, opinions can differ dramatically. No one *knows* what the next big trend will be in the kind of films people want to see. No one knows anything.

And yet, there are books galore you can buy about film and screenwriting, but there are also websites full of information about screenwriting, full of wisdom and both good and bad advice. And because of the web, it's all free. It doesn't hurt to look around on the web for sites you might find interesting. So explore.

The WGA site, www.wga.org, is full of info that can be of help to all writers. You'll find the MBA (Minimum Basic Agreement) there, which lists all the rules that everyone in the business needs to abide by when working with

writers, as well as charts that tell you what minimum rate you can expect for any work you do in film or TV. You'll also find helpful info on research as well as articles on topics of interest to the screenwriter.

Another site that's so full of stuff that you won't have enough time in your LIFE to explore it all is www.johnaugust.com. John is a screenwriter himself and writers who are trying to make their way in Hollywood tell me his is the go-to site. As I write this, John has just received an award from the WGA for what he's done on his site.

It's always important to remember that there's a lot more work to be done *after* you've finished writing that first draft—from rewriting and even more proofreading than you did before, to working to get the script out there so you can get noticed, it's a long haul—and you're not really done until you've done the post-writing part of what it means to be a screenwriter.

PART FOUR
Knowing Your Business

As I hope I've driven home, this is a business you're getting into—show *business*, the film *business*, the screenwriting *business*. No one is in this because it's their favorite charity—everyone's in it to make money. Of course, after an actor/producer/company has made a ton of money, they might be inclined to support making films that they aren't sure will make money but that are just high quality films—but they'll only do that at the point they can afford to do so because they have other, bigger films that could offset the loss on this smaller, quality, perhaps character-driven film.

Getting to know the business you want to get yourself into is crucial.

Understanding the Collaborative Process

If you're a novelist, you can, at this point in time, put your novel online with Amazon for people to buy—you don't even need to attract a publisher to get your novel out there. If you're a playwright, you can rent a theatre and put together a company for a relatively small amount of money and showcase your play if you can't find a theatre company willing to take a chance on it. But if you write feature films? Sorry, unless you have a few million hanging around, there's no way for your work to be seen by the movie-going public.

This means that you're going to need collaborators—and lots of them—to get that film made. And most of all, you'll need people to take a chance on you. Is it about your work? I mean, isn't it your work that they're taking the chance on? Sure. But guess what—it's also you.

Producers and studio execs want to know that they can work with you. They want to do projects with people who can be team players. And in screenwriting, that means working with screenwriters who are open to making changes in the script.

Nearly every screenwriting deal has multiple steps. Your contract most likely says that you will write a first draft, second draft and a polish. I remember being asked the question by a young screenwriter, "Well, what if it's perfect on the first draft? What if it doesn't need a rewrite? Why would they commit to pay you to write it three times if the first time was fine?" My answer? The first time is never fine, never perfect. You can be the most brilliant screenwriter on the planet but your first draft will still need work. This is because multiple people will read it and they'll all get together to talk about how it could be even better. You make SO many choices as a screenwriter, and it's entirely possible that if you'd made some different choices here and there, the script could be even better. And everyone at the studio wants to have their hand in the story. Most of the people working in film don't do it for the money—they genuinely love movies. And perhaps they can't write themselves, but they enjoy tinkering with a story to make it stronger. Sure, what someone else thinks might make it stronger, you could think will make it weaker. But hey, try it their way and see what happens. Maybe you'll discover the executive had a point.

I like to think that the executive who told you to make a particular change, and that change survived into the finished film, sits at the premiere with his wife and whispers to her—"There. That was my idea." My thought is that the executive hopes what they do has made the film better and they want to brag about that to their loved ones—nothing wrong with that.

But your job in all of this can be tough. You could go to the notes meeting and be told to make changes in the script that you absolutely do not want to make. So you refuse, right? Sure. You can do that. But you'll be off the project—and they'll hire another writer to make the change you refused to make. And who knows what else that writer will change? Usually, even if you balk at a change, you should give it a try—that's what a team player does. And in trying, you may discover a really cool way to satisfy the executive's concern without hurting the script and maybe even make it better!

I emphasize being a team player because I made a really bone-headed remark in a notes meeting early in my career that I regret to this day. I was sitting around the table with the two producers and the director getting notes on my most recent draft. One executive, we'll call her Desiree, clearly hadn't read my new draft—she kept saying things that were already in it and if she'd have read it, she'd know that. The other producer and the director both realized this and we exchanged eye contact to share that knowledge, but I thought it so rude of her to have not even bothered to read the new draft before coming to the meeting, that when Desiree again suggested something that she wouldn't have suggested had she read the script and the director got testy with her and said, "Desiree, that's already in the script," I followed that up with "But this of course would presume that you know how to read."

SILENCE. Nobody said anything more, Desiree turned beet-red, and we moved to the next note as if I'd never spoken.

But I had spoken. And to this day, if someone raises my name to Desiree, they will get an earful of how difficult I am to work with. Why? I mean, I was right—she hadn't even read the draft we were having the meeting on! But a team player doesn't call out a colleague in a situation like that. Honestly, the woman was a dipstick, but still—why couldn't I keep my mouth shut?

So take a lesson from my bad behavior. Hold your tongue—don't get personal, talk only about the issues at hand and NEVER confront a producer with their lame-ness. They could get better, become the opposite of lame, become powerful even—but if they're small-minded, they'll spend their career badmouthing you whenever your name is mentioned—and that could lead to people not wanting to work with you.

It's important to remember that like any team, some players are stronger than others—but you need to collaborate with them all.

Keeping Up with Trends

What's the hottest kind of film being made today? No question. As I write this in 2016, it's the franchise film. Sure, Hollywood has always been in the franchise/sequel business—from *101 Dalmatians* to the James Bond movies, if money was made on a film and audiences liked the characters, hey, why not try a sequel? But it's become the vast majority of the business when we're talking about high grossing films today—*Furious 7, Mad Max, Star Wars, Harry Potter, Avatar, Jurassic Park, Iron Man, Lord of the Rings*—and there are so many more. The *big* movies are the ones that bring in the big bucks—audiences today want those special effects and car chases and larger-than-life experiences they can only get on the big screen. This doesn't mean small, character-driven stories are dead—it just means that the studio isn't expecting them to pay the studio's overhead for the year. And hopefully, the big movie can also have characters we care about.

So once you see a trend like that, what are you supposed to do with it? How should it affect your writing? My answer: not at all.

Sure, it's important to understand trends, it's important to know what kinds of films producers are looking for. And if you write a detective story or thriller or action or futuristic apocalyptic film, it might be nice if you didn't kill off the main character at the end of the film—thus leaving yourself open for a sequel! But beyond that, I wouldn't let the trends tell me what to write.

If you're a storyteller, chances are you have more than one story you'd like to tell. I keep a list of scripts I'd like to write—this isn't just an idea list—I keep one of those too, but this is a list of scripts that I can *see*, that have a beginning, a middle and an end, that are cinematic and I just *know* the story

would make a good film. So when I'm ready to begin a new script, I can go to the list and decide which of them to write next. I've also taken 3–5 stories from my list to my agents, pitched each one, and asked them which one they think is most marketable at this time. If it's on my list, I already want to write it—so why not let someone who knows the marketplace way better than I do make the decision?

There are so many trends happening in the film business that it's hard to keep up with them, let alone know which ones could have an impact on what you write or want to write. If you're an independent filmmaker, your hope could be to get your film in a festival and have a studio buy it there. It's worked in the past for films like *Napoleon Dynamite* [2004] that was made for the incredibly low budget of $400,000, was bought at Sundance, and grossed over $46 million. That kind of a Cinderella story makes a filmmaker inclined to max out those credit cards making a film—hoping that a success like that could come their way. But though other independent films have had similar good luck, recently the trend of studios buying independent films suffered a blow when films bought at Sundance like *Me and Earl and the Dying Girl* [2015]—which the studio bought for a record $12 million at Sundance—pretty much died at the box office. Something like that scares buyers from spending big money at film festivals, and in the next festival, in Toronto, hardly anything sold. So even if you were hoping for a success in the independent film world—which is just about as hard to crack as Hollywood these days—knowing the trends could show you that making your decision on what to write with the hope of selling at Sundance might not be the best reason to choose what you're writing next.

Bottom line—write what you want to write. The 'trends' of the moment can also change and by the time your script gets read, those trends could have changed completely.

It's still a good idea to keep up with what's happening in the film world—after all, this is your business—even when it may not directly impact your writing. One of the best ways to do this is to go to a website like www.deadline.com where stories are released throughout the day (and sometimes night!) about everything related to the business. You can also subscribe, for free at this writing, to have news alerts sent to your email address. Places like Deadline will report on everything from what studio bought the new John Grisham book and whether or not a writer has been assigned, to who's been cast in a film, to who's looking for action scripts, to what films are making money and on and on. You can, of course, ignore the articles that have no interest for you, but as scripts get bought or assigned by the studios, it's nice to keep up with that.

There's no doubt that film can be a very trendy business—one studio hears another studio is doing a pirate movie and they decide to follow their lead and do a pirate movie too, and a trend is born! In the end, I think it's original

thought and work that changes things, and maybe if you do that, *you'll* spark the next trend without even realizing it.

Knowing the Players

The film business isn't like anything else. It's speculative artistic investment—and it's unique. But because, as our friend William Goldman taught us, nobody knows anything, no one can predict with certainty what the best business practices are to follow if a production company/producer/studio wants to succeed. But it's important as you navigate the waters to know who's swimming around you—to know the organizational structure of the business as it impacts you as a writer.

Every producing entity—whether individual producer, production company, or studio—has people who read scripts. They're called readers. Agencies have them as well. Big agencies have in-house readers who read only the scripts their clients write or bring to them, but they also employ outside readers whom they hire on a per-script basis to read scripts that other agencies or companies send to them for their clients to consider.

After the readers at a producing entity, you have development executives—junior development executives, senior development executives, V.P.'s of development, heads of development. Any of these people could pluck your script from obscurity and put your project into development.

When a script goes into development, it means they're going to try and package it so that it looks worth the monetary risk to make. Their first job is to find people to attach. When someone is attached to your script, it means they agree to act in it or direct it or do the cinematography for it if someone puts it into production. So the producing entity will attach that star, director, or cinematographer, and then they'll take that package to a financier (sometimes a studio, sometimes a group of private investors) and try and convince them that *this* project should be made—that *this* project has a chance to succeed.

If your script is chosen by the powers that be and gets funding, it goes into pre-production—where budgets are scrupulously made, locations scouted, and all the other people needed to make the film are sourced out.

When the studio is satisfied that this project will work, they'll 'greenlight' it, meaning it's good to go, and announce a start date for principal photography. The start date for principal photography is a date you *really* want to know because the day those cameras start rolling is the day that you get another check. Per most deals, you get part of your money when you write the screenplay and another part of it when it starts filming.

It's possible during all of this that other writers will be brought on—this is normal, sorry to say. If you were a playwright, no one would ever rewrite your work—neither the director nor an actor would change a syllable

of dialogue without your permission. And they'd *never* bring in another writer to rewrite your play. In the theatre, you are king. If you're a novelist, your editor might suggest changes—strongly suggest—but it's still up to you to decide whether you're going to make the change. But in screenwriting, the collaborative nature of the business means that the screenplay isn't really 'yours' but belongs to the project. As such, producers or directors or studio executives may decide that, to succeed in the marketplace, it needs to go in a certain direction. If they feel you don't support their thoughts or that you can't make the changes because your vision is in a different direction, they'll replace you on the project. Sometimes, after turning in a first draft, it won't be anything like what they were expecting and they'll replace you. You'll probably have been contracted to do a first draft, second draft and a polish—and for each step, you get more money. If they decide to replace you after the first draft, they still have to pay you for the second draft and the polish. I know writers who've made more money for not writing because they've been paid off than they have for writing. But when you're in your notes meeting, it's important to remember that if you argue too vociferously for a particular point that it's clear everyone in the room does *not* want, they might feel you're being inflexible and think about replacing you right then. So it's a good idea to nod and smile to everything you're being asked to change in a notes meeting and then just get back to your computer and make it work. You may discover as you try to make a *stupid* change that someone suggested that, once you find a way to make it, it wasn't stupid at all! Imagine that! If you're working on your second draft, though, and there's one change that was requested that doesn't work, that you simply can't do, that makes the script worse every time you try, don't do it. Turn in your second draft without that change. If the draft is good enough, if you've made it better in most of the ways they requested, it's entirely possible that no one will remember that change they asked you to make that you didn't make. No one sits reading your script with a list of the notes they gave you and checks them off. The producing team and studio execs read the script fresh and just see if it works. Period. They may hate some of what you did—even though the change was *their* idea—but their goal is simply to read the script and see if it works. They'll then give you a second set of notes for you to go off and do another draft or a polish, whatever was in your contract.

Screenwriting is, as currently practiced, a collaborative process. You're writing a story and anyone who reads it can, and probably will, have an opinion on how to make it better. It's a good idea to be open to all those opinions and use them to do just that. You should know from participating in your writers group that when you're open to feedback, you do another pass at the script and it gets better. That's true once you're being paid to write as well—all the people who read it want you to use their ideas to make the script the

best it can be. Everyone in that notes meeting wants your script to go before the cameras. Be a good collaborator and see if you can make this happen for the team.

After the film is made, you'll get residuals four times a year based on TV sales, cable sales, streaming, foreign sales and so on if you produced work where you were paid by a legitimate studio or production company—all of whom are what's called signatories of the WGA. Being a signatory just means they agree to pay minimum wages set up by the WGA as well as pension and health benefits. You don't have to worry about this—the WGA keeps track of all these residuals and pays them to you quarterly.

One more thing to remember as you think about all the people you encounter in the process of becoming a professional—be as thoughtful as you can be to everyone you encounter. I remember having a meeting with a very important producer and he was famous for being difficult and downright mean. He lived up to his reputation. I remember, though, my first meeting with him. An assistant came out to the lobby to ask me if I wanted water or coffee and to apologize that his boss was tied up but it should only be a few minutes. And then he told me he read the script that my agents had submitted for the job I was interviewing for and he'd loved it. He began to talk about a particular group of scenes that blew him away. I thanked him and asked him about his career (most assistants aspire to be something other than an assistant in the business) and we had a very brief conversation. I remember being impressed by him because he'd actually *read* my script—I could tell that because of the detail he knew when discussing it. A couple of years later, my agent got a call that a producer wanted to meet with me—a producer neither of us knew—and I was escorted by an assistant to the producer's office, and guess who? Yep, it was that very same assistant who'd liked my work a couple of years back. This is completely normal—today's assistant is tomorrow's producer—so take the time to get to know everyone you meet at a meeting, and you too can congratulate that assistant after he/she's moved up the ladder!

These are a few of the players you'll run into as your script finds its way from your computer to the big screen—and you should keep a running list of every single person you meet. Some of those steps can be tough to live through when things don't seem to be going your way, and things may happen regarding the project that are completely out of your control—which can be beyond frustrating. But—how can I say this—enjoy the process if possible, and if bad things happen, try to have a sense of humor about them and just push on . . . to the next draft or the next script or the next deal. Be a professional, do your work, be nice to everyone you meet, and hope for the best. In this collaborative business, so much is out of your control but you do have control over how you behave to others and what you choose to write— be thoughtful about both.

It's also important to realize that it's not just about Hollywood anymore—film is truly international in scope. Two of my current projects in development are with companies in France and Australia. People in other countries sometimes work differently than we do—you may be asked to be involved in different ways than you would with a U.S. company. But just like traveling to a foreign country, when you work with foreign companies, you need to respect their ways of doing business. So tread carefully. But whomever you're writing for, knowing your business is important. And this is a crazy one—lots to know, lots to try and figure out, and it can change pretty rapidly. Read the trades (*Hollywood Reporter, Variety*) and consult websites like www.hollywoodreporter.com/roundtables and www.filmcourage.com to keep abreast of what's happening in your business. Talk to friends about what's going on in the business, network with people you meet along your journey, really work to *know* the business you're in. While the vast majority of your time should be spent writing, it would be a mistake to think you don't have to work at understanding the business. It would be nice, wouldn't it, if you could just write your script, give it to that agent, and let him/her deal with all the messiness of selling and rewriting it. A nice thought, but that's not how this business works. Being a screenwriter means also being someone who understands the business of screenwriting—you really need to be both to succeed. So do your best to become that savvy screenwriter who's also savvy about the business.

FADE OUT

The day I arrived in L.A. in 1990, I was driving in the valley and got stopped on a street because the block in front of me was roped off while they were filming part of a car chase. I can still see the yellow car that was in the chase. I was *very* excited. I remember telling myself that I'd have to remember this car so that when I saw it in the movie or TV show, I'd remember that I was there, that on my first day in L.A., I saw a movie being filmed. That's who I am—and probably always will be—a wide-eyed kid from Iowa who loves the movies and all the magic that goes with them.

Needless to say, I never saw that car on a film or TV show—to this day, I look for it when I watch an old episode of *The Rockford Files* or any film from the 90s. After living in L.A. for 16 years, I had many encounters with such shoots—to the point where my primary response would be to complain because I was being held up in traffic for some stupid film shoot. But I prefer to resist giving myself over to the jaded screenwriter that it would be so easy to become. I want to remain the screenwriter who is hopeful and starry-eyed.

Film is the art form of our time. But writing for film is not an easy road. In many respects, it's a jungle out there and to navigate your way, you may need a machete. A big one. But keep at it—keep carving out your own path. It will probably be one of the more difficult things you do in your life—because it's a super *dense* jungle—but it will also be one of the most rewarding.

If there's something better than being a writer, I don't know what it is. Just remember that it's what you *do*, not who you *are*. Who you are is someone with family and friends who will hopefully support you on your trip into the jungle. But even if the path is too fraught with danger, it's not the only path in life, and nurturing those friends and that family will give you a place to always be you—whether you're a screenwriter or not. But hey, why not try?

Happy travels, my friend.

GENERAL INDEX

adaptations *see* adapted screenplays
adapted screenplays 3–11, 94–117, 126
Adventures in the Screen Trade 48, 184
agents 21, 64, 96, 106, 114, 152–3, 177–82
anti-narrative film 72
Aristotle 48–9
Arndt, Michael 60, 94, 178
assistants 153–4, 193
attachments 177, 191
attorneys 111–13, 178, 181–2
August, John 185

backstory *see* story
BEAT 138
biopics 21, 100–1
bookending 118, 122
brainstorming 12, 18–19, 42–3, 51

character: bio 35–6, 38–9; emotional life of 15, 34, 40, 42, 44–7, 63, 79–80, 147, 154–6, 161, 165–6; main 33–6; subconscious of 33–4, 141; supporting 37–9; understanding nature of 29–47; voice 36–7, 75–6, 90, 93, 168; wants/needs 9, 16, 30, 33–4, 55, 140, 142, 155, 164
Clarke, Gerald 107
Cohen, Dan 17

collaboration 50, 187, 189, 192–3
concepts 12–19
contests *see* screenwriting contests

development 11, 17, 50, 106, 113, 153, 191
dialogue: and action 66; expository 137–8; and formatting 130–1; how to write 74–93; listening to 168; and montages 119–20; and pacing 62–4; and the polish 175; sparseness of 137; and surprise 158; understanding character through 36; and voiceover 124–6

emotional timeline 156

Facebook 99–101, 152
feedback sessions 144, 166–71, 174, 192
Fincher, David 100
flashbacks 36, 42, 110, 118–19, 122–6, 146
formatting 120, 124–5, 127–30, 136
Futterman, Dan 107–8

Gaghan, Stephen 65
genres 20–8, 78, 94, 152: writing action 23–5; writing comedy 22–3; writing family 27–8; writing horror

General Index **197**

36; writing romantic comedy 23; writing sci-fi 26–7; writing thriller 25–6
Goldman, William 48, 184, 191

Hanson, Curtis 97
Heyman, David 178
Hitchcock, Alfred 25, 58, 157
The Hollywood Reporter 194

ideas: and creativity 12, 100; generating 12–19, 31, 105; and plagiarism 175; and travel 172; TV *vs.* film 10
improvisation 93

Katzenburg, Jeffrey 14–15
Kaufman, Charlie 102–3

life rights 101
loglines 15–19, 28, 117

managers 178, 181
margins *see* formatting
McCarthy, Tom 101
metamessage *see* subtext
Miller, Bennett 107–8
montages 119–23, 146

narration *see* voiceover
narrative: and adaptations 126; density of 52–4; intrusiveness of 87–90, 137; and script timing 129; writing of 22–3, 63–6, 133–6
new media 9–10
nonlinear film 72

options 105–7, 111–14, 145
original screenplays 3–10, 95, 108
Orlean, Susan 102–3
outlines 7, 57, 61, 73, 138

pacing 23, 62–6, 72, 79, 87, 101, 133, 136
parentheticals 86–7, 130–1
pitching 147–54, 176, 179
point of view (POV) 13, 30, 118
premises 17–19
proofreading 53, 142–5, 174–5

Proulx, Annie 75
public domain material 6, 103–5, 117

reality television 5–6
representation *see* agents; attorneys; managers
research 35, 104, 152, 172, 185
rewriting 91, 93, 146, 168–70, 173–5, 188–92
Rice, Luanne 164
Rudin, Scott 100

scene heading *see* slug lines
screen shots 135
screenwriting contests: and finding agents 178; The Nicholl Fellowship 183; Scriptalooza 184; Sundance Institute 184, 190
script length 110
Selbo, Jule 22
shopping agreement 111, 114–17
Singer, Josh 101
sitcoms 10
slug lines 131–3, 135–6
Sorkin, Aaron 99–101
spec script 49, 94, 129, 176
spit-balling 30–1
story: and adaptation 95–111; and backstory 52, 84, 137, 140; being flexible about 50; and brainstorming 43–4; and character 29–33, 35, 38; and character's journey 41; choosing original or adapted 3–8; and dialogue 84; emotional nature of 80, 154–6; endings of 55–6; ethics of 99–103; how to write 22, 50, 110–11, 118–27, 135–42; importance of 10, 25; and loglines 14–16; and narrative 52; and nonlinear film 72; and pacing 63; and pitching 147–54; and premises 16–17; and public domain properties 103–5; and slug lines 133; and structure 44–6, 49–63, 95; and studio executives 188, 192; and subplots 41–4, 54; and surprise 156–61; and theme 8–9; and travel 172; and trends 189–91; and writing action 72

subtext 90–1
surprise: and character 31, 140; in comedy 23; how to write 154–61; importance of 9, 52; in loglines 16–17; realistic 56; and story 118; and structure 41; and tension 45, 101; and travel 171

team players 187–9
themes 8–11
travel 171–2, 195
treatments 61
trends 184, 189–91
TV writing 7–10, 179, 185

Variety 194
video games 10, 43, 50, 95–6, 103, 106
voiceover 118–19, 124–6

webisodes 9–11
websites: Academy of Motion Picture Arts and Sciences (AMPAS) 78, 183; for contests 183–4; Deadline 153, 190; dianelake 1; filmcourage 194; IMDB 79, 104, 152; johnaugust 185; LinkedIn 152; movieinsider 153; querytracker 106; for research 153, 167, 175; screenwriterspath 1; Scriptalooza 184; scriptorama 79; simplyscripts 78; Sundance Institute 190; Writers Guild of America (WGA) 78, 184, 193; Youtube 10
white space 66, 72, 87–8, 90, 133
writers groups 31, 166–71, 173–4, 178
writing routine 161–2, 171–2

Zuckerberg, Mark 99–101

FILM INDEX

Adaptation 102–3, 125–6
Alien 157
All the President's Men 184
Argo 123, 136
Avatar 189

Back to the Future 27
Bambi 27
Big 155
The Big Chill 155–6
The Blair Witch Project 26
Bourne series 24
Bridge of Spies 16
Bridget Jones's Diary 35
Bringing Up Baby 78
Brokeback Mountain 75
Butch Cassidy and the Sundance Kid 184

Carol 122
Casablanca 149–51
Charade 159–60
Citizen Kane 72, 159

Deadpool 24
The Devil Wears Prada 119–20, 123
Die Hard 45–6, 160–1
Django Unchained 149
Dumb and Dumber 22

The Family Stone 28
Fight Club 125
Free Willy 27
The French Connection 24
Frida xi, 78
Furious Seven 189

Gone Girl 149–51
Gone with the Wind 149, 157
Gravity 16
The Great Gatsby 126

Harry Potter 189
The Hurt Locker 140

The Imitation Game 26
Inception 27
Inside Out 27
The Intern 156
Iron Man 189
I Was a Male War Bride 78

Jaws 159
Jurassic series 189

Kung Fu Panda series 27

L.A. Confidential 97
Legal Eagles 158

Little Miss Sunshine 60, 94, 178
Lord of the Rings 189

Mad Max series 189
Manhattan 22, 59
Me and Earl and the Dying Girl 190
Mean Girls 57
Memento 72

Napoleon Dynamite 190
Night of the Living Dead 26
North by Northwest 25, 58, 158–9
Notting Hill 121

101 Dalmations 189

The Philadelphia Story 180
The Player 8
Pride and Prejudice and Zombies 26
The Princess Bride 184
Psycho 157
Pulp Fiction 72

Raiders of the Lost Ark 157
Rashomon 125
Rear Window 25, 159

Reservoir Dogs 35
The Revenant 25

Scanners 157
The Shawshank Redemption 125
The Shining 26, 157
Silence of the Lambs 29
Silver Linings Playbook 23
The Sixth Sense 157
The Social Network 99–102
Some Like it Hot 78
Speed 158
Spotlight 26, 98, 101–2
Star Wars 24, 178
The Sting 159
Sunset Boulevard 125
Syriana 65

Tootsie 157
Toy Story 3 94, 178

Vicky Cristina Barcelona 125

The Wizard of Oz 9

You've Got Mail 23

Made in the USA
Columbia, SC
03 December 2019